Landscapes of Origin in the Americas

Landscapes of Origin in the Americas

Creation Narratives Linking Ancient Places and Present Communities

Edited by Jessica Joyce Christie

THE UNIVERSITY OF ALABAMA PRESS

Tuscaloosa

The University of Alabama Press
Tuscaloosa, Alabama 35487-0380
All rights reserved
Manufactured in the United States of America

Typeface: Garamond

∞
The paper on which this book is printed meets the minimum requirements of American National Standard for Information Sciences-Permanence of Paper for Printed Library Materials, ANSI Z39.48-1984.

Library of Congress Cataloging-in-Publication Data

Landscapes of origin in the Americas : creation narratives linking ancient places and present communities / edited by Jessica Joyce Christie.
 p. cm.
 Includes bibliographical references and index.
 ISBN 978-0-8173-1673-0 (cloth : alk. paper) — ISBN 978-0-8173-5560-9 (pbk. : alk. paper) — ISBN 978-0-8173-8247-6 (electronic) 1. Indians—Origin. 2. Indian mythology—America. 3. Sacred space—America. 4. Indians—Folklore. 5. Creation—Mythology—America. 6. Physical geography—America. I. Christie, Jessica Joyce, 1956–
 E61.L226 2009
 398.2089'97—dc22
 2009013456

Contents

Illustrations

Preface and Acknowledgments

This volume "originated" with a session titled *Landscapes of Origin in the Americas* at the Conference of the American Anthropological Association in Atlanta in 2004. The theme inspired great interest, fruitful discussions, and opened doors that led into various directions, resulting in independent publications. I would like to thank the "original" authors and those who came on board later for enriching this promising project and Judith Knight, senior editor at The University of Alabama Press, for her diligent work and sense of staying in control while turning it into a book.

I further express my thanks and deep gratitude to Dumbarton Oaks. I received a fellowship in the summer of 2008 and it was in the supportive and nourishing environment of the Dumbarton Oaks Library that final editing was accomplished.

At East Carolina University, I thankfully acknowledge the always-available help of Kelly Adams and her graduate assistants, and Michael Dixon in creating and formatting digital images. Without them, this book could not have been completed.

—Jessica Joyce Christie

Introduction

In the world today, there is a common held belief that, thousands of years ago, as the world counts time, Mongolian nomads crossed a land bridge to enter the western hemisphere, and became the people known as the American Indians. There is, it can be said, some scanty evidence to support the myth of the land bridge. But there is enormous wealth of proof to confirm that the other truths are all valid.

—(Bill Reid in Holm and Reid 1976:7)

This volume is about the "other truths."

The following chapters will demonstrate a variety of ways of how to look at *Landscapes of Origin* in a number of societies in the Americas. At the outset, it is important to consider that landscape is not simply what we see out there. In conventional anthropological literature, *landscape* has been used as a framing convention within which the author develops his or her topic; or the term has been linked to the meaning local people bestow on their cultural and physical surroundings. Some chapters will take this approach. A further reaching methodology is to explore local ideas about landscape but use them reflexively to interrogate Western notions and concepts. It is insightful to be aware that the word *landscape* appeared in the English language in the late sixteenth century as a technical term used by painters, thus establishing a painterly origin of the landscape concept (see Hirsch 1995:1–2). What this implies for our volume is that "landscape" by its etymological history refers to a "painted" or "picturesque" concept an individual has created or a societal group has constructed. A large body of theoretical literature has expanded on these issues since (e.g., Ashmore and Knapp 1999; David and Wilson 2002).

The term *origin*, used in this volume as it relates to the beginnings of a society or a particular social group, is closely related to memory. Anthropologists have argued that memory must be understood not in the individual psychological context Sigmund Freud had treated it but in the social world of collective interaction (e.g., Connerton 1989; Golden 2005). Connerton (1989:6) starts his discussion of social memory with the words "All beginnings contain an element of recollection." He explains that "the absolutely new is inconceivable" and that human beings base all new experiences on a prior context in order to make them intelligible. Thus Bill Reid's "other truths" above are socially constructed. Further, each individual in any society is not just part of one but of a variety of social groups. Individuals recall different memories that often have to be modified when being communicated to other members of the group and therefore become selective reconstructions of

past events that continue to serve a present collective need. Such a process can be observed in the ways many indigenous societies in the Americas have adapted, illustrated, and newly performed their origin stories.

Landscape is a powerful factor in the operation of memory because of the associations narrators make between the local landscape and the events of the stories they tell. In this continual interaction between the past, the present, as well as the future, time is subordinate to place, and history as defined in Western academic terms does not exist. It follows that Native consultants explain their landscape and origin in ways rather different from those of Western-trained anthropologists. They have identified specific physical places—for example, Temekú, the site where the culture-hero Wiyot of the Payomkawichum in California was cremated, or Tampu Toq'o, the three caves from which the Inka ancestors emerged—as well as imagined places—such as Tollan, a name applied to multiple locations as well as being a concept used and redefined by most MesoAmerican peoples. Narratives have been told of them and they have been represented in their visual and performance arts.

This volume draws together origin places from diverse regions in the Americas and origin places in diverse forms. Anthropologists have shown how ancestors and mythological events often become fixed in a specific landscape and act as timeless reference points. In a wider sense, individuals in all succeeding generations have to learn about the land, and in so doing, they not only renew the ancestral past, but they also transform it by adjusting it to present circumstances (Morphy 1995). Authors address the above and related theoretical issues and how they were and are being lived by specific cultures and groups in the Americas. At the same time, we must be aware of our *personal landscapes of origin* with which each one of us—as author, consultant, or reader—approaches the topic, based upon our disciplines, upbringing, as well as personal experiences. None of us—whether writer or reader—is neutral, and therefore our presentation and understanding of the material in the following chapters will be tilted and individually differ due to our academic training, cultural perceptions, as well as personal preferences. To put it simply, we will unintentionally overlay our *personal landscape of multiple origins* upon the origin places of indigenous people, and we should open this volume keeping this in mind (personal communication with Ron Graziani, 2004–2008).

The core of the book is divided into three parts, which discuss selected cultures and their origin places/narratives in North, Central, and South America. Although the case studies are incomplete and many cultures remain unmentioned, they present three main themes that help frame a loose model that will assist future researchers in understanding origin locales.

Theme 1 addresses the physical characteristics of origin and creation sites that often focus on mountains, caves, and water sources. Precontact peoples in the Americas understood the cosmos as having three vertical layers conceptualized as the underworld, the world of man, and the world above as well as four horizontal

divisions defined by the movements of the sun as the cardinal directions. The landscape features named above constitute liminal points that reach above or below one layer and aim to connect two levels. For these reasons, indigenous peoples all over the world have considered them power places at and through which spirits and supernatural forces may be contacted, as Mircea Eliade has so eloquently demonstrated (1969:Preface, 72–87, 1974:3–24).

Theme 2 deals with the ways specific groups and cultures relocated and often multiplied origin sites and repeated creation events and with which motivations. Unlike the pan-American geological features of Theme 1, these activities are very much individualized and culture-specific. Fascinating new perspectives on this theme have been coming from the work of Alexandre Tokovinine (2008a, 2008b), who analyzes the concepts of place and associated identity among the Classic Maya. Tokovinine has shown that Classic Maya rulers and their polities formulated multiple origin locales, such as the site where a specific dynasty came from, the seat of the dynasty, and the region over which this dynasty ruled. All three locales constructed the identity and fed the ideology propagated by this polity. The Classic Maya construction of place and origin will draw intriguing comparisons with corresponding notions among contemporary Maya groups.

Theme 3 refers to the continued though altered relevance origin places exert upon the direct or not so direct contemporary descendants of those ancient people who formulated the origin stories/myths and anchored them in their landscape, which was then pristine in the sense of being untouched by Western civilization and technology. This third theme is extremely important in providing the link between the past and the present and to demonstrate that the two are not disconnected— see the contributions by Will Tsosie, Richard Arnold, Larry Eddy, Betty Cornelius, and William Wasden. It also raises the challenge of how we, as Western scholars, may respectfully work with and write about indigenous people.

It is hoped that these themes sketch a model for follow-up Landscapes of Origin studies.

Landscapes of Origin in the Americas

I
North America

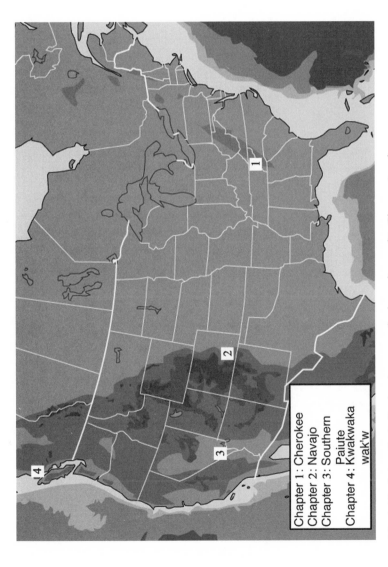

Map 1. North America indicating the areas and cultures discussed in Chapters 1 to 4.

Chapter 1: Cherokee
Chapter 2: Navajo
Chapter 3: Southern
 Paiute
Chapter 4: Kwakwaka
 wak'w

1 The Center of the World

The Principle People and the Great Smoky Mountains

Christopher Arris Oakley

According to Cherokee oral tradition, the world was once all water, and the animals lived in the sky above the great stone arch. But the animals felt overcrowded, so they sent the little water beetle down to the large sea below to explore. The beetle darted around on top of the water for a long time, but he tired and looked, in vain, for a place to rest. Eventually, he dove under the water and came back up to the surface with some soft mud, which grew until it formed a large island in the center of the sea. Someone, no one knows who, fastened the island to the stone sky vault with four chords. And thus, the Earth was born (Mooney 1995).

At first, the ground was very soft and wet. The animals, still overcrowded, were anxious to get down to the island, so they sent different birds to explore and test the ground. Finally, they sent the great buzzard, who flew all around the Earth, which was still muddy. As the buzzard tired, his wings began to strike the ground, making deep valleys on each downstroke and great mountains on each upstroke. When the animals saw this, they called him back, fearing that he would do this to the entire Earth. Eventually, when the ground dried, all of the animals came down to live (Mooney 1995).

The Principle People (Ani-Yun Wiya), more commonly known as the Cherokees, lived in the mountains and valleys created by the wings of the great buzzard. The Cherokees built small towns along the waterways of the region, known today as the American Southeast, and created a distinctive society and culture. This chapter examines the relationship between the natural environment of the southern Appalachians and the evolution of the Cherokee worldview. This relationship can be analyzed by a careful examination of Cherokee oral traditions. As described in these traditions, the mountains and rivers of the region, combined with the indigenous flora and fauna, shaped Cherokee culture and life. Consequently, for the Principle People, the mountains of present-day eastern Tennessee and western North Carolina were more than simply a homeland; rather, the mountains were a special place, a sacred landscape that helped forge Cherokee society and identity.

The Origin of the Cherokees

During the ninth and tenth centuries, the Mississippian culture spread across the American Southeast, from the Mississippi River valley eastward across the Appalachian Mountains. Native Americans in the Mississippian era practiced maize agriculture, lived in large cities, some numbering in the tens of thousands, and built large, flat-topped earth ceremonial mounds, upon which priests held rituals and ceremonies. Powerful hereditary leaders ruled these chiefdoms, which sometimes formed alliances with others to form super or paramount chiefdoms. War was common during the Mississippian period, as chiefdoms and paramount chiefdoms competed for land and resources in the region (Hudson 1976; Hudson and Ethridge 2002; Satz 1979).

Despite its quick rise, the Mississippian culture collapsed in the 1500s. The cause remains somewhat of a mystery. The arrival of Europeans in the 1500s certainly was a factor. The introduction of new diseases, most notably smallpox, spread by De Soto's expedition in the 1540s, devastated Native Americans and perhaps reduced the region's indigenous population below the level that could support large chiefdoms. But some scholars have argued that the Mississippian culture was already declining by the late 1400s, well before De Soto and European contact, because of warfare, overpopulation, and internal political and social unrest (Finger 1984; Hudson and Ethridge 2002; Rodning 2002; Ward and Davis 1991). Further archaeological evidence may provide new insight into this question, but what is clear is that by the 1600s, the Mississippian period in the Southeast was over. The death of the chiefdoms in the region, however, gave birth to the Native American peoples, polities, and cultures that would become so well known to Europeans during the colonial era, such as the Catawbas, the Creeks, the Chickasaws, and the Cherokees. Or, as noted anthropologist Charles Hudson has argued, "all of the major Indian polities in the seventeenth- and eighteenth-century eastern U.S. were formed out of the coalescences and amalgamations of the survivors of shattered prehistoric societies" (Hudson and Ethridge 2002:xxxvi).

Much like the collapse of the Mississippians, the exact origin of the Cherokees is disputed. Some scholars argue that the Cherokees were relative newcomers to the region, having migrated southward after losing a war with their linguistic kinsmen the northern Iroquois. According to this theory, shortly before European contact, the Cherokee invaders left their northern homelands and moved into the southern mountains, where they defeated and subjugated other indigenous peoples. But others argue, and archaeological evidence seems to support, that the ancestors of the Cherokees had occupied the southern Appalachian Mountains for more than 1,000 years prior to the arrival of Europeans, and that these ancestors, like other southern Indians, organized into Mississippian chiefdoms around 1000. It is also possible that both theories are partly correct, that a core group of Native

Americans, Cherokee forefathers, lived in the mountains for centuries, but other Iroquoian-speakers moved in, settled, and assimilated during later periods of migration. Many Cherokees believe that their ancestors have been in the southern Appalachian Mountains from time immemorial (Hudson and Ethridge 2002; King 1979; Perdue 1998; Rodning 2002; Ross 1999).

Unlike other southern Native American peoples, the Cherokees thrived after the Mississippian period ended. After the chiefdoms collapsed, people left the cities and built small settlements along the rivers of the southern Appalachians, where they established new towns, independent polities, and a distinctive culture. The mountains, which offered seclusion and protection from disease and foreign invaders, may have been a popular choice for new settlements during the stressful postcontact era. In fact, according to Hudson, "the Cherokees are seemingly exceptional in the Southeast for being more formidable in the eighteenth century than they were in the sixteenth century" (Hudson and Ethridge 2002:xxxiv). Moreover, the mountains provided further protection during the turbulent 1700s, a century when European colonization devastated many Native American peoples in the Southeast. Consequently, the collapse of the Mississippian chiefdoms combined with the geography of the southern Appalachians created in the 1600s the Cherokee "tribe" that would thrive during the colonial era. And the mountains of the Southeast, the center of the Cherokee world, became the heart of that Cherokee culture (Perdue 1998; Rodning 2002).

Cherokee Culture

In the late 1600s and early 1700s, the Cherokees, who numbered approximately 25,000, claimed 40,000 square miles of land in the Southeast. This territory included parts of the present-day American states of North Carolina, South Carolina, Tennessee, Georgia, Alabama, West Virginia, and Virginia. Other Native American peoples, enemies of the Cherokees, often contested the borderlands. The Creeks and Chickasaws lived to the southwest, while the Tuscaroras and Catawbas lived to the east and southeast. Despite the claim to much of the region, the true center of Cherokee society, the culture hearth of the Principle People, and the place where the Cherokees primarily lived, was the Great Smoky Mountains, the part of the southern Appalachians that is located today in western North Carolina and eastern Tennessee. It is this sacred homeland that witnessed the growth and maturation of the Cherokee people and their culture (Altman 2006; Finger 1984).

The Great Smoky Mountains contain high peaks, deep and narrow valleys, and numerous gaps, ridges, knobs, and knolls. The average elevation is about 5,500 feet (Camp 1963; Ross 1999). The rainfall and temperature vary depending on elevation, but in general the region averages approximately 60 inches of rain and 10 inches of snow per year. The growing season typically lasts 165 to 175 days per

year, though that decreases significantly in the higher elevations. Temperatures average around 60 degrees Fahrenheit in July and 40 degrees in January, though again it varies based on altitude (Sharpe 1958, 1965). Several important rivers, such as the French Broad, Tennessee, and Little Tennessee, run through the plateaus and valleys in the area. The expansive forests of the region provided a wide variety of resources that were very important to the Cherokees, especially the hardwood trees, such as maple, birch, ash, and oak. At higher elevations, spruce and fir dominated, along with longleaf pines and other deciduous trees. Although limited by the mountains, good agricultural land was available in the river valleys, where fertile alluvial soil allowed for the cultivation of maize, beans, and squash (Ross 1999). Wild game, especially deer and bear, provided the Cherokees with meat, clothing, and tools. The numerous rivers and streams of the mountain valleys also offered food, and the Cherokees became excellent fishermen, employing several different types of traps, nets, and poisons (Altman 2006; Rozema 1995). Life was not always easy for the Cherokees, but the Smoky Mountains provided them with the necessary resources. According to author Roy Dickens, the Cherokee culture "was the end product of a long, continuous, and multilinear development in the South Appalachian region" (Dickens 1979:28).

The peaks and valleys of the Great Smoky Mountains divided the heart of Cherokee country into numerous small settlements. Unlike the chiefdoms of the Mississippian era, and perhaps even as a reaction to them, the small Cherokee towns of the late seventeenth and eighteenth centuries were politically autonomous. There was no Cherokee nation, at least politically, until the 1800s. Because of the scattered nature of the settlements, scholars have often divided Cherokee towns into three general areas: Lower Towns, Middle Towns, and Overhill Towns. The Lower Towns were located along the Keowee, Tugaloo, and Savannah rivers. The Middle Towns were situated along the headwaters and tributaries of the Little Tennessee River, and the Overhill Towns were along the upper Tennessee River and the lower Little Tennessee River, near the border separating present-day Tennessee and North Carolina (Finger 1984; Ward and Davis 1991).

After the collapse of the chiefdoms, the Cherokees created in the mountains a new society, one that was influenced by both the late Mississippian culture and their physical surroundings. Therefore, a shared environment and culture, not a central political system, united the Cherokees. As with the Mississippian culture, maize agriculture was a staple of Cherokee society. But new practices distinguished the Cherokees from the Mississippians, thus defining Cherokee identity. First, as noted above, Cherokee towns, which numbered between 50 and 80 in the 1600s, were politically autonomous. Most towns consisted of a collection of households, sometimes very close together, sometimes spread out along a waterway in the mountain valleys where the soil was best for growing corn. The mountains separated the towns and settlements, making political unification, which was the norm dur-

ing the Mississippian period, more difficult. At the center of the town was a large council house, where Cherokees would gather to discuss important issues. Each town handled its own affairs, and the residents tried to reach a decision through consensus. There was no Cherokee central authority, either at the village or tribal level. Moreover, Cherokee society was much more egalitarian, both socially and politically, than the Mississippi chiefdoms. Among the Cherokees, the acquisition of personal wealth was frowned upon, which contrasted sharply with the economic stratification of the Mississippian chiefdoms (Hudson 1976; Perdue 1989; Rodning 2002; Satz 1979).

Second, the Cherokees spoke an Iroquoian language, which though not unique in the region, was unusual, and helped unite the towns. The Cherokee language was related to the languages spoken by the Iroquoian nations of the American Northeast (Cayuga, Oneida, Onondaga, Mohawk, and Seneca). Fewer Native American peoples in the South spoke an Iroquoian language, though the Tuscaroras, enemies of the Cherokees, were a notable exception. Although united by a common general language, there were several dialects. Cherokees living in each of the above three general areas of settlement—the Lower Towns, Middle Towns, and Overhill Towns—spoke a different dialect of their Iroquoian language, and some scholars have suggested that there were other dialects as well (Altman 2006; Perdue 1985).

Third, Cherokee society consisted of matrilineal clans, which were family groups supposedly all descended from the same individual or entity. There were seven known Cherokee clans (Wolf, Deer, Bird, Paint, Wild Potato, Blue, and Twister) and membership was passed down through the mother.[1] Moreover, a child was raised in the household of his or her mother, surrounded by her clan. Among the Cherokees, clan membership defined one's role and place in society, including obligations and responsibilities. Furthermore, women controlled Cherokee households and the surrounding fields (Finger 1984; Perdue 1989; Rozema 1995). According to historian Theda Perdue, "matrilineality placed women in a unique position: they alone could convey the kinship ties essential to a Cherokee's existence" (Perdue 1998:46).

And finally, balance and harmony were important fundamental concepts in Cherokee society. Ideally, when the world was in a state of balance, everything was in harmony. The concept of balance naturally included the Cherokees' interaction with their environment, but extended to internal affairs as well. For example, men and women, who had separate but complementary roles, balanced each other. The women took care of the household and tended the fields, though the men helped clear them. Corn, beans, and squash provided the majority of the calories in the Cherokee diet, which meant that control of agricultural production and consumption was economically very important. Moreover, most of the important rituals and ceremonies in Cherokee society revolved around the agricultural cycles. The

Green Corn Ceremony, a time of renewal and forgiveness held in the summer after the first harvest of corn, was the most important Cherokee ceremony. During the days leading up to Green Corn, Cherokees would extinguish village fires and discard old clothes and tools. All disputes and crimes, except murder, were settled or forgiven. After a period of fasting, a great feast was held, followed by dancing and the igniting of new fires from the ceremonial flame (Hudson 1976; Perdue 1998).

To supplement the Cherokee diet, the men hunted and fished in the forests and waters of the mountains. Cherokee men also handled most political and military affairs, though women did have some input into both. In many ways, Cherokee men and women lived in separate worlds, and each sex was somewhat ignorant of the other's world. But, unlike in some other societies, the men's world was not considered superior, and women's work was not considered inferior. Rather, they worked together to promote balance and harmony in Cherokee society. According to Perdue, "men and women had separate and distinct responsibilities. But the Cherokees viewed the tasks both women and men performed and the contributions they made as essential to their society and, like the sun and moon, to the integrity of the universe" (Perdue 1998:40).

Balance and harmony existed in other areas as well. Summer balanced winter, the sun balanced the moon, animals balanced plants, and so forth. When that balance was altered, the natural harmony of the world was disrupted. Within Cherokee society, the matrilineal clans were charged with maintaining that harmony. A crime, such as murder, upset the natural balance and demanded the restoration of harmony, which could be done in a couple of ways. First, the clan members of the victim could kill the wrongdoer or another member of his or her clan. This act of "revenge killing" would restore harmony. Or, alternatively, the clan of the wrongdoer could try to address the transgression by giving gifts to the clan of the victim, an act referred to as "covering the dead." The victim's family, depending on the egregiousness of the act and the generosity of the gifts, could choose whether or not to accept the offering. In short, Cherokee clans regulated society by trying to maintain balance and harmony, which was very different from the Western legal system of regulating society, where the primary goal is punishing the perpetrator and dispensing justice.

Cherokee Oral Tradition and Sacred Landscapes

The geography of the southern Appalachian Mountains was vital to the evolution of Cherokee society. Consequently, the local environment was, for the Cherokee people, a sacred landscape. The significance of the region was illustrated in Cherokee oral tradition, which connected the Principle People to the mountains and valleys of their homeland. For the Cherokee, the mountains of the region, es-

pecially those along the North Carolina–Tennessee border, became much more than their place of settlement. This, of course, was not uncommon—other peoples' culture and worldview have been influenced by their natural environment (see the Southern Paiutes, Chapter 3). Nevertheless, understanding the connection between the Principle People and their environment is vital to understanding Cherokee history and identity. In Cherokee oral tradition, this could be seen in three ways. First, [1] the Great Smoky Mountains provided the setting for many of the important legends and myths that explained Cherokee society and worldview. Likewise, the nu- [2] merous waterways of the Smoky Mountains, vital to Cherokee existence in many practical ways, were also important settings for oral traditions. And finally, the na- [3] tive plants and animals of the mountains played important roles and characters in Cherokee mythology.

The mountains along the North Carolina–Tennessee border, the center of the Cherokee world, provided a variety of settings for Cherokee mythology. Particular places in the mountains, especially knobs and caves, became associated with important oral traditions that explained Cherokee beliefs. One of the most important and well-known Cherokee myths illustrated the significance and mysteriousness of the region's mountains and caves (compare with the Spring Mountain range in Chapter 3 and Aztec Malinalco in Chapter 5). Kana'ti (Lucky Hunter), his wife Selu (Corn), and their son lived at Pilot Knob. Kana'ti was an excellent provider, and he always returned home with plenty of meat, which Selu washed in the river. Selu provided the family with corn and beans, thus establishing the traditional gender roles of Cherokee women (agriculture) and men (hunting). One day, Selu and Kana'ti heard two voices down by the river where their son was playing. When asked about the other voice, the son told them that he had a playmate who lived in the river because his mother was cruel to him and threw him away. Selu and Kana'ti immediately understood that their son's playmate, who they referred to as Wild Boy, came from the blood of the game cleaned in the river (Mooney 1995).

Wild Boy, who was very mischievous, eventually moved in with the family. One day, the son and Wild Boy followed Kana'ti into the woods to find out why he was such a good hunter. They followed him up Pilot Knob until he came to a large cave blocked by a rock. Kana'ti lifted the rock, a large buck ran out, and the great hunter quickly shot and killed the buck with his bow and arrow. He then replaced the rock, thus blocking the cave. A few days later, the two boys decided to go back to the cave and kill a buck for themselves, but when they moved the rock, all of the deer escaped, followed by all of the raccoons, rabbits, turkeys, pigeons, and other wild game that had been trapped in the cave. This is why, according to legend, Cherokee men have to hunt for game in the forests of the mountains (Mooney 1995).

The two boys returned home from the cave hungry, so they asked their mother, Selu, for something to eat. Lacking meat, she went out to the storehouse to get

some corn and beans to prepare a meal. Again curious, the boys followed their mother to the storehouse to see how she managed to keep so much food in such a small building. The boys spied on her as she produced corn by rubbing her stomach and beans by rubbing her armpits. Shocked by their mother's powers, the boys determined that she was a witch and decided to kill her. When she returned to the house, Selu instinctively knew what her boys were going to do. She told them to clear the ground in front of the house and drag her body seven times around in a circle, then seven times over the ground inside the circle. If they did this, they would always have corn to eat. The boys killed her and put her head on top of the house facing west, but they only cleared seven little spots, which is why corn only grows in certain places. Furthermore, they only dragged her body through the circle twice, which is why the Cherokees harvest corn only twice per year (Mooney 1995).

The legend of Kana'ti, Selu, and their two children was one of the most important Cherokee oral traditions. Selu was a dying deity, which, according to authors David Leeming and Jake Page, is commonly associated with fertility in mythologies from many different peoples (Leeming and Page 1998). Moreover, the story broadly described the matrilineal kinship system of the Cherokees. The mother was the head of the household—her head is even placed on top of the house after death—and she was the provider of corn, the most important source of food for the Cherokee. The husband, Kana'ti, was the hunter who provided meat. Similar oral traditions were common to other peoples and cultures, but what made this one, and others, so important to the Cherokees was the location. The cave located within the mountain was the source of the wild game so important to the Cherokees. Consequently, it was not just the legend that was sacred but also the setting, which specifically tied the Cherokee to their mountain homelands.

Numerous other Cherokee oral traditions were associated with other specific locations in the Great Smoky Mountains. According to other Cherokee traditions, dangerous insects and creatures lived in the higher elevations. The legendary Uktena, a large monster snake with horns and a body as big as a tree trunk, lived in high altitudes. Another great serpent lived on Cohutta Mountain. The Cherokee called it Ustu'tli, or foot snake, because it had four feet that gripped the ground like suction cups. The foot snake lured hunters by bleating like a fawn. Eventually, a brave Cherokee hunter was able to trap and burn Ustu'tli. Cherokee oral tradition memorialized the exact location of the serpent's death (Mooney 1995). Along with monster serpents, giant insects also lived on the mountains. For example, a Great Yellow Jacket (U'lagu') once terrorized the Principle People living in the old Cherokee town of Kanu'gala'yi, which was located on the Nantahala River, by flying down and stealing children. Finally, the Cherokees followed the Great Yellow Jacket eastward, discovered its nest in a large cave, and burned it. The Cherokee named the cave Tsgagun'yi, or "where the yellow jacket was," and called the place from where

they first saw the nest Atahi'ta, or "where they shouted." Both of these places became well known in Cherokee lore (Mooney 1995).

Other great creatures also terrorized the Cherokees from high in the mountains. Large hawks living in a well-protected cave on a cliff above the north bank of the Tennessee River would swoop down and capture small animals and children. The Cherokee called the nest the Tla'nuwa'i, or "the place of the great mythic hawk." A medicine man climbed the cliff when the adult hawks were away and threw the young ones down into the waters of the river below, where a serpent ate them. When the large hawks returned, they swooped down into the river, grabbed the serpent with their talons, flew high into the air, and shredded the snake into pieces, which fell to the ground making great holes, still visible today. The Cherokee called this place "where the Tla'nuwa cut it up." The large hawks subsequently flew away and never returned. As with others, these stories marked courageous acts committed by Cherokee individuals, and as such were a source of community unity and pride. Moreover, the physical settings of these stories became revered locations to the Cherokees, and thus an important part of oral tradition and tribal identity (Mooney 1995).

Along with animals and insects, dangerous people lived in the mountains as well. An ogress named U'tlun'ta (Spear-Finger) lived along the peaks of the mountains, especially near Chilhowee Mountain. She had a long stony forefinger on her right hand that she used to stab her victims before eating their livers. She once began to build a great rock bridge in the mountains from the Hiwassee River over to Whiteside Mountain, but lightning hit the bridge and destroyed it. According to the Cherokees, large fragments from the bridge can still be seen throughout the area (Mooney 1995).

The Cherokees have numerous other names for places in the mountains where important oral legends originated. The Cherokees named a high peak on the western border of Swain County Tsistu'yi, or "rabbit place." In the old days, the rabbits lived there with their leader the Great Rabbit, who was supposedly the size of a deer. The Cherokees referred to two peaks at the head of the Cheowa River as Sehwate'yi, or "hornet place," because a large hornet kept a nest there (Mooney 1995).

Along with mountains and caves, the waterways of the region were a vital part of the geography of the Cherokee homeland. According to Cherokee beliefs, there are three worlds: this world, the upper world, and the lower world. The numerous rivers and streams in the region were trails that led to the underworld. Consequently, certain places in these waterways, especially springs and rapids, were very powerful and potentially dangerous. They were also important settings for Cherokee oral traditions (see the Nimpkish River in Chapter 4). According to one, a giant red and white leech lived in a deep hole in the Hiwassee River near present-day Murphy, North Carolina. The Cherokee referred to this place as Tlanusi'yi, or "the leech

place." The leech could make the water in the river boil and foam until a giant waterspout erupts and carries people away; later they are often found with their noses and eyes eaten off. According to the version of the legend recorded by anthropologist James Mooney in the late 1800s, "the great leech is still there in the deep hole, because when people look down they see something alive moving about on the bottom" (Mooney 1995:330).

As with the mountains and caves, Cherokee waterway place names were connected with oral traditions. And, also like the higher elevations, many of these names were associated with danger. Toco Creek in eastern Tennessee was named after a monster fish that supposedly lived in its waters. The Cherokee referred to a series of whirlpools on Suck Creek in Tennessee as Un'ttiguhi', or "pot-in-the-water." They named a spot on the French Broad River in Madison County Dakwa'i, because a Dakwa' or monster fish lived there. A tributary of the Chowan River was known as Yunsa'i, or "buffalo place," because a buffalo used to live there under the water (Mooney 1995). The animals that lived in the mountains also played key roles in Cherokee oral traditions and thus are an important part of the sacred Cherokee landscape. Many legends explained why animals looked and behaved the way that they did. For example, in one story, the rabbit, a notorious trickster and deceiver, raced a deer to determine who was the swiftest through the woods. But the rabbit cheated, so the deer, who had a smooth head at the time, won the race and was rewarded with a large pair of antlers. Angry about losing, the rabbit later tricked the deer into filing his teeth until they were so blunt he could only chew grass and leaves, thus explaining why deer have antlers and eat only vegetation (Mooney 1995).

Another oral tradition explained how the bat and the flying squirrel earned their wings. A great ball game was to be played between the birds and the four-legged animals. The playing of this ball game, which was similar to modern-day lacrosse, was common to Native Americans in the Southeast. In the game, two teams of players try to score by using sticks to throw a small leather ball through one of two goals. In many Cherokee oral traditions, animals often took on human characteristics and participated in similar activities, such as contests and races. The bat and the squirrel wanted to play in the big game, but the other four-legged animals, such as bears and deer, laughed at them because they were so small. Feeling rejected, the bat and the squirrel climbed a tree and asked the eagle and the hawk if they could play with their team, so the birds created wings for them. In the game, the bat and the flying squirrel helped the birds defeat the animals, and afterward, they kept their wings (Mooney 1995).

As alluded to above, in Cherokee oral tradition there are few distinctions between humans and animals. For example, in the "old days" animals talked and interacted directly with humans. Therefore, animals and humans were in essence equals. This suggests that humans are merely part of the world, not special or dis-

tinct from other living creatures, a belief that is vital to understanding Cherokee society. In one story, a widow encouraged her daughter to marry a good hunter, so that he could provide for their family. One day, a man called on her and claimed to be an excellent hunter, but after the marriage, he turned out to be a poor provider, only occasionally bringing home meager scraps for food. The woman ultimately learned that her husband was in fact an owl, and she chased him out of the house. According to the version recorded by Mooney in the late 1800s, "the owl went into the woods and there he pined away with grief and love until there was no flesh left on any part of his body except his head" (Mooney 1995:292).

Cherokee oral tradition also taught that humans should live in harmony with animals, or face the consequences. Previously, humans, as their population increased, had abused their relationship with the animals by overhunting large game and destroying the habitat of little ones. Consequently, the animals met, denounced the humans' cruelty, and plotted revenge by inflicting them with a variety of maladies. For example, if a hunter killed a deer without asking for forgiveness, then the deer would give that hunter rheumatism. Fish and reptiles would inflict humans with terrible nightmares. The plants, however, who were generally more friendly with humans, decided to help the Cherokees by producing cures to each of the ailments caused by animals. This, of course, explained how the plants indigenous to the region provided remedies to many common ailments (Mooney 1995).

The mythology of the Cherokees clearly illustrated the importance of their homelands to the Principle People. Oral traditions involving Kana'ti, Selu, caves, mountains, rivers, animals, and plants connected the Cherokees to the mountains of the southern Appalachians, especially the Great Smoky Mountains. Some of the morals and characters of Cherokee mythology were common to other cultures and peoples, such as the trickster rabbit, but the Cherokees made them their own by rooting them in very specific locations in the mountains, locations that became known and named for their role in the oral traditions. In Cherokee mythology, humans, animals, and plants interacted in the mountains; thus, all were an important part of the "center of the world." According to James Mooney, "almost every prominent rock and mountain, every deep bend in the river, in the old Cherokee country has its accompanying legend" (Mooney 1995:231). And it is these legends, and their locations, that helped shape the Principle People's identity.

Conclusion

Cherokee society was forged in the southern Appalachian Mountains of the present-day American Southeast. This strong attachment to a particular place may have begun in the Mississippian period, but it solidified in the sixteenth and seventeenth centuries, after the collapse of the southeastern chiefdoms. Consequently, the southern Appalachian Mountains were more than simply a place to live and

farm—they were a culture hearth, a sacred landscape of origin. To the Cherokees, the mountains created by the wings of the Great Buzzard were the center of the world. The mythology of the Cherokees—the legends and oral traditions that explained their origins and beliefs—was rooted in these mountains, where their ancestors had been interacting with their environment from time immemorial.

In the early 1800s, the U.S. federal government encouraged the Cherokees to leave voluntarily their homelands for new lands west of the Mississippi River. A few left, but most Cherokees, not surprisingly, stayed. Undoubtedly, some worried that they could not remain the Principle People if they left; after all, could the Cherokees remain Cherokees if they moved away from their homelands, away from the center of their world? In the 1830s, the federal government tried to force the Cherokees to leave, but even after Congress ratified in 1835 the Treaty of New Echota—an illegitimate removal agreement signed by a few Cherokees who lacked the authority to represent the entire tribe—most Cherokees stayed. For the Principle People, it was not about farmland, or even gold, which prospectors found in Cherokee country; it was about sacred land. Finally, in 1838 federal troops forced them westward on the notorious Trail of Tears, where one out of four died en route to Indian Territory. But about 1,000 Cherokees hid in the mountains of western North Carolina, refusing to leave their sacred homeland. They became the ancestors of the present-day Eastern Band of Cherokee Indians. Today, about 13,000 Cherokees still live in the mountains of western North Carolina. Most reside on the 44,000-acre Qualla Boundary, which is adjacent to the Great Smoky Mountain National Park. Although they maintain connections with the descendants of the Cherokees in Oklahoma, the federal government has recognized the members of the Eastern Band as a separate people.

The fact that the Cherokees strongly resisted removal, even at the point of a gun, should not have been surprising. The mountains of the American Southeast were more than a place to live. By the 1830s, Cherokee identity was so rooted in the local environment that to leave threatened their existence as the Ani-Yun Wiya. According to Perdue, "they were, after all, the principal people, the descendants of Kana'ti and Selu. They lived in the center of the island that was the world, and they protected that world by maintaining harmony and order" (Perdue 1989:25).

Note

1. The exact translation of these clan names remains a source of debate, and some scholars have argued that there were other clans that have disappeared.

2 Xeroxed on Stone

Times of Origin and the Navajo Holy People in Canyon Landscapes

Polly Schaafsma and Will Tsosie

Introduction

Jii ne' is the Navajo word meaning "it is/was said." Oral tradition references cited in this essay dealing with the Navajo Holy People comes from *jii ne'*. Oral tradition from the orthodox Navajo traditionalist has many versions because it comes from many perspectives. When the events that are related occurred, not just one person, but many were there to witness them—this is where the different versions come from. In the Navajo world, it is good to hear as many versions as one can. These different versions are different perspectives that see the same object from different angles. What does this mean for Holy People and rock art? What is shared freely in oral tradition and what is pictured is not gospel; these are individual warps in the tapestry of knowledge related to the Holy People. The reverence Navajo hold for the Holy People in oral tradition should be used carefully and with respect.

There are many narratives that recount how human beings and their supernatural associates related to each other during the turbulent times of the creation and origin of the Navajo people. As noted, the narratives concerning the Navajo creation do not comprise a single story but a kind of "boundless, sprawling narrative with a life of its own, so to speak, fixed in its actual limits only by what might be recited during a particular performance. From telling to telling, it could change" (Zolbrod 1984:19). Navajo oral traditions recount that during the creation, the Holy People were immediately present among the Navajo, also known as the Diné, and they taught the Navajo the ceremonies necessary for survival and readied the world for living. A central theme of their teaching was how to achieve and maintain *hózhó*—beauty, balance, and harmony.

While oral traditions are "a dynamic flux emerging from a central core of basic values" (Schaafsma 2004:631; Schaafsma and Schaafsma 1996:173), it is the purpose of this essay to explore Navajo concepts of how things came to be and how they pertain, often indirectly, to the rich legacy of Navajo religious art on the walls

of canyons of the upper San Juan drainage. The region of concern, known as the Dinétah, can be roughly described as being east of Farmington, New Mexico, north of Cuba, New Mexico, and south of the New Mexico/Colorado border (see Towner 1996:15 for further discussion). Here imagery and myth conflate with landscape and, for the archaeologist, establish these canyons as landscapes of origin during a time when a Navajo cultural identity was forged. The mid-twentieth-century "rediscovery" of the wealth of Navajo rock art in the Dinétah and neighboring regions was due in large part to the salvage archaeological work in preparation for the construction of Navajo Dam (Schaafsma 1963) and to oil and gas exploration in the Largo Canyon drainage to the south (Olin and Hadlock 1980).

Before describing the upper San Juan landscape and its rock paintings and petroglyphs, it is crucial to define the broader principles of the Navajo landscape in the current and fifth world in which living takes place. This world was created by the Holy People in the beginning and into which the Navajo themselves emerged, first as insectlike beings, and eventually, with the aid of the Holy People, into fully human form. The Navajo world is bordered on four sides by sacred mountains. Frequently cited as the bounding mountains—as known to the world of the Bilagáanna, or white man—are Blanca Peak in the Sangre de Cristo range (east), Big Sheep Mountain (north), the San Francisco Peaks (west), and Mount Taylor on the south. It is, nevertheless, essential to point out that even these fundamental boundaries, easily identified within the topographic scheme of things, can vary according to the narration (see Zolbrod 1984:364n8). The important point, however, is that whatever mountains are named as boundaries, these the gods created, and each is sanctified in several ways (compare with the worldview of the Southern Paiutes centered upon the Spring Mountain, Chapter 3). First of all, each is built out of materials brought up from similar mountains in the fourth world (Zolbrod 1984:86). Each is attached to the sky by either lightning, a great stone knife, a sunbeam, or a rainbow; each is adorned with jewels such as turquoise, shell, and other valuables, blessed with feathers and birds; and to each is assigned a supernatural pair that permanently dwells within (Zolbrod 1984:86–92, 345n20). The boundaries established by the variously conceived four sacred peaks define a landscape within which Navajo order and stability are found and within which numerous important events took place during the time of creation, as the earth was made suitable for living.

Within these boundaries, other natural features or smaller mountains were named and sanctified during the time of creation (Zolbrod 1984:89–90), and places where important supernatural events took place are named in oral accounts and myths. Some of these may have been places where rock art was made but whose original significance has been lost. Places named in oral traditions are often ambiguous (Schaafsma 2004:630) and cannot be assigned to a specific place to be pinpointed

on a map, or they shift according to the narrator (this is also true for the Spanish chronicles reporting on the Andes, see Chapter 9). Topographic locations designated in oral accounts often relate to places with which the narrator is especially familiar and tailored to the audience, thus synthesizing story and place in a meaningful way in order to empower the message conveyed.

Therefore it is problematic for the archaeologist, but not necessarily so for the Navajo, that the Dinétah (Towner 1996:15) as the "traditional Navajo homeland" and its sacred places, is often forgotten by the Navajos themselves,[1] an exception being the Junction Site where the Pine River meets the San Juan. As for rock art sites that denote where major events took place at the time of creation, the importance of this confluence was never lost from Navajo memory. Here the Hero War Twins were painted on the cliffs and are said to reside still, coming there after the world was rid of the monsters. As described (see following) this location was visited by Navajos for ritual purposes until the mid-twentieth century when Navajo Dam was built and destroyed the area. The Junction Site is also referenced in several myths (Schaafsma 1963:63–64).

At this location and in the broader region, the images of the Holy People carved and painted on the cliffs and in rock shelters of the sandstone canyons tell a story of the Navajo beginnings as they synthesized their beliefs with Rio Grande Pueblo worldview between roughly 1670 and 1760. In addition to rock art, the deteriorated remains of hogans (the traditional house), stone masonry pueblitos, lambing pens, a variety of ceramics, and a few well-preserved caches of ceremonial paraphernalia comprise much of the material evidence of this phase of Navajo culture history (Brugge 1994, 1996; Carlson 1965; Dittert et al. 1961; C. Schaafsma 2002; P. Schaafsma 1963, 1965, 1980:301–333, 1992:26–41; Towner 1996, 2003).

The Navajo as a discrete ethnic group came into being in protohistoric times. Deriving from Apachean populations entering the Pueblo region of the Rio Grande Valley from the Plains around A.D. 1500 (Hester 1962; Schaafsma 2002), the people now known as Navajo distinguished themselves from other Apacheans in the seventeenth century by adopting numerous Puebloan practices and many aspects of Pueblo cosmology and ritual, including a definition of the sacred landscape. Both maize horticulture, borrowed from the Rio Grande Pueblos, and sheep and goat husbandry (Spanish) characterized Navajo life by the early seventeenth century. Conflict with both the Pueblos and the Spanish eventually pushed the Navajo north and west out of the Rio Grande into the canyons of southwestern Colorado and northwestern New Mexico. Dates for the earliest appearance of the Navajo in the Dinétah region vary and are the subject of debate among scholars. Evidence indicates that hogans constructed possibly as early as the 1670s were built of scavenged wood. Beginning around 1710, masonry pueblitos were constructed as defense against the Utes. Seven hundred and ninety-eight tree-ring dates from pueblito sites establish a continuous occupation of the Dinétah from the early

to mid-1700s. The exception here is Tapacitos Ruin with cutting dates between 1690 and 1694. There are no Navajo dates after 1755 in the Dinétah (see Towner 2003:129–131 for details).

The earliest known Navajo rock art is ritual in nature and, as indicated in the previous discussion, pictures the Holy People and other supernatural beings important in the time of origin. This rock art, although dating from the historic period, is fully indigenous in content and incorporates a worldview derived from the Pueblos in which beliefs pertinent to maize horticulture and masked and other supernatural beings figure prominently (Figures 2.1–2.3). The imagery features not only multitudinous representations of supernaturals, but also corn (maize), cloud, lightning, snakes, eagles, shields, and star ceilings. Included among the Holy People, are the *ye'i*, the masked supernaturals associated with the various ceremonials but most significantly the Nightway performances.

The Holy People are supernatural powers that are "personalized in the Navajo mind as beings . . . capable of assuming human form," and whose powers are "interdependent complementary items in a well-ordered universe" (Wyman 1983a:17). Although, as discussed previously, according to oral tradition the *ye'i* and other Holy People were present and active among the Navajo after the emergence from the underworlds and while the earth was being made suitable for human life, ultimately, "The creation of the Navajo world concludes with the departure of the Holy People . . . to their own spiritual domains. [They] depart, announcing that they will never again be seen in their primordial forms, but that they will be forever overlooking and directing life in the Navajo world" (Gill 1983:505). Oral tradition states that they departed to the east and toward the Rio Grande. At this critical juncture, the Holy People are said to have put their images on the cliffs—"like a Xerox"—so that they would not be forgotten and as reminders of their continued spiritual presence among the Navajo.

Holy People on Stone: Some Possible Functions of Navajo Ceremonial Rock Art

The rock art from this period has been described and its content interpreted in numerous publications (Brugge 2001; Chamberlain and Rogers 2001; Chamberlain and Schaafsma 2005; Copeland 2001; Copeland and Rogers 1996; Schaafsma 1963, 1965, 1980:301–333, 1992:26–41, among others). The imagery pictured in the landscape of the Dinétah is closely allied with that of the much later ritual sandpaintings, also known as "drypaintings," first recorded in the late nineteenth century (Matthews 1887, 1902; Stevenson 1886). The latter, however, due to their ephemeral nature, are not known from archaeology. Whether drypaintings replaced rock art imagery or whether they once occurred simultaneously in time but

with different ritual functions is not known. While today the sandpainting tradition is ongoing, the practice of rendering ceremonial themes and supernaturals on cliffs or under shallow rock overhangs was rare by the end of the 1700s or possibly shortly after 1760 when the Dinétah country of northwestern New Mexico was vacated for points west and south in southern Utah and northern Arizona. In Canyon de Chelly, for example, although there is an occasional rock art figure of a Holy Person, ritually coherent groups, including figures replete with symbolism, are rare, if they occur at all. Pictures of dance impersonators replace representations of the Holy People themselves. The scarcity of religious content in later Navajo rock art would seem to signal a significant change in ritual practices and how rock art functioned within Navajo culture. While later Navajo rock art may feature Yeibichai dancers (*ye'i* impersonators) and much more commonly social dance scenes at Enemyway gatherings—known as the Girls' (Squaw) Dance (Haile 1938:11)—depictions of the Holy People themselves are absent from these renderings (Schaafsma 1992:Figures 44, 45). Alternatively, secular drawings, incised or sketched in charcoal, picturing horses and other livestock, Navajo cowboys, trains, shoot-outs, and so forth (Kolber 2001; Schaafsma 1992:46–47; Yoder 2001) became popular.

In the following discussion we address the possible ways in which the permanent protohistoric rock art images from Navajo cosmology may have functioned on canyon walls and overhangs, as opposed to the fleeting images of the historically known sandpaintings. In so doing, we explore certain Navajo values in regard to image making and ways in which ceremonial practices and some attitudes may have changed over time. An examination of the purposes served by the transitory depictions of the Holy People in drypaintings is critical in order to understand the possible roles played by these same images, or sets thereof, in their landscape settings.

The ceremonial Navajo rock art in the upper San Juan drainage was produced *c. 1670–1760* in an inspirational milieu and florescence of creativity during the formative years of Navajo cultural development (ca. 1670–1760). By this time, Navajo religion as we know it today was synthesized, incorporating important selected elements of Pueblo cosmology, myth, and symbolism (Schaafsma 1963:57–60, 1980:Figure 199). The related rock art displays a complex iconography in which images and symbols of the Holy People are not only commonly present but also often predominate. Although cautionary advice on interpretation is well taken (Blackhorse 2001:74), and some figures are unidentifiable, others are easily tied to supernaturals still evoked in Navajo ceremony. Distinguishing attributes include headdresses, body form and design, and hand-held paraphernalia. The War Twins (also known as the Slayer or Hero Twins), and/or their symbolism, occur frequently (Figure 2.1). In some localities along cliff faces or under overhangs, linear sequences of *ye'i* or

Figure 2.1. Paintings in red and white of the Hero Twins in Largo Canyon. The hourglass motif incised through the red paint on the body of Born-for-Water is his symbol. Lightning is incised on the side of Monster Slayer's face. (Photograph by Polly Schaafsma.)

other Holy People suggest groups pictured in historic/contemporary sandpaintings (Figure 2.2). In numerous instances, complexes of these deities are even assignable to chantways still ongoing. This is especially true of the Nightway, Mountainway, the Shooting Chant, and possibly others (Wyman 1983a:Figures 6 and 7; Schaafsma 1963:60–63). Unrecognizable or seemingly nonspecific imagery may relate to chantways long since abandoned by Navajo medicine practitioners. Oral traditions state that masks depicted in rock art that are no longer recognized by the Diné are those that were taken away from the people as punishment because of conflicts and lack of respect. This state of affairs provoked a keeper of the knowledge to take the masks and destroy them. They were never to be used again.

Among the many identifiable figures, the Night Chant *ye'i* appear more promi-

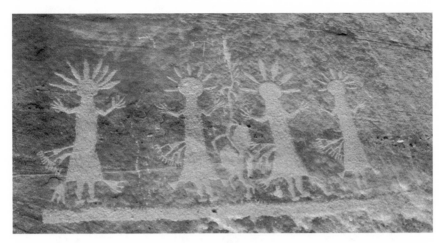

Figure 2.2. Four *ye'i* and a corn plant symmetrically arranged in a linear pattern similar to the layout of a sandpainting. *Ye'i* attire typically consists of tasseled kilts and sashes. Note the baseline and the central maize plant with disproportionately large ears of corn, Largo Canyon. (Photograph by Polly Schaafsma.)

nently in the Dinétah rock art than any others (Figure 2.3). Although the masks of these *ye'i* may be used in other Navajo chantways, they are *borrowed* (emphasis Faris 1990:158) from Nightway *jish* (ceremonial bundles) (see also Copeland and Rogers 1996:225). As James Faris (1990:235) points out in his extensive work on the Night Chant: "In Navajo terms, the Nightway is a healing practice undertaken for stricken people. It is a healing practice by which human beings attempt to re-harmonize and re-order and re-balance their relationships with one another and with a Navajo universe." He goes on to explain that the Nightway was given to the Navajo by the Holy People after the Diné appeared in the present world, "after the earth was rid of monsters . . . and after the Holy People became invisible." Faris (1990:236) further notes the unchanging nature of this ritual over the last hundred years or so when it has been known from ethnographic studies. It is worthwhile pointing out that this ceremonial stability appears to extend into the more distant past as well, as the same persons, with the exception of Talking God, who is rare or absent in rock art, are pictured in the Dinétah. Talking God, however, is not pictured in these groups because he is still here and never left. Thus his image as a reminder of the Holy People's presence is not necessary. Similarly, because Changing Woman and White Shell Woman are also still with us—they do not have to be sought—they also are not represented in the rock art.

Both rock art content and ethnographic evidence can be marshaled to indicate that one of the important functions of rock art for the early Navajo as recent

Figure 2.3. Two photographs of sections of a Night Chant rock painting from Delgadito Canyon, Carrizo Canyon drainage. The rock face has been abraded and smoothed, and drilled holes may have held paraphernalia. The large humpback mountain sheep *ye'i* (left) leads the group. He was painted in white, red, orange, azurite blue, and turquoise. To the right he is followed by supernaturals that include other humpback *ye'i* and the female god of the Night Chant distinguished by her manta dress and square mask. Missing in these photos is Fringemouth god who was located in between. Unfortunately, the entire group fell from the cliff in 1965 and was subsequently destroyed. (For the complete panel in place see Schaafsma 1980:Figure 258.)

immigrants was to establish themselves in place and render it meaningful. Their landscape was infused with significance by identifying sacred places, including those important in origin mythology. Within a wide geographic region, the significance of major topographic features was borrowed from the resident Pueblos, who had already established their sacred landscape "texts" centuries earlier (see Ortiz 1969:171n15; Parsons 1939:221; Reichard 1963:20; Thompson 1879:321). In the Dinétah itself, however, long abandoned by the Anasazi (early Ancestral Pueblo people) by A.D. 950, the landscape was open to rewriting and redefinition. Making rock art at chosen localities was one means of doing so.

It is apparent that the issue of "power" was present early on, as many locations selected by the Navajo for making rock art were places already "marked" by Ancestral Pueblo figures, the presence of which had connotations of power. Some Navajo rock art sites have the appearance of shrines that were revisited, refurbished, and thus revitalized on numerous occasions. Signs of repeated "use" of these sites include worn rock surfaces; evidence of "handling" such as soiled spots, rubbing, smoothing of the sandstone in preparation for making a painting, or erasing an older figure to receive another; and the repainting of figures (Copeland and Rogers 1996:228). In some instances, holes were drilled in the vertical cliff face for the probable insertion of prayer sticks or feathers in or near the rock art. In this regard, the paintings at the junction of Todosio Canyon with the Pine (also known as the Los Pinos) River (Schaafsma 1963:64–65), the numerous petroglyphs at the mouth of Crow Canyon at its junction with the Largo drainage (Schaafsma 1980:Figures 253, 254, 261), the Delgadito site in the Carrizo drainage with its

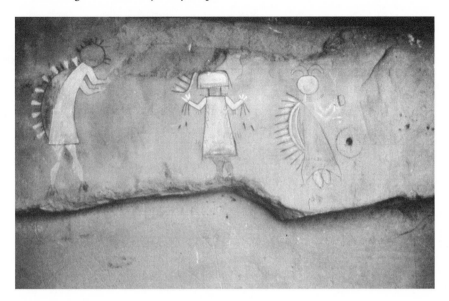

Figure 2.3. *Continued*

Nightway iconography (Figure 2.3), and others in the upper Largo (Copeland and Rogers 1996) are noteworthy sacred places that were revisited from time to time.

The Junction site, or "the Place of the Meeting Waters," mentioned earlier was also of this nature. Described in detail elsewhere (Schaafsma 1963, 1980:310–312), the locality is an excellent example of a synthesis of landscape, the Navajo creation story, and rock art. This "place of the meeting waters," has been noted on various occasions in the archaeological literature as well as documented in Navajo myths themselves. The rock art at this site was dominated by two large shields, reputedly representing the sun and moon, on whose faces the War Twins are sketchily pictured (Schaafsma 1980:Figure 256). The Twins are said to have retired to this location once they had destroyed the monsters. These monsters were entities that resulted from disharmony—a malevolent state of affairs caused by the inability of First Man and First Woman to get along. Once the monsters were demolished, the world was then safe for the Diné, and "the celebrated twins went to a place called Tho-hyel-li, the junction of the two rivers in the valley of the San Juan, where their images may yet be seen reflected in the waters. They still dwell in a mountain cavern near this place" (Matthews 1883:224). The images are purported to have been made by the Hero Twins themselves (Van Valkenburgh and Kluckhohn 1974:150), an ascription consistent with observations cited earlier. Other images in the Junction vicinity relating to the Twins were eradicated in a major flood in 1912 (Van Valkenburgh 1941:155–156). Historically Navajos returned there to pray after their return from Bosque Redondo (Roessel 1983:510–519) in the

1860s when the people were in a state of semi-starvation, when they again faced hard times during the stock reduction program in 1929, and in various times of drought (Van Valkenburgh and Kluckhohn 1974:146). In the early 1950s just before the dam was built, Navajo men slated for duty in Korea sought protection from the power of this sacred place.

While it is possible that some rock art sites may have served as mnemonic devices for some Navajo singers, it seems dubious that this was the primary reason for creating images of the Holy People in the landscape. Pertinent to this discussion is a Nightway account by Hosteen Klah in which the Dreamer, or Hero (the Navajo visionary who makes a supernatural trip to acquire religious knowledge for his people) is asked by Fringemouth god to draw the *ye'i* gods on a rock wall (Faris 1990:131). There is, however, no implication that these *ye'i* were made for mnemonic purposes by the visionary. More likely any rock art whose origins were (are) so ascribed, were viewed as validating the spiritual journey, and therefore perceived as having sacred origins and links to the supernatural realm. Once engraved or painted on stone, however, this imagery could have at least secondarily functioned to preserve ceremonial knowledge. Traditional practitioners today regard the ceremonial rock art as a validation of the traditions but not as needed to trigger their memories.[2]

The use of other kinds of imagery, however, as mnemonic devices by Navajo singers is known ethnographically. Frisbie (1987:54, 56, 60, 439n6) describes sketchbooks containing memory aids in *jish,* otherwise known as "medicine bundles" (see Frisbie 1987:12–17 for a full definition of *jish*). One Shootingway bundle from Waterflow, New Mexico, contained pictures largely done in watercolor and felt-tip pen of the Twin War Gods, one of the Twins on the Sun, and Female Snakes Crossed on the Wind, and other supernaturals (Frisbie 1987:56). Such notebooks described as "common" in *jish* (Frisbie 1987:439n6) were the property of accomplished singers. Elsewhere, however, Frisbie (1987:86–87) notes that traditionally, mnemonic props were not used by apprentices learning the chantways.

Navajo sacred places are described in some detail by Frisbie (1987:186). These places include various landscape features such as mountains, caves, creeks, river junctions, springs, bluffs, and rock crevices, as well as rock art sites. Activities traditionally conducted in designated sacred areas include gathering of materials for ceremonial use, praying, and leaving offerings. Frisbie notes that such places are sacred because of mythological associations with particular deities and that only ceremonial practitioners can visit these spots. This information fits well with what is known about the Junction site previously described and was probably true of other Dinétah rock art sites.

The remaining question is not whether these rock art locations were regarded as "sacred," but what the underlying perceptions might have been that facilitated the use of these sites in religious or ceremonial contexts. How did these images func-

tion? To examine this issue more deeply, the values ascribed to depictions of supernatural beings or Holy Persons in the ritual contexts of sandpaintings must be considered in order to understand the dynamic forces at work pertaining to similar imagery in landscape settings.

The Power of the Image

Pictures of the Holy People in the ceremonial dry paintings are said to be invisible powers made visible. As explained previously, the Holy People represent the human inner forms of natural phenomena, the "lying-in-ones." These powers may be dangerous, and Navajo sandpainting rituals are designed to control these Holy People for positive and specific ends (Wyman 1983b:552). Navajo ceremonies are held for restoring harmony, balance, and health. The focus of these ceremonials, which may last as long as nine days in some cases, is the sandpainting with its elaborate images of the Holy People and other spiritual beings that are coerced into attendance as described below. While these rituals are being conducted within the hogan, the landscape is engaged in the process of compelling the Holy People to attend, by the planting of prayer sticks in designated surrounding locations (Reichard 1963:xxxv).

The purpose of drypaintings is to attract holiness, to restore, and to reorder (Faris 1990:120). Drypaintings act both as magnetic fields and diffusers of supernatural power (Kenneth Foster 1964, p. 3 in Wyman 1983a:33). While they are perceived as indifferent to human affairs, the Holy People are irresistibly attracted or even compelled to the ceremony being performed through prayers, offerings, song, and "by their own likenesses drawn in the colored pigments of the drypaintings" (Wyman 1983a:16). They come to look for their portraits, and once arrived they become their likenesses. These drypaintings are likened to holy altars and are called 'iikááh, meaning the entry of several entities or beings (Wyman 1983a:33). The powers thus invoked by the images are then actively engaged during the healing processes of the ritual, when the dry pigments from different parts of the images are applied to various parts of the patient who, in turn, sits on the painting itself. In this way the patient absorbs the powers pictured and becomes strong and immune to danger (Wyman 1983a:33). As the patient is identified with these supernaturals (Reichard 1963:112), the sands, in turn, absorb the "evils" that have caused the illness being treated. Therefore, ritual disposal of the dry sandy pigments, that have absorbed the malevolent powers that caused the illness, is necessary at the end of the ceremony.

This information regarding Navajo cosmological concepts and the perception of the power of imagery may provide some insight into understanding how similar imagery and rock art sites themselves may have functioned in landscape contexts. If the drypaintings representing the Holy People command their presence, then

logically their portraits painted and carved on sandstone cliffs and in rockshelters would have had a similar effect. The locations in the landscape where their images are found, therefore, would seem to be where the supernaturals pictured are perceived to reside in spirit form and where communication with the Holy People is facilitated. A little-known rock art image of the Humpback *ye'i* in southern Colorado is located in a canyon in the upper San Juan drainage that is still remembered as being a favorite home of the *ye'i* (Jeancon and Roberts 1923; Matthews 1897:238). Historically the previously described Junction site is another case in point, further validating this interpretation.

As well, cliff faces and rockshelters where the Holy People are pictured give the impression of being removed from places of habitation, in which case they may have been places visited only by ceremonial practitioners who could control the powers pictured. Future surveys of these Navajo sites could verify this perceived distribution. Visitation to sacred sites was said to have been limited to religious practitioners, as mentioned earlier.

In spite of the formal similarities between the sandpaintings and the rock art in terms of iconography and the presumed ability of both to attract the supernaturals they represent, a basic difference has yet to be pointed out. The sandpaintings are ephemeral, and in their ritual functions, during which they are destroyed through application, *process,* not *product,* is paramount. The sands of the paintings, having absorbed the illness, are ceremonially disposed of (Wyman 1983a:32–34). In turn, the powers of the supernaturals they represented are absorbed by the patient. During the ritual, the short-lived image becomes more *valuable*—a term denoting spiritual importance. As the aesthetic and emotional impact of the "fleeting image" empowers the ceremony within which it is created, the temporality, on the one hand, becomes an important aspect of the power of art itself. The rock art images, on the other hand, remain permanent in the landscape, thus implying a significantly different functional role.

Images, Context, and Taboos

When the Navajo moved out of the Dinétah in the mid-eighteenth century, for the most part—the Junction site being a notable exception—they abandoned the memory of this region with its many images as they resettled to the west and southwest. Van Valkenburgh (1941: see especially pp. 86–87, 111, 123) in his review of Navajo places notes that there were no oral traditions in regard to Largo and Carrizo Canyon and other locations in the Dinétah region where Navajo ceremonial rock art is prevalent. In moving, the Navajo often "took their sacred locations with them" in that they redefined the cultural landscape to conform with new surroundings and reascribed the places of importance and mythic times to new topographic features and places (Jett 1982; and see Luckert 1977:24–26 for the significance of

confluence of the San Juan and Colorado for Navajo Mountain Navajo). Meanwhile, the practice of painting and carving the Holy People on stone nearly stopped by the end of the eighteenth century. The new landscape, even when important topographic features are identified with mythic events and times, usually lacks the pictured presence of the Holy People. Holy People in Canyon de Chelly and Del Muerto rock art are depicted only rarely. In canyons east of Chinle Wash near the New Mexico–Arizona line, social gatherings revolving around the Girls' Dance of the Enemy Way, are carved at many sites, all probably dating after ca. 1760 (Gilpin 1996:195), but renderings of the Holy People are scarce. A single figure, also post-dating 1760, is hidden under a tall rock slab near the San Juan River in Utah. The belief in the presence of the Holy People in the landscape, however, has not waned (see interviews with western Navajos in Luckert 1977). The Holy People pervade the landscape via their travels as described in myths, but their rarity in rock art after the late eighteenth century is notable.

It is significant that the rock art in the Dinétah region with its emphasis on the Holy People, the Navajo creation story, and other cosmological themes was made when the Navajo were establishing themselves in the Southwest. At this point in their history they were creating a cultural identity, and constructing a newly synthesized cosmology that they tied into the landscape of which they were recently in possession. This phase lasted less than 100 years. By the late 1800s, from which the first ethnographic records derive, although they continued to command the assistance of the gods that had been with them at the time of their creation, these gods were pictured ceremonially only in the context of sandpaintings.

Beginning in the late nineteenth century and continuing into the twentieth, the ethnographic documents cite taboos regarding the picturing of the Holy People outside of ceremonial contexts (Reichard 1977:6). As we have seen, notebooks in *jish* bundles contained sketchbooks with the Holy People pictured for mnemonic purposes. These, however, were (are) still carefully under the control of the owner of the *jish* and not publicly available. The discussion of taboos frequently has to do with picturing *ye'i* on rugs or as *ye'ibichai* dance impersonators in sculpture, both for sale to a white market.[3] Picturing "a reflection of the divine form of the Holy People"—images that actually compel their presence—outside of a ceremonial context, and therefore beyond ritual control, is clearly deemed inappropriate and even dangerous (Reichard 1977:6–7). A "Yeibichai curse" resulting in paralysis and blindness and even death is specifically cited as a result of breeching this taboo (Valette and Valette 2000:54, 56; Valette and Valette 1997:68n3).

Prohibitions against invoking the Holy People outside of the controlled ceremonial environment are deeply rooted in Navajo traditions, even within the myths themselves.[4] When the Holy People taught the Hero in the ways of a particular myth and the images to be invoked, it is said that Navajo were to represent them in sand so that they would not be lost (that is, abandoned or forgotten), or "wear out

or be stolen, soiled, or damaged" (Wyman 1983a:43). In the course of instructing the Hero, the Holy People are said to have made these paintings on sheets of sky, on sheets of cloud, or on black fog, or cotton blankets, which were subsequently rolled up and taken away or thrown away to the north in the manner of sandpaintings today (Wyman 1983a:43). In one case: "The yéi who unfolded it [the painting] to show the prophet said: 'We will not give you this picture; men are not as good as we; they might quarrel over the picture and tear it, and that would bring misfortune; the black cloud would not come again, the rain would not fall, the corn would not grow, but you may paint it on the ground with colors of the earth'" (Matthews 1902:165).

Provocative in this regard is a rock painting on the Pine River (LA3041), executed prior to ca. 1720, that consists of a panel of Mountain Chant Holy People pictured against a background of blue clouds (Schaafsma 1963:Plate IV). This is very reminiscent of Matthews's reference to a Mountainway story (1887:404): "They drew from one corner of the cave a great sheet of cloud, which they unrolled, and on it were painted the forms of the yays [*sic*] of the cultivated plants." At a minimum, the rock painting indicates that a similar concept—painting the *ye'i* on a "sheet of clouds"—was present at an early date. The rock painting, however, was "lost" and subsequently damaged (Schaafsma 1963:46), thus justifying the admonishments against permanent imagery reiterated above by Wyman (1983a:43).

Prohibitions against permanent imagery, so poetically expressed in Navajo mythology, were apparently developed after the rock art featuring Holy People in the Dinétah was created. Following the evidence provided by archaeology, these prohibitions came into place, seemingly gradually, sometime after 1760 when the Dinétah was vacated. The question has not been answered, however, of why the Holy People gradually ceased to be pictured—and thus conjured—in rock art. It appears that changes occurred in ceremonial and social practices and related values that dictated a ban on ceremonial landscape imagery. There is little ethnographic documentation in this regard, except for the evidence already cited. Any hypothesis to explain this change has to be grounded in inferences based on tangential ethnographic information, and a certain amount of speculation is inevitable.

It is likely that prohibitions against painting and carving these figures in the landscape were responses to several issues. Among possible factors for change in this regard were increased social tensions as Navajo culture interacted more closely with dominant Western society during the nineteenth and twentieth centuries. One well-documented response to these tensions was witchcraft (Kluckhohn 1944:95). Given the forces that these images are perceived to embody, left unprotected in their landscape settings, they may have been increasingly viewed as dangerous and a source of power that could be used toward malevolent ends. That "power" in and of itself is conceived as neutral, but once tapped it can be manipulated for any purpose. Therefore, to avoid these powers being controlled for harmful ends, pro-

hibitions against picturing the Holy People outside of well-controlled ceremonial contexts may have evolved over time in an environment of increasing uncertainty, social conflict, and distrust, as traditional values were threatened.

Once an extant image has been targeted by an evildoer for its power, a counter-response has been to destroy the figure in question, thus voiding it of its potency and rendering it useless. Fear in times of stress, such as periods of epidemics, has promoted the purposeful destruction of rock art on the San Juan River and else-where on the Navajo Reservation.[5] In summary, one possible explanation for the later scarcity of pictures of Holy People in landscape contexts may have resulted from a taboo against their representation, thereby both avoiding a power source for evildoers, as well as protecting the supernaturals from maltreatment, hereby re-calling the admonitions described previously, given by the Holy People themselves to the Dreamer.

Xeroxed on Stone: The Persistence of the Rock Art Images of the Dinétah

The power of rock art takes many forms, and imagery is never mute. Once made, rock art becomes a dynamic force in the landscape, evoking new meanings as time goes on and assuming new roles in the historical\cultural process. For the archae-ologist, these images document the first evidence of Navajo religious history with a continuity with today's traditional beliefs, forged in synthesis with Pueblo world-view in the early historic period. The rock paintings and petroglyphs of the Hero Twins and Holy People of the Night, Mountain, and Shooting chants and possibly others are the earliest documents of these stories and ritual practices. For the tradi-tional Navajo, although concepts of space change through time, these images tell of times of origin and validate the spiritual knowledge given by the Holy People.

As noted in these pages, stories are modified to retain pertinence to the mo-ment. Notions of "history" in the Western sense are of lesser value to the Navajo people than the immediacy of a religious account that maintains health and har-mony here and now. Although traditionalists have maintained their awareness of this geographic region, the Dinétah was largely forgotten by most Navajos. The general absence of knowledge about this primal landscape is grounded in historical events that took place around 1864. When reservations lines were drawn, for a time Navajos were forbidden to travel outside of these boundaries. The Dinétah was no longer accessible, and thus it became less pertinent in Navajo affairs. For traditional Navajos, the historic "lock out" converted Dinétah to a mystical place somewhere nearby "just on the other side of the fence."

Today the Navajo people are once again gaining the knowledge of and access to Dinétah. They are starting to feel comfortable visiting the sites. They are in the process of getting acquainted with the places that oral traditions tell of the time

when the Holy People were among them. For the Navajo—wherever they now live—pictures of the Holy People on stone, wherever they occur, contain a spiritual message confirming an earlier time when the Navajo world was being created. Left by the Holy People themselves, the images infuse the landscape with their ongoing presence, as they bespeak of a time when these supernaturals moved among the Navajo and taught them how to live in harmony on the earth. The presence of the *yeʼi* images watching over the land today distinguishes the Dinétah region from all others in the history of the Diné.

Acknowledgments

We would like to thank Jessica Christie for inviting us to participate in this extraordinary volume honoring ancient landscapes. Robert Mark of Rupestrian Cyber Services rendered photographic technological assistance for one of the images. This collaborative chapter is a revision of an earlier paper by the senior author to be published in *Cosmos: The Journal of the Traditional Cosmology Society*, Edinburgh (forthcoming).

Notes

1. In reference to the contemporary loss of memory of places identified as important in the Navajo religious past, it is worth noting that in 1995 at the Navajo Studies Conference in Farmington, Alfred Yazzie, a noted Nightway singer from the Window Rock–Fort Defiance area stated that he had never learned about the mesas east of Bloomfield when he studied to be a Nightway singer in spite of the fact that the Nightway is perhaps the most important chantway pictured in this rock art. A similar example from the Northwest Coast is that very few ʻNamgis visit the archaeological site of Cheslakees, which has been identified as the place of origin in their creation narrative (Chapter 4).

2. Hosteen Klah described to Franc Newcomb (1964:93–95) the discovery of a cave with *yeʼi* paintings on the west side of the Chuska Mountains. This finding evoked the suggestion from Klah's uncle that the paintings might have been made to preserve ceremonial knowledge before the forced evacuation to Bosque Redondo. This is probably a cave known today as the home of Fringemouth, Zah-dohl-Jiah. The cave, unlike those in the Dinétah, was well hidden, and medicine bundles had been left on the floor. If the interpretation offered is correct, the Chuska paintings would postdate the Dinétah rock art by over 100 years, and the motivation would have been specific to a particular historical crisis.

3. Because these products were attractive to whites, they brought money, and therefore, traders in the early twentieth century, emphasizing their rarity to white customers, encouraged the Navajo to produce *yeʼi* rugs and wood carvings of *yeʼibichai* dancers for sale, in spite of cultural prohibitions against them (Valette and Valette 1997; Val-

ette and Valette 2000). A fury against the making of *ye'i* blankets is described by Amsden (1990:105–106) who also mentions that a transgression will result in blindness. *Ye'i* rugs are described as "bad taste," and a sacrilege and out of context of ceremony. He notes that there is nothing ceremonial implied in the weavings or their use. An even more conservative view has been expressed by Harry Walters of Tsaile who explains that the human body is a "reflection of the divine form of the Holy People" and therefore a ceremonial context is the only one appropriate to rendering the human form at all (Valette and Valette 2000:54).

In the face of strong pecuniary pressures, individual weavers and other artists have been persuaded to render these images for sale. It should be noted, however, that ceremonial protection is often sought for these transgressions.

4. Note that these oral traditions cannot be dated. Whether they developed as a creative response to a gradual development of restrictions in regard to rendering the image of the gods in permanent media or whether they preceded it is simply not known.

5. A multitude of Basketmaker anthropomorphs (ca. 200 B.C.–A.D. 400) were defaced and even obliterated with chisels by Navajos during a flu epidemic in the late 1950s. The Navajos responsible believed that the illness was caused by a person who obtained power from these images and used it for pernicious purposes.

3 Nʉvagantʉ, "Where Snow Sits"

Origin Mountains of the Southern Paiutes

Richard Stoffle, Richard Arnold, Kathleen Van Vlack, Larry Eddy, Betty Cornelius

The Spring Mountain range is a powerful area that is centrally located in the lives, history, and minds of Nuwuvi people. The range is a storied land which exists as both physical and mythic reality, both simultaneously connected by portals through which humans and other life forms can and do pass back and forth. This is as it was at Creation.

> —Quote by Larry Eddy, religious leader for the Chemehuevi Southern Paiute people.

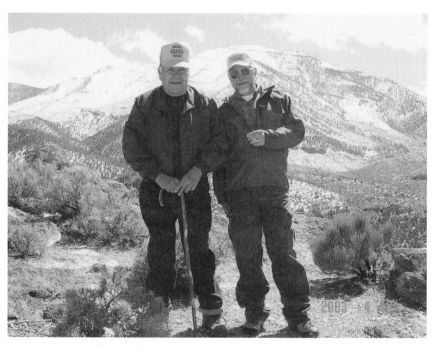

Figure 3.1. Larry Eddy, Richard Stoffle, and Nʉvagantʉ.

Creation Lands and Places

American Indian people all have a place where they were created. According to De-loria and Stoffle (1998): "Tribes often identify a specific location where the people became conscious of having been created and this site is related to a number of other landmarks in the region, which mark the locations where creative acts, which form our world today, were performed. For many tribes the proper explanation should be that of a sacred complex of interlocking sites rather than a simple lo-cation." At this place and for a surrounding distance of many miles, the land was formed, earth elements were distributed, places of power were established, and the area became a single cultural landscape for a particular Indian people. The Creator gave them the rights and obligations to maintain and be sustained by these lands and resources. While not an exact conceptual translation, Spicer (1957) suggests that the European concept of Holy Land best fits that of Indian Creation Lands. Place and landscape (mountain and region) are tied conceptually, but analytically separable (Tilley 1994:7–34). A corresponding example from the Maya region is the network of holy places associated with the ancestor Francisco Sojuel surround-ing the town of Santiago Atitlán (Chapter 7).

This Indian view of where they came from contrasts with non-Indian origin theories that attribute American Indian origins to somewhere in East Asia. Many Indian people express the opinion that such theories are designed to distance them from their Holy Lands and cause them to be just another immigrant group now re-siding in North America.

Creation thus established a birthright connection between an Indian people and a portion of land in North America. A birthright connection differs from other types of land connections derived from conquest or purchase in that it can never be taken away. It is a bond defined by Creation itself, so the concept of being cre-ated somewhere is associated with the idea that you have somewhere that is and al-ways will be exclusively yours. For land attachment reasons, most Indian people have two origin places—an origin place for their ethnic group and one for their lo-cal group. This is a concept that is difficult to explain to non-Indians who tend to hold an epistemology whereby a people can only be created once. The debate is so fundamental that it has been the foundation for others to cast doubt on the authen-ticity of any Indian creation story. Vine Deloria (1995:69, 82–84, 202–203, 212–214), a lawyer by training, responded to such critiques by stipulating the reverse—that is, all Indian origin stories are true until proven false. He centered these stories as true Indian origin beliefs, thus forcing critics to bring evidence to dispute this stipulated position.

In the western United States, origin places tend to be identified with the tallest peak in the mountain range that produces the most convectional rainfall. In this

region, Origin Mountains are understood as the places where the Creator made the
culturally connected ethnic group, as well as the rest of humanity. Origin Moun-
√ tains serve as symbols of ethnic unity and a common relationship to the Holy
Land. While in general terms, mountains feature as origin locales in many indige-
nous American societies, one cannot overlook the subtle contextual differences; for
example, mountains as boundary markers among the Navajo (Chapter 2) and snow
mountains as sources of water as well as symbols of visibility and resulting social/
cultural unity in the Andes (Chapter 9). When asked where their local group was
created, however, most Indian people also will give a second location. This place
tends to be a prominent peak in the district where their local group traditionally
lived.

 The following are the major peaks, mountain ranges, and one or more second-
ary creation places for Owens Valley Paiutes, Western Shoshone, Yuman People—
especially Hualapai, Northern Paiutes, and Southern Paiute people (Stoffle et al.
2004).

Kura'ngwa, Mt. Grant, Wassuk Range, Nevada (for Northern Paiutes)
 Job Peak, Stillwater Range, Nevada (for Toidikadi, Cattail Eaters)
 Pavatoya've; Big Mountain, Mt. Tom, Sierra Nevada, California (for Bishop
 Paiutes)
Mt. Whitney, California (for Lone Pine Paiutes)
 Big Pine Glacier, California (for Big Pine Paiutes)
 Coyote Valley, between Mt. Tom and Sugarloaf Mt., Sierra Nevada, Cali-
 fornia (for Owens Valley Paiutes)
Avikwame, Spirit Mountain, Newberry Mountains, Nevada (for all Yuman-
speaking peoples)
 Whavo, a rockshelter in Matawidita or Spenser Canyon, Arizona (for the
 Hualapai)
Nɨvagantɨ, "where snow sits," Mt. Charleston, Spring Mountains, Nevada (for all
Southern Paiutes)
 Coyote's Jar—Pahranagat Valley, Nevada (for Pahranagat and Moapa Paiutes)

 It is easy to fall into the Western intellectual trap of essentializing Indian con-
cepts about origin places. First, it can be falsely assumed that the largest or most
dramatic peak or mountain of origin is the exact place of creation. This normally
is not the case because creation, as mentioned before, is perceived as occurring in a
powerful area composed of various earth elements. Powerful actors such as Creator
beings (for example, wolf and coyote) may actually live in caves on or near the
mountain, but other forces of power exist in the area such as rain-making plants,
spirit helper animals, the wind, and water. The latter, for example, is produced

when the mountain range talks with the clouds; who, in turn, bring down the rain and snow. Second, it is easy to view the power of the peak as emanating solely from its own dramatic structure, rather than viewing the peak as deriving its power from being on a special mountain range in a creation area. The mountain range and surrounding area are the primary source of power rather than the peak, which does serve as the symbol of the creation place.

One way to illustrate the physical and spiritual relationship between water and power is through the University of Nevada–Reno's climate Web site (http://www .wrcc.dri.edu/pcpnfreq.html), which can produce precipitation frequency maps that graphically display the water-generating capacity of all places in the West. These maps document that the above creation places are major water generators. The Spring Mountains, for example, generate more water than most Great Basin ranges.

Other examples illustrate that origin places involve both water and extreme topography. The Wussak Range, Nevada, is a major water generator and also the western boundary of a large natural lake (Walker Lake). In this area, Kura'ngwa (Mt. Grant) was the first mountain to emerge after the world was covered with water. A fire on its top may have been a volcano. Sage Hen fanned the water back to save the fire, then Rabbit helped the people get the first fire for the Paiutes. Elsewhere, Job's Peak, Nevada, is not only associated with the ecologically important Stillwater Marsh and the origin of the Toidikadi (Cattail Eaters), but it was also where the culturally important social split between the Paiutes and Shoshone occurred. The Coyote Valley area is associated with that portion of the Sierra Nevada Mountains, California, that contains the primary water sources for the Owens Valley River.

The Newberry Mountains, Nevada, and the major peak Avikwame (Spirit Mountain) are a stunning example of the water-mountain connection. When the Creator made the channel of the Colorado River he piled the earth in a single place forming the mountain of Avikwame and the rest of the Newberry Mountain range (Hinton and Watomigie 1984). At the junction of the river and mountain, where the earth from a thousand miles of channel and the water from an even larger region come together, all humankind initially was created. Later people were created again in Whavo (a rockshelter) that marks an area in Matawidita (Spenser Canyon) where a fight between children caused a major ethnic split between the Hualapai and the Havasupai (Kroeber 1935).

These cases illustrate the close physical and spiritual tie between the amount of water and extremely high and rugged mountain topography in Indian origin places in the western United States. The origin stories further identify the essential and contributing power of animals, plants, winds, and minerals in the cultural centrality of creation places.

The Spring Mountains

Southern Paiutes have cultural concerns for places and landscapes in the Spring Mountain range in what is today called southern Nevada. These are a people who speak a Numic[1] language, who call themselves Nuwuvi[2] or Nungwu.[3] They interact with the Spring Mountain range and surrounding landscape as a place of creation.

Since the beginning of time, the Spring Mountain range area has been known as the place of human creation. When the Creator made Nuwuvi people here, they became specially attached to this place and the place to them (note the quite different creation narrative of the Tz'utujil Maya centered on the three volcanoes at Lake Atitlán, Chapter 7). This is a birthright connection of rights and obligations, which is transferred from generation to generation forever. The Creator showed the people how to talk with the mountain range and how to behave in its presence. They were taught that here on these high peaks was a major source of *puha* (a force generally defined as power or energy). Puha was placed in everything at creation, making the world sentient; so rocks, water, air, plants, animals, and humans can talk with one another and work together to maintain balance in the world. These elements of the Earth all have agency, thus they control their own behavior, move in space, and influence others.

The Spring Mountains and the Southern Paiute Perspective

Complex epistemological knowledge is required in order to explain the cultural importance of the Spring Mountain range, the places and natural resources, and the reasons it is the center of so many ceremonies for Southern Paiute people. Although few non-Indian people have the cultural background to fully understand what is being said by the Nuwuvi about their Spring Mountain range; the latter, as well as non-Indian people, have tried to explain this place since the nineteenth century (Fowler and Fowler 1971:73–78; Jensen 1929). This effort in cross-cultural communication continues today (Fowler 1992:170–179; Goss 1972:123–128; Miller 1983; Stoffle et al. 2004:27–39).

Paiute people try to explain the Spring Mountains and what may happen to the Nuwuvi and to the world if the mountains are somehow harmed. In the early 1980s, they were asked to comment on the potential cultural impacts of the high voltage power lines associated with the Intermountain Power Project (IPP). Their site identifications and assessment, which referred to Nevada places from Utah to California borders, were issued in a report they decided to call "Nuvagantu" after the highest peak in the Spring Mountains (Stoffle and Dobyns 1983). On the frontispiece of that report they asked that the following quote be recorded in

Numic and English. It is reproduced here as published: Nʉvagantʉ *"it has snow,"* *the Paiute name for Charleston Peak, the place where nʉngwʉ—the people—were* *created.*

The following is a Paiute religious leader's comments on the IPP proposal:

In our Indian way I could say it . . . nʉngwʉrʉvwipʉxaip marʉ.
Axani, axani, axani, nʉngwuxʉpi ura'navachʉ
uamʉ kiyakapi ura'pʉxaivyach, the sacred places you know.
Axan uru'as aik, mara'rʉ nʉngwʉrʉvwipur ava ur mara'rʉ.
Mar ̦ sʉwaxantʉapa urʉmpur kunur avikuvani aik.
Ich ma nʉngwʉrʉvwipur sʉwavʉxianar.
Arukwaiaip nʉngwʉrʉvwip aik.
Mava nʉngwʉnchingwung kanixaipʉxantʉm.
Ichʉ manoni ichʉ apa nʉngwʉrʉvwip.
Urʉ upa nʉngwʉchingwʉ unipʉngʉr.
Nʉngwʉxup ura'navach urʉs . . .

(translation by line)

In our Indian way I could say it . . . that former Paiute country.
How, how, how, there must be Paiute graves there used to be
Places where they round-danced the sacred places you know.
There, I said, how it is, that is Paiute land there.
I think the electricity will lie on sacred things.
This Paiute country is sacred.
So is that part of the Paiute country that was under the ground.
The Paiutes used to have camps there.
All that is Paiute Country
Paiutes used to live their lives there.
There must be Indian graves . . .

That report, which was later published by the Nevada Bureau of Land Management (Stoffle and Dobyns 1983) as the first of its kind in southern Nevada, became a cornerstone for understanding future Paiute responses to development projects near the Spring Mountains. The IPP studies documented the cultural centrality of Nʉvagantʉ and the Spring Mountains and how they are connected to other mountains, natural resources, and places throughout Southern Paiute traditional territory.

Southern Paiute efforts to communicate the importance of their lands and these mountains were elaborated in the context of perceived risks from develop-

ment projects. During the analysis of the impacts from widening U.S. Highway 95 near the traditional Las Vegas artesian springs a Paiute woman said, "On top of Mt. Charleston, that is where we came from—the snow up there."

This is a statement to remind us that mountains call down the rain and snow from the clouds. Without this action there would be no life—no water. The Creator also placed snow fleas (PHYSORG.com 2005) to drill holes in the snow, which helps the water enter the mountain. Puha, like water, flows into and down the sides of mountains and emerges below as the great artesian springs in the Las Vegas valley. The water cycle is the best analogy for puha.

During the same study, a Paiute man describes the spiritual connections between places: "All the mountains are a big circle, all connected. Mt. Charleston is where we were created; it is connected with Sunrise, McCullough, and Bird Spring mountains. People would go to Gypsum Cave in the Frenchman Mountains to get our songs. Mountain sheep would come to them in songs along with other animals used in doctoring. Pintwater Cave, in the Pintwater Mountains is where wolf lived and it is the home of little mountain spirits and the wind. Sheep Mountains are a point of connection between the Indian people living in Moapa, Las Vegas, and Pahrump. There is red paint there too." During the analysis of Hoover Dam bypass impacts, a Paiute woman observed that "the mountains stand on their toes so they can look at each other. They enjoy each other's company and share their energy."

These are among many observations that say so much about Spring Mountain range and how it is alive and available to help bring into balance individuals, communities, and the world.

Puha, Place, and Landscape

Although all elements of the earth have puha, differences exist in who has how much of what kind of puha. To achieve goals established at creation, it is necessary for each element of the living earth to seek out and interact with other elements to make puha partnerships. Puha tends to flow in channels like water; or as some say "like blood in the veins of the body." The channels of flowing puha consolidate at certain points creating a spider-web-like latticework of places where puha is concentrated. Such places have special purposes and are composed of the different earth elements, which have moved to be at the place and with each other.

Connecting the functional-specific puha places are puha paths. These trails exist in this physical world and in the storied world of mythic reality. Puha flows along these trails as do spirits, water babies, animals, the wind, and people. The puha paths are understood best as being alive—somewhat like high voltage power lines. Paiute people travel on these puha paths physically across the land, mentally in a dream state, and spiritually after death. Religious leaders recount frequently

traveling to the Spring Mountains in song and prayer. The Salt Song trail, for example, is the puha path to the afterlife that is traveled by all the Nuwuvi. It has specific topographic features as well as spiritual places located along its thousand-mile length. Portions of this trail travel through the Spring Mountains, and for some people it ultimately ends here in/at Nʉvugantʉ. Understood as a synergistic whole, the latticework of puha trails as they exist in and around the Spring Mountain range represents what Western science terms a *cultural landscape.*

It is essential to understand the relationships between puha, natural resources like birds, snow lice, and water, and topographically distinct places like mountain ranges, caves, and prominent peaks. To illustrate this point, we return to the case of the linguistic meaning of Nʉvagantʉ (Mt. Charleston Peak), which is the highest point of elevation in this mountain range and the region.

Nʉvagantʉ is sometimes translated as "where snow (nʉva) sits (gantʉ)." Deeper analysis reveals that the name implies much more. To pursue this argument we need to know more about puha and people. Puha exists in people like it differentially exists in natural places; that is, puha varies in kind and concentration. Some people, known in English as shamans or medicine doctors, are predisposed to have certain kinds of puha and to use it productively to accomplish balancing goals. Such people gain access to additional puha from spirit helpers, songs from caves, and special vision questing places over the duration of their lives. When they use their puha to cure (that is, to bring back into balance) individuals, communities, or even the world these individuals are like windows through which their puha and the puha of all their helpers combine in the production of a ceremony performed to achieve the cure. When they function as a window (a traversable gate), they span or connect the physical and the spiritual worlds. Such people are said to be a *Puha'gantʉ,* which is translated as "to have power." Here we begin to compare the use of the term *gantʉ* for powerful healers and for the largest peak in the Spring Mountains. There is a close connection between higher elevations in mountains and puha, and between puha and water in its various forms from rain to snow. Thus, it is suggested that Nʉvagantʉ means more than just "where snow sits." The mountain peak is like the medicine doctor, it is a window through which power flows in its various forms back and forth to achieve balance in the world. The mountains are a gateway between the physical and storied worlds. *Nʉvangantʉ* means "to have snow" like *Puha'gantʉ* means "to have puha." Snow in this context implies there is an extreme concentration of puha and a doorway to another dimension on this mountain.

Cultural Landscapes in the Spring Mountains

An essay titled "Piecing the Puzzle" (Dewey-Hefley et al. 1998/1999) suggests that cultural landscapes are not easily understood. Others emphasize that land-

scapes are more complex than places, thus requiring special theories and research methods (Greider and Garkovich 1994; Stoffle et al. 1997; Zedeño 1997). The intact landscape, not just the mountain, potentially is harmed by culturally insensitive development (Toupal 2003). The pattern and meaning of landscapes usually is only revealed by many interviews conducted at various locations over a long period. Landscapes cannot be discussed in the absence of place knowledge, and understanding the latter often requires years of site visits and multiple interviews. The cultural meaning of places is complex, but it is even more difficult to understand that places achieve synergistic relationships due to being connected with puha paths.

Southern Paiute cultural landscapes within and connected from elsewhere to the Spring Mountain range are all formed from places; which, in turn, are networked. Once local networks are understood then it is possible to know how the Spring Mountains are networked with places existing hundreds of miles in all directions.

The landscape map (Figure 3.2) shows how places are connected by the trails between them. On this map, the boundaries of the Spring Mountains are indicated with a dotted line. Trails found in the region are also indicated with dotted lines. The solid lines represent the path of the Colorado River during the mythic period. This original Colorado River flow path was modified to its present location by mythic creatures. A small-dotted circle marks a place of sacred importance on the lower Virgin River. Note that some trails were drawn beyond the map on its blank outer edge. Seen from this regional perspective, the Spring Mountains are clearly in the center of a series of trails that meet just outside the Spring Mountains. Key trail nexus points are Ash Meadows, Pahrump Spring, the Colorado River along Black Canyon, the Las Vegas spring complex, and Indian Springs.

Trails to the Afterlife

One way that the Southern Paiute people interact with the landscape is through a series of puha paths that cross the landscape in the form of songs. More than simple mnemonic devices to find one's way through the desert, these songs represent a spiritual connection to the land. This is most strongly represented in the Salt Song Trail. The Salt Song is part of the ceremony known as the Cry, in which a deceased person's soul is guided to the afterlife. This song trail guides the soul throughout Southern Paiute territory, as well as part of Hualapai territory, during the course of a sister song known as the bird song. This song trail is arguably the most important song trail in the Southern Paiute world, in that every person will eventually travel to the afterlife. This puha path cuts directly through the Spring Mountains, thus the mountains have a number of sites, which are explicit in the song. The song breaks at midnight in the Spring Mountains, and the song immediately follows places found in the range. This song trail is so significant to Southern Paiute people that it surfaces in many interviews:

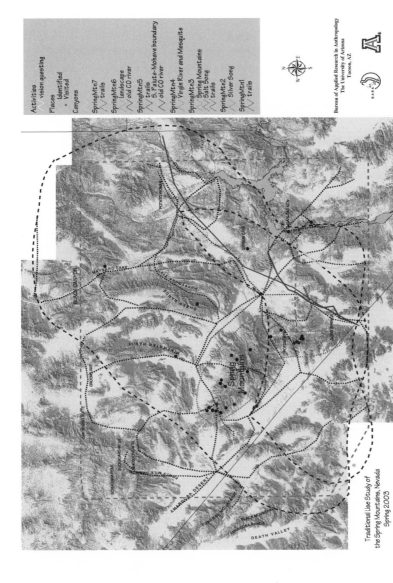

Bureau of Applied Research in Anthropology
The University of Arizona
Tucson, AZ.

Traditional Use Study of
the Spring Mountains, Nevada
Spring 2003

Figure 3.2. Landscape connections to the Spring Mountains.

- The Salt Song Trail comes up into this area. Midnight it goes to the Las Vegas–Spring Mountain area and came to the south from Moapa. The Songs stay in the mountains for about four songs, like the Hualapai Mountains, which has 3–4 songs.
- From the Whipple Mountains to the Spring Mountains is the Fox Song Trail. It stops along the way at springs created by legend being who shot arrows to make them.
- There is a big cave in the Spring Mountains—It is THE cave of creation.
- All places along the Salt Song route and the Fox Song route are connected with Creation.

A Local Puha Path

Just as there are spatially larger cultural landscapes involving hundreds of places and connected by an extensive series of trails, so too are there local landscapes composed of a few places connected by one or more puha paths. One local landscape, Mount Potosi, is on the head of a portion of the mountain range, which the Southern Paiute view as a living spiritual being. This portion of Mount Potosi contains concentrated puha that is both unique in what it can do and in its power (Figure 3.3). This puha path is primarily used for vision questing on two of Mount Potosi's highest peaks. Vision seeking in the severe environment of Mount Potosi requires one or more support persons to assure the safety of the vision seeker.

The Mount Potosi vision questing puha path is comprised of six distinct places: (1) Yellow Yucca, (2) Aztec Tank, (3) Yellow Plug, (4) vision quest support camp, (5) southern vision quest peak, and (6) northern vision quest peak. Each place is sequentially and functionally linked. Yellow Yucca serves as both an entrance and an exit. There the vision seeker introduces himself or herself to the place while conducting a series of prayers. The site is significantly marked with the knotted string symbols (*tapitcapi*), which indicate that the place is a pilgrimage stopping location. The second place is Aztec Tank where water (and by implication puha) that has come from the mountain is held in one or more natural stone tanks. The water is viewed as an offering to the seeker and serves spiritual and physical needs. The rock tanks can also provide a song, which is then taken by the pilgrim to Potosi Mountain and used during the vision quest.

The third site is the Yellow Plug rock outcrop where the vision seeker further explains his or her purpose to the mountain and seeks the special puha needed to continue the pilgrimage. After ceremonies are completed at Yellow Plug, the vision seeker and the support person(s) climb directly up the steep mountain to the fourth site on Potosi Ridge. They probably follow the natural dry wash, thus they are never out of direct visual contact with the summit of the ridge. Puha moves from the peaks where snow and rain fall down the flanks of mountains in paths that are similar to those of water flowing; thus, the primary path to the mountaintop corre-

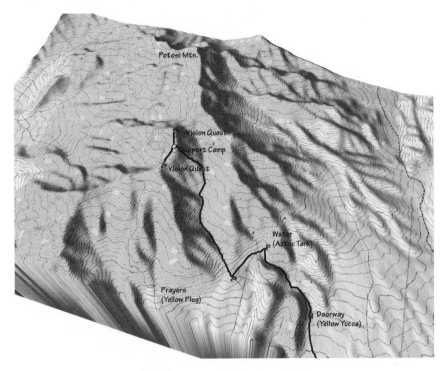

Figure 3.3. Mount Potosi puha path.

sponds with the path that puha takes on the way down to the three powerful places below.

Once on the Potosi Ridge, a small camp is set up to serve as a place to support the vision seeker. This is close to where the vision seeking occurs on nearby peaks, but is sufficiently removed from the locations to afford privacy. Vision quest support people had their roles: to serve, to advise the seeker, to help interpret what was happening, and to assure that the vision seeker did not become comatose. From the support camp, the seeker travels alone to one of the nearby peaks, and vision questing occurs over a period of two to three days. When the vision is achieved, or at such time that the support person suggests the time to leave has come, the pilgrims return to Aztec Tanks for water. Once again, the water from this tank is used for personal needs and for ceremony. Thanks are given to the mountain and to the Yellow Plug rock. Lastly, an exit prayer is given at Yellow Yucca.

Local cultural landscapes formed out of puha places and paths, such as this one on Mount Potosi, exist throughout the Spring Mountains. Understanding the use of these puha paths demonstrates how sites near one another can be a part of a single pilgrimage event.

There also is a methodological lesson in this case. This local landscape interpretation emerged from a series of interviews conducted at each of the involved

places and a landscape interview held at the Potosi Ridge support site. In all, it took thirty-seven interviews to understand this local landscape, and it is possible that additional interviews would provide even more understandings about the places and how they are synergistically networked.

Management Implications

Southern Paiute responsibilities for the protection and management of the Spring Mountains were established at creation. At that time, the proper balance between use and preservation was established. Each animal, plant, and place occupied a role in the lives of Southern Paiute people who in turn assumed a responsibility for sustainably using these earth elements. Since creation, these responsibilities and rights to use properly the Spring Mountains and their natural resources to achieve balance in individuals, communities, and the world have been transferred as a birthright from generation to generation.

Today, it is recognized that the physical control of much of Southern Paiute aboriginal lands has been transferred to the United States, and in turn to various federal land management agencies. Still, Southern Paiute people wish to note that these lands were recognized in the U.S. Indian Claims Commission hearings as being owned by them before these lands were transferred to the United States. So, while the legal ownership has shifted, the moral, spiritual, and cultural stewardship responsibilities for these lands remain as defined by the Creator, in the hands of Southern Paiute people. For that reason, the Southern Paiute people share portions of their knowledge of this creation land so they can remain in a stewardship capacity to advise on moral, spiritual, and cultural matters in the Spring Mountain range.

Notes

1. Numic is a linguistic term that is applied to Northern Paiute, Western Shoshone, and Southern Paiute languages.

2. This chapter uses *Nuwuvi* as the Numic term that refers to the Southern Paiute people, but it is recognized that other terms like *Nungwu* are also used.

3. Linguists have suggested various ways of spelling Numic words in English. In general, these are not useful to untrained readers and Indian people say they do not need them because "we already know how to speak our language."

4 Origin Narratives, Places, and Concepts among the 'Namgis, a Kwakwaka'wakw Group in British Columbia, Canada

Jessica Joyce Christie

Legend of the 'Namgis
Legend of the T'sit'sal'walagama'yi "Famous Ones" 'Namima
1st Clan of the 'Namgis
In ancient times, many of our first ancestors came to the world as animals or supernatural beings that transformed into people and began our tribes. After some time, the first people became bad and were very disrespectful to one another and mainly to the animals and the land. The Ik'I Gigame' "Great Chief Above" was going to send a huge flood that would cleanse the earth and create a new beginning. There were some people who were to be spared from this great catastrophe due to their respect and following of the ancient ways. Some of these people were sent messages through dreams or visions about the flood that was to come.

One ancestor of the 'Namgis Tribe was sent a message from the Creator in a dream that when the flood came, the great Halibut-Like Sea Monster 'Namxiyalagiyu "Only One" would rise from the depths of the ocean to come and take him to a place where he would be protected for the duration of the flood. This man waited on the beach out in front of his village at the mouth of the river when it began to rain and never stopped for a very long time. This man waited and waited until the water had risen to very high levels and was standing in the water that had risen up to his neck. He had almost given up believing that he would be saved and was ready to run and try to seek refuge. Then a great swell came from the sea and the water levels began to drop. Out of the ocean surfaced 'Namxiyalagiyu that swam to the beach and allowed the man to climb on and walk toward its back. This creature was so big that the man appeared to be a small speck on the rim of the monster.

The man was bestowed with supernatural power and the ability to breathe under water and was then carried to the bottom of the ocean. He was taken

there for a great length of time. The flood was said to have lasted a very long time and the tides were extremely rough around the world. A great number of people perished during this time. When the flood receded 'Namxiyalagiyu surfaced from the depths of the sea and returned the man to the shore at his home at Xwalkw "Foundation" and then returned to its home under the ocean. During the Great Flood the former people who did not survive were transformed into animals and stones.

The man looked around the land and saw that there were no other survivors; therefore, he called himself 'Namukustolis "Having Come to the Earth as the Only One." In time 'Namukustolis grew lonely, so he made a snare and caught seagulls that he transformed into people. These people became his tribe and he married one of the women. Soon, he had a son called Nage' "Mountain." Together he and his son kept a fire going on the beach and were always sitting beside it. Then one day K'aniki'lakw the "Transformer" in his canoe passed their way and landed at Xwalkw "Foundation." He sat down by them at their fire in such a way that 'Namukustolis and Nage' were sitting on one side and he was on the opposite. He wanted to test his spiritual power with them, so he put some fish, which he had with him, by the fire and roasted it. Nage' wished to eat some of this fish, so his father held his hand underneath it and caught the fat dripping down and gave it to his son to taste. K'aniki'lakw took the fish and broke it and gave it to them to eat. He thought that they would die because it was really a Sisiyut "Double-Headed Serpent," but to his surprise it didn't seem to harm them. 'Namukustolis himself had a Sisiyut, which he roasted and gave to K'aniki'lakw to eat in return.

K'aniki'law was very surprised at this. K'aniki'lakw tried to transform the two into a pair of ducks. He succeeded, but after a short time they both became human again. They sat down by the fire again and K'aniki'lakw then transformed them into two large mountains. Again, the two soon regained their human shape. Then he transformed them into a pair of kingfishers. These too, soon became human again. 'Namukustolis also transformed K'aniki'lakw three times, but was not able to prevent him from assuming his real shape each time. Thus, when K'aniki'lakw saw that he was not able to defeat them, he made friends with them and journeyed on. At this time 'Namukustolis went up into the valley to see if there were any other survivors. When he found no one, he returned back down the small river and then assumed the name Gwa'nalalis "Coming Down River in This World."

In time, K'aniki'lakw eventually returned to Xwalkw, the home of Gwa'nalalis. Then K'aniki'lakw took some gum of rotten wood and chewed it and put it on his face and when it dried up it made him look like an old man. He now had small sore-looking eyes and fine wrinkles on his face. Then K'aniki'lakw went and sat down by the side of the small river above Xwalkw.

With his supernatural power he wished for the princesses of Gwa'nalalis to come and bathe in the river. He had not been wishing long when four women, the fair beautiful daughters of Gwa'nalalis, came down the hill carrying a kwe'tsi "chamber vessel." The oldest one was the first to see the old man sitting on the ground by the river. Immediately she said "I have had good luck today, for I have found a runaway slave!" Then her younger sisters spoke and said to her, "Take good care of him! He shall be our messenger!"

K'aniki'lakw started to wish again, saying in his mind, "Wash, wash children of Gwa'nalalis" (his supernatural power took over their minds and they lost their senses). The oldest daughter of Gwa'nalalis then took water and began washing herself, and the next two followed her, but not the youngest. Then K'aniki'lakw wished for them to want him to wash their backs, so he sent this thought into their minds. Then the oldest daughter called K'aniki'lakw, "Come, wash my back." Then K'aniki'lakw washed the back of the woman. Then K'aniki'lakw took gum and put it on his index finger. He touched with his index finger the womb of the oldest daughter of Gwa'nalalis. When he did this she let out a scream.

Two of her younger sisters asked her why she screamed. Then the eldest sister spoke and said "Oh, my dear ones! Go ahead; call our slave here to wash your backs, for the way he does it is good." The slave was called at once. The next oldest sister said to the slave, "Come, sonny, and wash my back." K'aniki'lakw arose at once and sat down on the ground behind her. He washed her neck and went down her back and then he put the gum from the rotten wood on his index finger and touched the womb of the woman. Then the woman screamed.

Then the woman spoke and laughed and said, "Oh, go ahead and also call this slave of our eldest sister, the way he has washed us is very good. Do the same, or else you will regret that you have not found out how good it is that which he is doing."

Immediately, the third one called the slave and said, "Oh, little old man, come and wash my back!" The slave went at once and sat down behind the naked woman who was sitting on the ground. Immediately, he began to wash her and moved his hand downward on her back, again, he put the gum from the rotten wood on the point of his index finger and touched the womb of the virgin girl. Then the girl screamed.

He had touched the three eldest daughters of Gwa'nalalis from behind with his finger, but the youngest daughter did not permit him to wash her. K'aniki'lakw thought to himself, "Why is this one so resistant?" The youngest daughter thought to herself, "Do I know where this man comes from?" K'aniki'lakw was challenged by this and thought, "I will have this woman for my wife." She thought something was not quite right and just said that

she had already bathed. Now the three eldest daughters of Gwa'nalalis were pregnant and did not know it.

When they had finished bathing, they went home and the eldest sister was leading the slave. They entered the house of their father Gwa'nalalis. Immediately, the women reported to their father that they had found a runaway slave. Gwa'nalalis was very leery about the new slave and did not say a word to his children.

It was evening when K'aniki'lakw wished that he could lie down just outside the room of the youngest daughter of Gwa'nalalis. Then night came. Each woman went into her own bedroom. Then the slave was told by Gwa'nalalis to lie down on the floor outside of the room of the youngest one and keep guard, for that was what he had really wished for.

As soon as it was dark, K'aniki'lakw arose and went into the room of the youngest of the four daughters. Then K'aniki'lakw turned into his rightful shape of a handsome man. As soon as he lay down, the girl questioned him and said, "Oh, my dear! Who are you?" Then K'aniki'lakw replied at once and said, "I am not K'aniki'lakw who your father has warned you about!" Then the girl told him at once what her father had said about K'aniki'lakw, "Don't sleep too much and always go and bathe in the river, so that you may have good luck and be able to recognize K'aniki'lakw, for he may come toward our place; and therefore I am thankful that you have come instead," she said.

Immediately, K'aniki'lakw spoke, "You have done the right thing and did not agree to the words of your elder sisters when they wished that the little slave should also wash your back. I was glad that you did not call him, because now your three elder sisters are with child because he sat down behind them; and you would also be with child without a husband if you allowed him to wash you too."

Then the woman felt glad, for she now had a handsome man for her husband. Then they "played" together until late into the night. Gwa'nalalis was surprised that his daughter was talking with what sounded like a man's voice. In the morning when daylight came, the youngest daughter of Gwa'nalalis came out of her room. Immediately, Gwa'nalalis questioned her and asked, "Oh child! Who were you talking and playing with last night?" The girl answered her father at once and said, "I was lying down with a handsome man on account of the one whom you wished us to bathe and to watch out for. I have found this handsome man who I shall have for my husband." Now the youngest daughter was also pregnant and with child.

Gwa'nalalis told his daughter to go and call her new husband to come and eat breakfast. When he sat down K'aniki'lakw looked at Gwa'nalalis and revealed to him who he really was and that he had impregnated all four of his

daughters. Now Gwa'nalalis was truly downcast for K'aniki'lakw had broken his spirit through shaming him by impregnating all of his daughters. Gwa'nalalis thought about what he should do to his new son-in-law to be. Gwa'nalalis did not want K'aniki'lakw to know he was ashamed and pretended to be grateful for what K'aniki'lakw had done. Gwa'nalalis pretended to be thankful for the words of K'aniki'lakw and told him he could marry his youngest daughter. Then K'aniki'lakw was treated well by his father-in-law. However, K'aniki'lakw knew all the thoughts of his new father-in-law.

The three sisters-in-law of K'aniki'lakw were the first to give birth. Then the wife of the Transformer also gave birth to a child on the following day and K'aniki'lakw wished at once that his name should be Gi'yi "Chief." Then Gwa'nalalis spoke to K'aniki'lakw: "Let us go and split boards to make a cradle for my new grandchild." K'aniki'lakw told his wife not to worry even if they were gone for a long time.

Then they paddled away together in a canoe. They walked and saw cedar trees that were favorable to be split for boards. On their way, K'aniki'lakw saw a little wren so he borrowed its blood bag. Gwa'nalalis chose a large cedar tree and drove in his wedges and the tree opened up and he put in spreading sticks to hold it open. Then Gwa'nalalis dropped his hammer into the crack. Gwa'nalalis called and said, "Come, son-in-law, and get my hammer, for it has dropped into the tree." K'aniki'lakw climbed into the crack of the tree to get the hammer. Then Gwa'nalalis knocked out the spreading sticks and the tree snapped together shut on his son-in-law. K'aniki'lakw had the blood bag in his mouth so he spat out some of the blood and it oozed out of the tree and Gwa'nalalis thought that K'aniki'lakw was dead. After Gwa'nalalis saw the blood of K'aniki'lakw, he took the wedges and put them into the wedge bag. "Serves you right, you came to make me ashamed!" Gwa'nalalis said and started to walk away carrying his wedge bag. Then K'aniki'lakw came shortly afterward walking behind him carrying the hammer and saying, "Oh, father-in-law, why are you walking away and leaving me? Here is your hammer."

Gwa'nalalis looked astonished and said, "Come my son-in-law, I was going to go and call people to come and help open the tree," as he pretended to cry. "Let us go and finish our work!" Gwa'nalalis went back to the tree and began to drive in his wedges again. Then the cedar tree opened up and spread out. Then he dropped his hammer in again. "Come, my son-in-law! My hammer has dropped in, go in and get it for me!" When K'aniki'lakw went into the cedar tree and got it once more, Gwa'nalalis knocked out the spreading sticks from the cedar tree. It snapped shut and a greater amount of blood came rushing out, and Gwa'nalalis thought K'aniki'lakw must be dead for sure. "Serves you right, you came to make me ashamed. You did not see what

I was going to do to you. You are finished now and you said nothing could kill you!" Gwa'nalalis started to walk away and heard K'aniki'lakw behind him saying, "Don't go away! I am bringing your hammer to you father-in-law!" Gwa'nalalis did not say anything and headed down toward the canoe.

On the way, K'aniki'lakw picked many salmon berries and instructed them on what they would do. He told them: "I have picked you so that you may do great harm to my father-in-law Gwa'nalalis. When we enter his house I will get my wife to feed you to him and after he has swallowed you, you shall grow in his belly and grow out through his eyes, ears, nose, and rear end. You will grow into bushes." K'aniki'lakw also picked up four pieces of rotten wood and hid them. K'aniki'lakw took the salmon berries and put them into a bucket. Then they paddled and headed toward home.

As they traveled K'aniki'lakw whispered to the rotten wood and said, "You shall become dolphins and do great harm to my father-in-law Gwa'nalalis." Then he threw them into the water and the rotten wood began to jump and became four large dolphins. They came and jumped toward and hit the head of Gwa'nalalis. Then his face began to swell. His eyes could not be seen because he was so very swollen. The dolphins were sent by K'aniki'lakw to do this harm to him. Gwa'nalalis was very hurt and did not say anything. K'aniki'lakw looked at his father-in-law and said, "Turn toward me so that I may fix your face." K'aniki'lakw put the palms of his hands on the swelling of the face of Gwa'nalalis and immediately the swelling went away. Now he was once again a handsome man.

When they arrived at Xwalkw, K'aniki'lakw gave the salmon berries to his wife to feed to her father. After he ate them, Gwa'nalalis did not feel well at all. He remained in his room and soon began to scream. The salmon berry bushes were growing out of him everywhere. When Gwa'nalalis was almost dead, K'aniki'lakw went into his room and pulled the bushes out of Gwa'nalalis and made his body right.

K'aniki'lakw was resting and lying down in the house. K'aniki'lakw's wife asked him, "Why are you downhearted?" K'aniki'lakw replied, "The reason that I am so downhearted is that my brother 'Namugwis "Only One" is probably dead." For K'aniki'lakw had left him by himself a long time ago when he came to Xwalkw. Then Gwa'nalalis spoke, "Go and see him." Then Gwa'nalalis said to his daughter, "Make sure you take your chamber vessel, for your urine is supernatural." Then K'aniki'lakw left in his canoe with his wife to go and see his younger brother. 'Namugwis was dead. K'aniki'lakw cried on account of his younger brother. The flesh of 'Namugwis was all gone and there were only bones now. Then the wife of K'aniki'lakw took her chamber vessel and sprinkled 'Namugwis with her urine and he came back

to life. "He!" said 'Namugwis, "I have been asleep for a long time." "You were not asleep brother," said K'aniki'lakw to 'Namugwis, "You were dead."

Gwa'nalalis thought to himself that if his son-in-law K'aniki'lakw should ever return, he would not fight with him anymore. Although K'aniki'lakw was far away, he heard the thoughts of Gwa'nalalis and immediately returned to Xwalkw. So finally K'aniki'lakw asked Gwa'nalalis, "What is it that you wish to become? Do you want to be a mountain?" Gwa'nalalis thought to himself, "No, for mountains have slides and then crumble away for as long as the days shall dawn in the world." K'aniki'lakw heard his thoughts and then asked, "Do you want to be a cedar tree?" "No," Gwa'nalalis thought, "for cedar trees when struck by lightning, split and fall, then they rot away for as long as the days shall dawn in the world." K'aniki'lakw heard his thoughts and then asked, "Do you want to be a large boulder?" Gwa'nalalis thought, "No, for I may crack and then crumble away for as long as the days shall dawn in the world."

K'aniki'lakw heard his thoughts and finally asked, "Do you want to become a river?" Gwa'nalalis thought for a long time and liked this idea, "Yes, let me become a river that it may flow for as long as the days shall dawn in the world and provide every kind of salmon for my next generations to come." K'aniki'lakw heard his thoughts and put his hand on Gwa'nalalis's forehead and pushed him down, saying, "There, you will be a river and flow for as long as the days shall dawn in the world, be full of salmon so that your descendants may never be hungry." So the small river began to flow over Gwa'nalalis's forehead and over his body and became a large powerful raging river. Its name is Gwa'ni and still is today, it is the river of the 'Namgis, the descendants of Gwa'nalalis.

Then K'aniki'lakw gathered up all the shellfish that was in the area and threw them away saying, "There shall be no need for shellfish here. The inhabitants of the neighboring islands shall collect them and barter them here for the great abundance of salmon."

K'aniki'lakw the Transformer finished by saying, "I am going to start again, I have seen many things that are wrong in the world, I shall go and make them right."

This is the origin narrative of the 'Namgis, one of the Kwak'wala-speaking tribes in British Columbia, Canada, in the form it was generously shared with me by William Wasden Jr. in Alert Bay. In the following, I will place this narrative in the context of the volume, without being a scholar specialized in Northwest Coast cultures. My information comes from the conversations I had with William and from the extensive Web site of the U'mista Cultural Society. The limited bibliog-

raphy should not be misunderstood as laziness and academic insufficiency on my part but it is the methodology of my conscious effort to include Native voices. William and others at Alert Bay are very suspicious about what was written about them in the past and what is being published now (compare with Allen Christenson's experiences with the Maya in Santiago Atitlán when he began to study the altarpiece in their church, Chapter 7). They feel they have frequently been misrepresented and, for example, laugh at Claude Lévi-Strauss (1982)! They wish to assert control over what is being said about them and how it is said. This control does not only extend to content but also to indigenous languages and spellings. An important project is the recording of indigenous languages, and they request that indigenous names should be spelled the proper way. In this chapter, I have expanded great effort to use the correct spellings of 'Namgis names but have not succeeded in using all of their correct grammatical signs. As William explained to me, he wrote the text of the origin narrative above but it has been edited and approved by many chiefs. What is posted in the U'mista Cultural Centre at Alert Bay and on the Web site of the Society represents the consensus of a majority of influential tribal members but not the consensus of all. Similarly, this chapter has been presented to William Wasden and Andrea Sanborn, executive director of the U'mista Cultural Centre, for approval before publication.

The 'Namgis are one of the at least 17 Kwak'wala-speaking tribes who live in the northern section of Vancouver Island, parts of mainland Canada, which faces it, and on some of the small islands in between. The Kwak'wala-speaking people have been known as the "Kwakiutl" in the anthropological literature but wish to be called the "Kwakwaka'wakw," that is, the people who speak Kwak'wala. This concern evidences how important language as a cultural bond is in uniting the dispersed groups. The city of Alert Bay is located on a small island and functions as an administrative as well as tourist center in the middle of Kwakwaka'wakw land.

'Namgis territory is situated on Vancouver Island more or less across from Alert Bay and centered on the watershed of the Nimpkish River (Figure 4.1). The Nimpkish River is Gwa'ni into which Gwa'nalalis was transformed by K'aniki'lakw, "it is the river of the 'Namgis, the descendants of Gwa'nalalis" (see above). Xwalkw "Foundation" is the home of Gwa'nalalis and can be considered the toponym, the geographical place of origin in the narrative. It has been identified as the archaeological settlement Cheslakees, a village site radiocarbon dated at 12,000–10,000 B.C. according to William. Neither native people nor tourists go there very much; it is not the kind of place that would impact people's lives today in their daily routines yet people know it exists and that it was inhabited a very long time ago.

Rather, the narrative presents a world in which humans, animals, and plants interact on somewhat equal terms (similar to Cherokee oral traditions, Chapter 1). Animals and plants can understand Kwak'wala and follow human orders. What

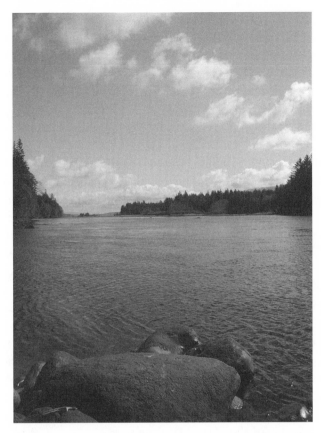

Figure 4.1. Nimpkish River. (Photograph by the author.)

elevates one being above others of its kind is size (the great Halibut-Like Sea Monster 'Namxiyalagiyu "Only One"), supernatural powers (Sisiyutl "Double-Headed Serpent"), and especially the power to transform (K'aniki'lakw). To a large degree, human interaction is based upon rivalry and the skill to outwit one another. Thus the 'Namgis creation narrative seems to be more concerned with portraying a worldview and order, ways in which people participate in and construct the world around them (see also the Spring Mountain range of the Southern Paiutes in Chapter 3) rather than describing a mystic and exotic "Landscape of Origin." We need to consider that perhaps our mythical notion of romantic "Landscapes of Origin" is a construct of our Western mindset, which is often thirsty for spiritually charged pristine and "natural" places. In fact, in many Native societies, very inconspicuous marks in the landscape could contain great spiritual and ritual powers. Other examples are a small cleft in a rock with a depression dug into the soil below to receive offerings that the Tz'utujil Maya at Santiago Atitlán described to Allen Christenson (2008) as "the heart of the world, the entrance into the place where the world

gods and saints live"; a small nondescript hill outside the town of Zinacantán that the local Maya understand as *mixik' balamil,* the navel of the world (Freidel et al. 1993:123–124); or the rugged holes in the unmodified rock outcrop on the Island of the Sun in Lake Titicaca, Bolivia, from which the Sun and the Moon followed by the ancestral Inka couple are said to have emerged.

Indeed, it is the world order, proper ways of interaction among all living beings leading to a state of balance, with which the 'Namgis and other creation narratives seem to be concerned. For some, "origin" may not be a separate place marked in the landscape or something addressed in an isolated story; "origin" is connected to everything else in life. It is the correct order that existed at the beginning of time, the healing balance and the proper connections between all things that people who suffer from alcoholism and drug abuse have lost. Such social ills reflect the harsh reality challenging many indigenous societies and that westerners in search of "natural" and "authentic" lifeways all too often choose to ignore. This raises the important point that our definition of "Landscapes of Origin" may have to be extended; "Landscapes of Origin" may not only be socially constructed as physical locations but may also become pure mental landscapes, "origin-al" or traditional—in the sense of pristine, pure, and undisturbed—ways of understanding the world and of relating to all things around us. At a point in history when we face the very real threat of new "floods" due to global warming, when we—like the "first people" above—have again become "bad and . . . very disrespectful to one another and mainly to the animals and the land," K'aniki'lakw's concluding words (see above) continue to ring true: "I am going to start again, I have seen many things that are wrong in the world, I shall go and make them right."

II
Mesoamerica (Cultural Region within Central America)

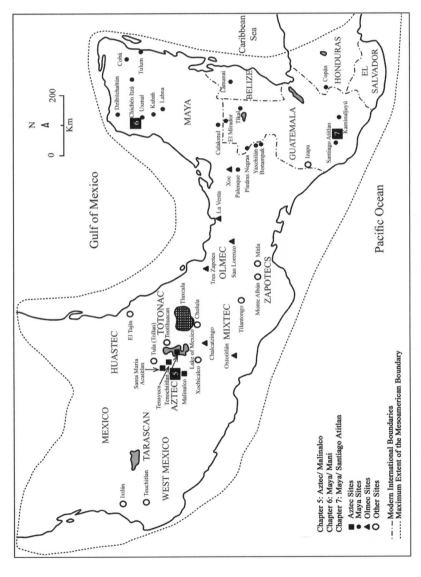

Map. 2. Central America indicating the areas and cultures discussed in Chapters 5 to 7.

Chapter 5: Aztec/ Malinalco
Chapter 6: Maya/ Mani
Chapter 7: Maya/ Santiago Atitlan

■ Aztec Sites
● Maya Sites
▲ Olmec Sites
○ Other Sites

–·–·– Modern International Boundaries
········· Maximum Extent of the Mesoamerican Boundary

Gulf of Mexico

Caribbean Sea

Pacific Ocean

MEXICO

HUASTEC

TARASCAN

WEST MEXICO

TOTONAC

AZTEC 5

MIXTEC

OLMEC

ZAPOTECS

MAYA

BELIZE

GUATEMALA

HONDURAS

EL SALVADOR

Ixtlán
Teuchitlan

Santa María Acatitlan
Tenayuca
Tenochtitlan
Malinalco
Xochicalco
Chalcatzingo
Oxtotitlán
Tilantongo
Lake of Mexico
Cholula
Teotihuacan
Tula (Tollan)
El Tajín
Tlaxcala

Tres Zapotes
San Lorenzo
Monte Albán
Mitla

La Venta
Xoc
Palenque
Piedras Negras
Yaxchilán
Bonampak

Calakmul
El Mirador
Tikal
Lamanai

Dzibilchaltún
Chichén Itzá 6
Uxmal
Kabah
Labna
Cobá
Tulum

Izapa
Santiago Atitlán 7
Kaminaljuyú
Copán

N

0 200
Km

5 Malinalco

A Place between Heaven and Earth

Manuel Aguilar-Moreno

The Aztecs and the Sacred Landscape

It is said that the nomads of the northern steppes of Mexico (the Chichimecs, who included the Aztecs) essentially had an astral religious view. Yet when they later migrated into the central valleys of Mexico, where peoples lived in a developed agricultural setting, they adopted agrarian gods related to the earth (rain and corn) and combined them with those of the Sun, sky, and stars. In essence, as these two religious ideas (astral and agrarian) were integrated, the Sun and the rain became the two great forces that came to rule the Aztec world, and became the gods of two dominant societies. The warriors worshiped the sun god Huitzilopochtli, while the civilian population worshiped Tlaloc, the rain god. Both gods shared the highest place in the temple of their city (Soustelle 1992:108–110).

This belief in the cosmological duality of sky and earth reveals the numerous aspects of nature that the Aztecs either deified or held as extremely sacred. Among the most important of these were the Sun, the mountains, the Earth, the caves, the wind, and especially water in the form of rain, lakes, and rivers. All of these forces in one way or another provided sustenance and were depended upon for survival. Thus, life-giving natural forces were not only deified but also permeated every aspect of Aztec daily life. The forces of nature were holy because they provided life. The combination of earth and water symbolized fertility itself, and most living things were thought to spring ultimately from the Earth. Caves played a major role in this respect as the metaphorical uterus of the Earth. According to the *Histoire du Mechique* (1965), Cinteotl, the maize god, was born in a cave and emerged to the surface of the mountains and fields to bring food to human beings. In keeping with this concept, religious and spiritual symbolism was incorporated into everyday living (Aguilar-Moreno 2006:52; Durán 1967, 1971; Gruzinski 1992; Soustelle 1992:111–115; Townsend 2000:136–138, 1992:46–47; to know the sacred landscape beliefs of the Maya, see Chapter 7 in this volume).

The culture of the Aztecs, as the last important culture that flourished in Mexico

in precolumbian times, was influenced most directly by the Toltecs and indirectly by almost all the previous cultures of Mesoamerica (Aguilar-Moreno 2006:32–36; Bernal 1980; León-Portilla 1971; M. Smith 2003; Townsend 2000). As the Aztecs' conquests, commerce, and relations with very distant peoples gradually became closer and more constant, it is natural to find diverse cultural features in all their manifestations the Aztecs adopted, but whose origins are difficult to identify with precision. However, during the two centuries of the empire's evolution, Aztec culture acquired so much strength that its buildings were developing a very clear and unique style, much like the impressive stone sculptures the Aztec artists also created (Aguilar-Moreno 2006:178–179, 218–220; Pasztory 1983). Aztec art and architecture were created to manifest power and monumentality; they served a very demanding social, political, and religious structure that had a diversity of ritual practices, including human sacrifice.

Aztec art and architecture show the harmony and adaptation to the natural forms of the landscape and became a setting for the interaction of the natural and supernatural worlds. This concept of a "sacred landscape," in which indigenous people attached special significance to geographic features, appears to have been of central importance to Mesoamerican cultures from the earliest times. Mountains, large rocks, caves, springs, rivers, lakes, trees, roads, particular features along the edge of the sea, or landmarks with a strange or unique form were identified with mythological events in the remote past, the creation of the world, the origin of human groups, deeds of ancestral heroes, or places inhabited by powerful spirits or deities (see also Chapter 7). This ideology explained the origin of the world and celebrated the central and special place of one's group in the natural order (Aguilar et al. 2005:69–71).

There are some ceremonial centers that were built not long before the Spanish conquest, like Cempoala in the state of Veracruz, Teopanzolco and Tepoztlan in Morelos, and Calixtlahuaca and Malinalco in the state of Mexico. In this chapter, I intend to show that Malinalco is the place where the three levels of the Cosmos unite: the Sky, the Earth, and the Underworld. It is the place of encounter of the Sun and the Earth to produce the energy of the world (see also Chapter 1 in this volume). I will discuss its role as a landscape of origin and creation, and it will be demonstrated that Temple I, the so-called *cuauhcalli* (house of eagles), is a cave-temple that serves as metaphor of the womb of Coatlicue, the Earth, where the Sun was born and therefore all life and fertility. Thus, if Temple I represents the womb of the Earth, consequently it is a metaphor of Chicomoztoc—the seven caves—the archetypical place of origin of the Nahua people (Aguilar et al. 2005).

Malinalco

The Ceremonial Center of Malinalco is located on a mountain cliff called the Cerro de los Idolos (Idols' hill). It resembles an eagle's nest amid a spectacular

mountainous region just a few kilometers west of the famous pilgrimage town of Chalma and east of Tenancingo. Malinalco has a strategic location, allowing the Aztecs to control the Valley of Toluca (Matlatzinca region), the Tlahuica region of Morelos, and the northern part of Guerrero.

The name Malinalco comes from the Nahuatl word *malinalli,* which means grass, herb, or twisted herb, and the suffix *co,* which means place. Thus, Malinalco is the "place of the grass or herb" (Peñafiel 1885; Sahagún 1975:Book IV:1, 3; Starr 1920:9). The historian Javier Romero-Quiroz (1980) identifies the *malinalli* as the exuberant plant called "cola de zorro" (foxtail), that has a beautiful white flower. Other sources point to another very similar plant called "zacate del carbonero," which is used to make ropes (Robelo 1974:127, 1951:154).

The linguists Antonio Peñafiel (1897:143, 1885) and Cecilio Robelo (1974: 127–128, 1951:154–155) suggest that Malinalco can mean "place where Malinal-xochitl (grass flower) is adored." Malinalxochitl was the name of the goddess sister of Huitzilopochtli who was abandoned by the Mexica in Malinalco because of her witchcraft activities. She is the mother of Copil from whose heart a prickly pear would rise, indicating the place of the foundation of Tenochtitlan (Alvarado Tezozómoc 1944:9–11; Durán 1967:Chapter IV:35–42).

The *malinalli* plant appears in the codices associated with the ritual of sacrifice and sometimes is represented accompanied by drops of blood, like in the *Historia Tolteca-Chichimeca* (1989). In the *Codex Magliabecchi,* a *malinalli* flower appears placed on the bundle of the dead, and in the *Codex Mendoza* the *malinalli* forms the hair of a skull, situations that can be taken as a clue to clarify the relationship of this plant with death.

Also, we find the *malinalli* in the representation of the *zacatapayolli,* which is a ball of grass where the maguey spines used in bloodletting rituals were inserted. The emblem of *zacatapayolli* appears as a decoration in *cuauhxicalli* (vessels to keep hearts of sacrificed people) and in *tepetlacalli* (stone boxes) that contained ritual objects (Aguilar-Moreno 2006:184, 200; Pasztory 1983:140, 247–248).

To climb the Cerro de los Idolos, which has an elevation of 215 m, the visitor uses a stone stairway covered by vegetation that runs on its slope. At the very top of the hill, there are remnants of platforms and temples that have been scarcely excavated. The main group of temples that we will explore was built on an artificial platform at an altitude of 100 m. From there, you can admire the gorgeous landscape that presents the magic shapes of the adjoining mountains and the fertile valley with the picturesque town of Malinalco, which has an interesting Augustinian monastery founded in 1540 (Aguilar-Moreno 1999, 2005; Peterson 1993).

Explorations of the Site

The first modern description of the ruins of Malinalco was given by Bishop Plancarte in his book *Tamoanchan.* He visited the site in 1905 and did not lead or par-

ticipate in any kind of excavation, but based upon the few elements not covered by vegetation that he could see, he wrote that the main temple was dedicated to Xiuhtecuhtli, the Aztec god of fire (Plancarte 1911). Later, Enrique J. Palacios (1935) argued that the relief of the facade of the temple was the face of Tlaloc, and the whole structure was a ritual fountain dedicated to this god of rain.

The first serious and official exploration was conducted by the archaeologist José García Payón from 1936 to 1939. It was sponsored by the Department of Prehispanic Monuments, which was a branch of the Education Ministry of Mexico. García Payón wrote his conclusions about the identification and function of the ceremonial center in a well-documented book published in 1947 and reprinted in 1974. More recently, the National Institute of Anthropology (INAH) undertook archaeological explorations under the command of archaeologist José Hernández Rivero from 1987 to 1989.

García Payón (1974:42–43), based on his observations of the military and religious nature of the site and supported by the chronicler and eyewitness Fray Diego Durán (1967:Chapter 88), decided to name the ceremonial center Cuauhtinchan, which means in Nahuatl "place or dwelling of the eagles" and metaphorically "the place where the Sun warriors are" or "the place of the invincible and brave warriors." This is a reference to the Cuauhtli (eagle) and Ocelotl (jaguar) warriors who were elite members of the most important Aztec military orders devoted to fight on behalf of the Sun (Caso 1974; Sahagún 1975:Book 8:Chapters XII, XVII).

According to the research of García Payón (1974:24–25), all the structures built by the Aztecs belong to the period between 1476, the date in which this region was conquered by Axayacatl, and 1520, when their construction was interrupted by the Spanish conquest during the rulership of Moctezuma Xocoyotzin. The Cuauhtinchan was abandoned after being destroyed by the expeditionary forces of Andrés de Tapia, one of the captains of Hernán Cortés (Díaz del Castillo 1976:284). This information is controversial because Torquemada (1986:I:556) indicates that it was Gonzalo de Sandoval who subjected Malinalco. With a portion of the stones of the Indian buildings, the Augustinians constructed their impressive monastery in 1540 at the center of the town, which was then reshaped with a new Spanish urban array (Aguilar-Moreno 1999:160–162).

The archaeological site has a group of six buildings located on an artificial platform on one of the slopes of the Cerro de los Idolos. It includes a drainage ditch system used for the collection of rainwater in order to protect the constructions.

The most amazing and unique feature of three of the temples is that they are carved out of the rock mountain, being among the very few structures on the American continent carved from a single, huge block of stone. In other words these buildings were not constructed with the assemblage of bricks, adobe, or other pieces of material that are normally used in the conventional techniques of architecture. In this case, the temples were carved and polished as monumental sculptures in the surface of the mountain. Even though the rock of this mountain is not

a very hard type of sandstone, this kind of work is difficult and must be precise because there is no way to correct mistakes. Temple I of Malinalco has its stairway, the balustrades, the walls, and several big sculptures carved out of rock. This fact alone is enough to place the Aztec artists among the best sculptors in the history of art, and this Temple I of Malinalco in the same exclusive and unique category of the handful of great monolithic structures of the world, such as the hydraulic works of Tetzcotzinco, Mexico (Aguilar-Moreno 2006:244–247; Townsend 2000:145–152), the outcrops of Pumaurqu and those in Machu Picchu (Chapter 9 in this volume), the temples of Ajanta and Ellora in India (Craven 1985:121–131, 137–141), the Longmen caves of China (Clunas 1997:103–105), the royal Nabatean tombs of Petra in Jordan (Taylor 2001), the Cappadocia cave monasteries in Turkey (Kostof 1972), and the Temple of Abu Simbel in Egypt (McQuitty 1965).

The structures of Malinalco are Sculpture-Temples, built in a fashion that can be described as sculptural architecture. They were carved into a sloping hill and oriented southeast for ritual purposes

Next, I will analyze the iconographic elements and the meaning of the different structures of the site that appear in the following map (Figure 5.1).

The Cuauhtinchan

Building I (The *Cuauhcalli*)

The most unique structure of Malinalco is the temple called the *cuauhcalli,* meaning "house of the eagles," according to the archaeologist José García Payón (1947: 40–45). The circular *cuauhcalli* pyramidal base and balustraded staircase is a rock-cut structure carved in the mountainside and is oriented south. It has two bodies in *talud* or *talus* (sloping walls), with one superimposed on the other with a height of 4 m (13 ft) (Figure 5.2).

The staircase, located in the front facade of the building, is 2 m wide and has 13 steps that may symbolize the 13 heavens of the supernatural realm. This is not a coincidence because we find the same number of steps in other Mesoamerican structures, such as the Pyramid of Tepoztlan, the Temple of the Feathered Serpent in Xochicalco, the round temple of Cempoala, and the Temple of Ehecatl in Calixtlahuaca among others (Aguilar-Moreno 2006:Chapter 9). The staircase has two balustrades (*alfardas*) with changing slopes at the top, each becoming almost vertical. On the left and right sides of the stairs, two squatting jaguars are found. Their identity is proven because on the surface of the stone, García Payón (1974:25) found the remains of paint consisting of black spots on a yellow background. Between the fourth and seventh steps, there are remains of a damaged sculpture of a sitting standard (*pantli*) bearer similar to one that once stood on top of the balustrades of the Great Temple of Tenochtitlan.

At the top of the stairs there is a low platform that functioned as an antechamber

Schematic Map of the Site of Malinalco

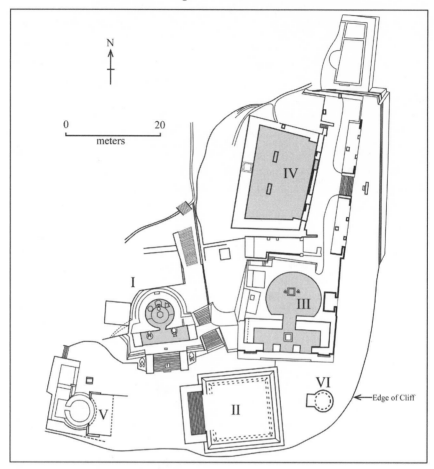

Building I - Rock Temple (Cuauhcalli)
Building II - Square Pyramid
Building III - Semicircular Shrine (Tlacochcalco)
Building IV - Rectangular Temple (Tonatiuhcalli)
Building V - Circular Small Temple
Building VI - Platform for Gladiatory Sacrifices (Temalácatl)
▨ - Temples Cut Into Rock

Figure 5.1. Plan of Malinalco after Marquina.

for the shrine of the temple. The platform floor has a rectangular perforation that is believed to have had an embedded *techcatl* (sacrificial stone). Three-dimensional figures of a serpent head with scales in the shape of arrow points or darts and an Eagle Warrior sitting on top (east side), and a *huehuetl* (vertical drum) covered with *ocelotl* (jaguar) skin surmounted with remains of a Jaguar Warrior on the west side, flank the doorway. The serpent head has clear allusions to warfare and being

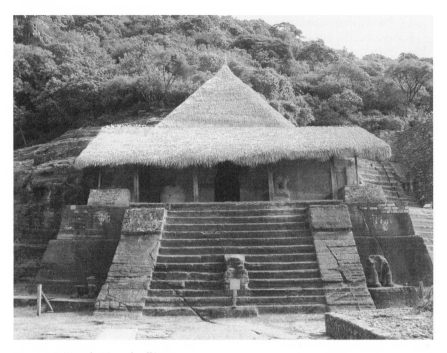

Figure 5.2. Temple I (cuauhcalli).

located on the east side, could be identified as an unusual version of the Xiuhcoatl, the serpent of fire, which was the weapon of Huitzilopochtli. The doorway of the shrine is the open mouth of a serpent, with fangs on each side, its eyes surrounded by scroll-shaped eyebrows and a bifid tongue sculpted on the floor. García Payón (1974:34, 37–38) said about this architectural sculpture: "despite the similarities that this figure has with the goddess Coatlicue, the god that better adjusts to it is Tlaltecuhtli because this relief represents the 'earth monster,' therefore, this sanctuary is the earth itself on which the Aztec Warriors had to struggle in warfare and perish fighting, offering their lives to the Sun, to whom this temple and the others in this unique ceremonial center are dedicated." I dissent with García Payón's identification of Tlaltecuhtli as representation of the "earth monster" in the doorway. The only reason why he disregards the image of Coatlicue as the image of the doorway is because he says that the Coatlicue of the Anthropology Museum in Mexico City has a head represented by two snakes looking at each other, and the image of Malinalco is a single frontal snake face (García Payón 1947:34). I think this is an iconographic misinterpretation, because if we carefully look at the head of the Coatlicue in the museum, we discover that there is a dual rendition, and we can read the figure showing a single impressive frontal snake head, or at the same time having the two serpent snakes in profile that García Payón saw. This reading of a single frontal snake head indicates that the image in the doorway is Coatlicue,

the mother earth goddess. This characteristic makes the *cuauhcalli* a cave-temple, the entrance to the womb of the earth.

The interior structure has a painted, raised ledge cut from rock that follows the circular contour of the wall and is almost six m (19 ft) in diameter. The east and west sides have sculptures of flat eagles, and the north side has an extended jaguar. The sculptures were zoomorphic thrones (Figure 5.3). Alvarado Tezozómoc (1944:Chapter LXXIII:347) points out that the Aztec king Ahuitzotl, during a visit to Malinalco in 1487, received tributes from the leaders of the town, seated in a throne covered by a jaguar pelt. *Codex Telleriano-Remensis* (1995) tells that Ahuitzotl sent stone carvers to Malinalco in 1501, which is when we can suppose the building program of the ceremonial site started. We can imply from this information that the jaguar throne inside of Temple I represents the seat of the Tlatoani (Aztec king) and the eagle thrones the ones of his main military officers (the Tlacatecatl and the Tlacochcalcatl) that were used in political and religious ceremonies (Townsend 1982:133). In the center of the shrine, there is the sculpture of an eagle facing the doorway. The eagle is the *nahual* (disguise) of the Sun and is the terrestrial form taken by the god Huitzilopochtli-Tonatiuh. Behind the eagle there is a circular hole, approximately 30 cm (12 in) wide and 33 cm (13 in) deep. It is believed that it was a *cuauhxicalli* (repository for the hearts of sacrificed victims) that held the offerings needed to maintain the movement of the Sun and human existence (García Payón 1974:29). The carved circular wall of the shrine was completed with an extension of *tezontle* to support the thatched roof.

As an interesting comparison, Freidel et al. (1993:67–69) show us that in the cosmology of the Classic Maya, there was the belief that the gods used three stones to light the fire of the hearth and set up the sacred space for the creation of the world. The God L, one of the powerful gods of the underworld related with war, placed the "jaguar throne stone." Also, the Maya considered the ceiba tree to be the World Tree (the axis of the Universe), having at its top a celestial bird (*itzam-yeh*) identified with the Sun. It shows that the Aztecs were representing, in their own style, the elements of an old religious tradition shared from culture to culture for 3,000 years. In Malinalco we have the three stones that are the three zoomorphic thrones, with the jaguar throne being the most significant.

More surprising is the parallel between the Maya reliefs in the Cross Group of Palenque and the Sarcophagus of Pakal, with the Aztec relief of the Foundation of Tenochtitlan that is part of the monument called The Teocalli of the Sacred War or the same theme in the *Aubin Codex*. The Maya reliefs were made around 800 years before the Aztec ones. In all of them, we find the World Tree, a ceiba, or the maize plant for the Maya and a prickly pear tree (*nopal*) for the Aztecs; the celestial bird related to the Sun is a macaw or quetzal for the Maya and an eagle for the Aztecs. In all the allegories, we see how the trees come out from the "monster of earth,"

Figure 5.3. Temple I, interior: Zoomorphic thrones in the bench and solar eagle.

and this is a metaphor for the belief that through death and sacrifice, life is reborn and the gods are nurtured to preserve the movements of the Cosmos. This is an incredible proof of the cultural continuity in Mesoamerica.

Like most Aztec architecture, the Temple I (*cuauhcalli*) is a reenactment of historical and religious beliefs. As stated above, it honors Coatlicue, the earth goddess, through its function of a sanctuary that represents the earth itself on which Aztec warriors struggled in warfare and perished fighting, offering their lives to the sun. This temple also represents, like the Great Temple of Tenochtitlan, the mount of Coatepec (Snake Mountain) that is a transitional place on the surface of the earth (*tlalticpac*) connecting it (middle world) with the heavens and underworld. It is the mythical house of Coatlicue, represented by the serpent's mouth door. When the interior chamber is entered, it leads to a cave, the womb of the earth. In this sense, it is a metaphor for the mythical places of creation and origin Tamoanchan-Aztlan-Chicomoztoc, where the human beings were born. Coatepec is the place where Huitzilopochtli was born from the womb of Coatlicue. The myth, an ancient explanation to understand the cosmological context of life, says that Huitzilopochtli (the Sun) was born from the womb of Coatlicue (the Earth) armed with the *xiuhcoatl* (fire snake). He defeats his siblings Coyolxauhqui (Moon) and the Centzohuiznahua (the Stars), dispersing them through the sky (*Codex Azcatitlan* 1949;

Sahagún 1975:Book III:191–192). There are physical elements referring to the myth of Coatepec in the *cuauhcalli* (Temple I). The *cuauhtlehuanitl* (ascending eagle) or rising Sun is represented by the carved eagle in the center of the shrine that faces toward the portal of the earth cave (Coatlicue). It symbolized Huitzilopochtli's birth and victory over his siblings. The battle was reenacted every day for human beings: when the Sun rose from the east, it was carried to the zenith by warriors who died in war or on sacrificial stones. When it set in the west, it was taken by the Cihuateteo, the deified women who had died in childbirth. The Sun was swallowed by the earth and traveled all night through the underworld to rise again the next day. It was believed by warriors that the hearts placed in the circular hole (*cuauhxicalli*) of the shrine's floor aided Huitzilopochtli in his nightly quests. In the exterior, next to the portal on the southeast side, as stated before, there is a *xiuhcoatl*, the weapon used by Huitzilopochtli when he traveled from east to west. The archaeoastronomical measurements of historian Javier Romero-Quiroz (1987:10) and astronomer Jesús Galindo-Trejo (1989:17–22) confirm that the day of the winter solstice (December 21) at noon, the light of the Sun coming from a cleft in a mountain located in front of the *cuauhcalli* enters through its doorway, illuminating the head of the eagle that is the embodiment of Huitzilopochtli, the Sun himself. We know through Fray Bernardino de Sahagún (1975:Book II:90–91, 142–147) that on the winter solstitial day, the Panquetzaliztli was celebrated, a festival dedicated to honor the flags of sacrifice, because this was the day of the descent of Huitzilopochtli to the Earth. It means that the orientation of this temple was built with this solstitial effect in mind (Aguilar-Moreno 2006:218–220; a comparison of the importance of the movement of the sun and solstices among the Maya can be seen in Chapter 6 of this volume).

Flanking the door are images of the Cuauhtli and Ocelotl warriors who were the guardians of the temple and worshippers of the Sun. The eagle and jaguar were the embodiments of the power of light and darkness, and the warriors designated by these names were especially committed to procure the food of the Sun, the *chalchihuatl* (blood) through human sacrifice.

Although Temple I is circular, it is not associated with the cult of Quetzalcoatl (many circular structures in Mesoamerica honor the deity). This temple was erected in honor of the Sun god Huitzilopochtli, and that is proven by all the iconographic motifs already discussed.

Next, I will explain the possible functions and uses of this unique monolithic construction, considering the hypotheses given by several scholars.

According to García Payón (1974:43–44), ritual practices were celebrated in this temple as well as ceremonies of military initiation or graduation of the Cuauhtli and Ocelotl warriors. These ceremonies were performed in the presence of the Aztec king, the Tlatoani; these ceremonies included fasting and bloodletting as well as

the piercing of the nose in order to place a bone or the claw of an eagle inside of it. Moreover, Corona Sánchez (in Hernández Rivero 1993:24) suggests that the perforation of the nose was performed by placing the warrior on the central eagle. In this way, the dripping blood fell into the *cuauhxicalli*. An element that supports this idea is the fact that during the excavation seasons of 1987 and 1988, conducted by José Hernández Rivero, a green obsidian perforator very similar to the maguey thorns used for the rituals of bloodletting was found. This can also explain the six rectangular cavities that exist in the interior of the round wall, which could have been storage units in which these ritual instruments were kept (Hernández Rivero 1993:36).

According to the observations of Muñoz Camargo (1978:45–47) in Tlaxcala, after the rituals described above, the Cuauhtli and Ocelotl warriors received in a public ceremony their bows, arrows, obsidian clubs (*maquahuitl*), shields (*chimalli*), insignias, and uniforms with helmets in the shapes of eagles and jaguars. It was a very formal graduation that gave them the high military and social status, which might well have taken place in the *cuauhcalli*. We can compare it to the "naming of knights" in Medieval Europe.

Mendoza (1977:63–80) conceives of the possibility that in this building, there could have been worship to agricultural deities, such as Tlaloc (Rain), Centeotl (Maize), or Coatlicue-Tlaltehcutli (Earth), due to the existence of a water spring in the hill where this cave-temple is located. Thus, the fertility generated by the interaction of earth and water was revered there.

The building, as I have shown, was the house of the Sun. Therefore it was oriented to the south, so, from the plaza the cyclical movement of the Sun (Tonatiuh Ollin) could be watched across the firmament from east to west (García Payón 1974:43).

Another hypothesis that is not contradictory with the previous ones is the one of Romero-Quiroz (1980:141–154) who, based on the account of Fray Diego Durán, says:

> The Malinalco's *cuauhcalli* was not exactly like the one in Tenochtitlan, but in this one, there is the laying sun in eagle's shape and behind him is his *cuauhxicalli*. In the Sun's house of Malinalco an impressive ceremony called the "dance of the messenger of the Sun" was celebrated on the date of Nahui-Ollin. The *teopixques* (priests) and the *yaotecas* (warriors), luxuriously dressed, watched how the *uauautin* (a prisoner striped in red), performed a dance in honor to the Sun. Afterwards in the *techcatl* located before the entrance of the temple, this captive, who was considered as a messenger between the humans and the gods, was sacrificed to give his heart to the Sun. This kind of sacrifice by extraction of the heart was called *Tlacamictiliztli* in

Nahuatl [Molina 1970:115]. The heart (*yollotl*) was placed in the *cuauhxi-calli* in the interior of the shrine. It was this dynamic organ that produced and maintained the motion and life of the Cosmos, and the *Chalchihuatl* (blood), the precious liquid, was the magic substance that was the preserver of life and sustenance for the Sun.

Besides the ritual killing, there was also the practice of auto-sacrifice or blood-letting, and it is important to comment on what Yólotl González Torres (1985: 320–323) says about the meaning of the ritual sacrifice:

> The bloodletting was a substitution for human sacrifice and the basic differ-ence between each other was that the last one was not beneficial to the vic-tim, but in favor of the offerent, while the offering of the own blood was a way of reconciliation with the deity and the acquisition of spiritual strength. The main objective of the bloodletting was to confirm or reestablish the link between the worshiper and his god in a more intimate way than just to kiss or hug the idol (image). This state of unity with the supernatural, was reached more profoundly through the bloodletting, the pain of the wound, along with fasting and the ingestion of hallucinogenic substances. In reality, it was one of the many techniques of asceticism, that included the belief of the en-livening power of blood.

I could add that the bloodletting ritual was a kind of communion and thanks-giving to the life-giving deities, serving also as a constant memorial to the belief that the god Quetzalcoatl gave life to human beings with the blood of his penis.

For López Austin (1988:I:59–61, 272–273, and in Schroeder Cordero 1985: 87–88):

> Malinalco is the place of the union of the 3 levels of the Cosmos: the sky, the earth and the underworld; the symbol is a *Malinalli* that is represented like a twisted herb, twined ribbons, or a skull or a jaw with an eye and vegetation coming out. In ancient as well as today's magic practices, the shamans believe that they can travel to the different levels through these helicoidal ribbons during altered states of conscience provoked by hypnotical trance. Malinalco is famous since ancient times until present days for having people who were very skillful in the practice of sorcery. The figure of the two intertwined bands is represented frequently with polar or opposing symbols: on one side there is the cold stream from the underworld with conches and jade drops and on the other side is the fire stream with horseshoe-like curves ending in flowery motifs, like the ones on the famous Malinalco's *huehuetl*. This op-position is also represented in the contrast of the eagle and the ocelotl; the

eagle means the sky and the warmth, and the ocelotl is the underworld and the moisture.

According to the opinion of López Austin, it is clear that there is a strong relationship of the sculptures of the monolithic temple, the wooden *huehuetl,* the name of the place, and the prestige of its sorcerers. It leads us to think about the possibility of shamanistic rituals in the *cuauhcalli* related to the connection with the supernatural realms and communication with the ancestors. Since the Olmec times we see the transmission of a basic and common corpus of ideas and traditions through the interaction of the different Mesoamerican cultures, establishing a continuity that despite the Spanish conquest, still exists today. Freidel et al. (1993:128) show that the Classic Maya believed in an umbilical cord, represented by one or two intertwined serpents, that connected the sky with the earth and the underworld. This umbilical cord (*kuxan sum*) transmitted the blood and energy of life to the world. The shamans and kings communicated with ancestors through this so-called vision serpent. We see in the Lintel 25 of Yaxchilan, how through a bloodletting offering, the queen is calling the vision serpent from which an ancestor is materializing. This kind of rite increased the legitimization of the accession to power of the new kings, as well as receiving divine attributions, through the connection with the deified ancestors who could pass the supernatural energy to them.

There is still another proposal from Richard Townsend (1982:134–136) about the function of Temple I that can give us some insight to complete the theories already discussed. He suggests a political interpretation for the use of this structure, saying that this monolithic temple is an extension of the ceremonial buildings of Tenochtitlan, and its iconography has the ideological objective to justify the Aztec imperial power and legitimize its position in the conquered provinces. In the exterior of the building he agrees, in general, with the iconographic analysis of García Payón, but he adds the idea that the squatting feline figures flanking the staircase could be emblems of selected groups of Ocelotl warriors. He considers the interior of the shrine to be the "cave" of the earth, the origin of life that could be related also to rituals of fertility. He thinks that this building was used as an assembly hall and identifies the sculptures of the hemicycle as thrones, the central eagle as an altar or table to place the offerings or ritual objects, and the round cavity on the floor as a kind of recipient for the bloodletting ceremonies related to succession of power, celebration of victories, and important political events. In this sense, Temple I was equivalent to the Yopico temple of Tenochtitlan because both were used for the same functions. Townsend's proposal does not exclude nor contradict García Payón's idea that Cuauhtli and Ocelotl warriors' ritual practices and ceremonies such as initiation and graduation were celebrated in the temple. Townsend concludes saying that the *cuauhcalli* was a memorial monument to justify the Mexica-

Aztec political power and its conquests because the Aztec warriors needed to feed Huitzilopochtli with the blood of the captives in war.

Building II

Temple II is a truncated pyramid that is located a few feet southeast of Temple I. It has a squared floor plan of 8.5 m by 7.5 m and a staircase on the west side of the facade. The balustrades were constructed with carved stones and were covered with stucco plaster. Altar carvings and a platform were incorporated into the building. The building is consolidated, but it shows a state of deterioration (Marquina 1951:212).

Building III

This interesting construction, identified by Garcìa Payòn (1974:46) as the *tlacochcalco* or *tzinacalli* (where the incinerators are) is located east of Temple I, and forms part of the natural slope of the mountain. It faces south and is built of stone joined with soil and lime mortar. Temple III has two chambers; the one in the front is rectangular, measuring 8.5 m by 2.5 m on the interior. The second chamber is round in shape with a diameter of 6.5 m. The temple's entrance consists of three doors that are separated by two columns. The rectangular chamber has a fire pit in the middle of the room. The room contains a bench that runs through the east, west, and north sides. It is interrupted at the center of the north side and gives access to the circular chamber, which has also a fire pit at its center (García Payón 1974:30).

Temple III was apparently used to celebrate the funerals of warriors who died in war or captivity and were worthy of going to Tonatiuh Ilhuicac (the paradise of the Sun). According to Sahagún (1975:Book III:Chapter III) a ceremony was performed for the deification of the fallen warriors at war with the participation of their relatives, companions, and friends who were singing sad songs, crying, and mourning. One of the activities held in this funerary ceremony was the incineration of the wooden images of the fallen warriors, symbolizing a purification. Immediately after, the ashes were buried, meaning that the warriors were already in the heaven of the Sun. As evidence that supports these ideas, several cremated burials were found during the excavations of 1939 (García Payón 1974:49–50). The rectangular chamber originally had a mural that according to García Payón (1974:50, 57) represented the *mimixcoua,* the deified eagle and jaguar warriors who lived in the heaven of the Sun and had the honor of accompanying the Sun in his daily cycle. Unfortunately, this mural no longer exists.

The face of the only complete warrior is covered by a black mask that is a symbol of the darkness of the night in the northern region. It suggests a relationship of the dead warriors with Mixcoatl (Tezcatlipoca), another celestial deity. We find examples of images of such warriors in the codices and on ceramic vessels (García Payón 1974:59–60). It is interesting to note that the last warrior of the

single file shows an *aztamecatl,* which is the rope used to tie the brave captives to the *temalacatl* (stone for gladiatorial sacrifices) (Aguilar-Moreno 2006:126). This means that this one is a sacrificed prisoner that should have had a high rank. This rope (*aztamecatl*) will appear in an Ocelotl warrior carved in the famous *huehuetl* of Malinalco, which will be studied later.

Building IV

Temple IV is partially carved into the living rock, faces east, and is considered to be a Tonatiuhcalli, Temple of the Sun. Half of the edifice is carved out of rock, while the other half, the front facade, is made of ashlars of stone. The building is raised from a platform and has a central staircase. The interior measures 14 m by 20 m and still has two rectangular pedestals that served as column bases that supported the roof (García Payón 1974:32). There is an altar carved out of the rock that lies along the main wall that could have served as a fire pit. García Payón (1974:44–45) suggests that an image of the sun, similar to the Aztec Calendar of Tenochtitlan may have been embedded in the main wall due to the fact that the temple wall, facing east, was designed to receive the light rays of the rising Sun (Cuauhtlehuanitl), illuminating every morning the face of the god.

Building V

This monument has a circular floor plan of 2 m (6.5 ft) in diameter and is built of stone ashlars over a platform. Even though it is dilapidated, it can be seen that its limited space and round form are similar to the kivas of the Southwest in the United States, an area located beyond the northern limits of Mesoamerica (García Payón 1974:33; Marquina 1964:289–294). The hole that this structure has in its center could have been used to hold the flag or banner of war.

Building VI

According to García Payón (1974:33), this structure was under construction at the time of the Spanish conquest, and was never completed. Its platform can be identified as that of a *temalacatl* (wheel of stone). Romero-Quiroz (1980:127–128) suggests Building V to be the *temalacatl,* but I disagree because the size and location of Building VI are more adequate for the design of this kind of stone that appears in the ethnohistorical sources. Chroniclers, such as Durán (1967:Part II:Chapter 9), Alvarado Tezozómoc (1944:Chapter XXX:117–121), and Sahagún (1975:Book II:Chapter II:78–79), as well as the codices *Telleriano-Remensis* (1995:Folios 32, 38–40) and *Magliabecchi* show that on that particular type of stone, brave enemy captives were exposed to the gladiatorial sacrifice (*tlahuauanaliztli*). According to those accounts, a good number of gladiatorial sacrifices were performed during the festival of Tlacaxipehualiztli (flaying of men) dedicated to the gods Xipe Totec and Huitzilopochtli. Some *temalacatl* were also considered to be *cuauhxicalli* (ves-

sels that contained the hearts of the sacrificial victims), as is the case of the Stones of Tizoc and Motecuhzoma I (Aguilar-Moreno 2006:182–184).

Ceramics and Lapidary

Hernández Rivero (1993:33) indicates that García Payón found a small and well-polished red copal burner with the representation of an *ozomatli* (monkey). The *ozomatli* was considered to be the embodiment of Song and Dance, a kind of nahual of the god Xochipilli. On his head, he is wearing the *yohualli* or headdress; on his wrists and calves there are bracelets of feathers and *chalchihuitl,* and in his right hand he carries a flower that symbolizes the dances and games.

García Payón also found figurines representing dead women that, according to Hernández Rivero (1993:34), could be the *cihuateteo* (deified women) who died in childbirth and had the honor to accompany the Sun during his journey through the underworld. Other objects found in the area are rock crystal beads, clay pipes, copper rattles, copper and obsidian ear flares, and ceramic sherds.

It is important to mention the three carved stone funerary urns found by the archaeologist César Sáenz at the top of the Cerro de los Idolos during excavations in 1963. It is very possible that given the functions of the site, these contained the ashes of important Aztec warriors who died in war or brave captives who were sacrificed (Hernández Rivero 1993:7; Sáenz 1963:4–9).

The *Huehuetl* of Malinalco

In the town of Malinalco was found a wooden *tlalpanhuehuetl,* or war drum, which was still used in some ceremonies until 1894, when it was transferred to its present location in the Regional Museum of the City of Toluca.

In this section, I will present an iconographic analysis of the *huehuetl* that will help to prove and reinforce the arguments about the meaning and function of the archaeological site of Malinalco that were already discussed. My analysis will be based on the foundations of four very fine studies of this magnificent musical instrument, which are: Eduard Seler (1960), José García Payón (1974), and Javier Romero-Quiroz (1958, 1980).

This *huehuetl* (vertical drum) contains the date Nahui-Ollin (4-Movement). The *ollin* symbol was used to represent the movement of the Sun and the dynamic life of the world. From the word *ollin* derives *yollotl* (heart) and *yoliliztli* (life) (Molina 1970:Part II:40). Inside this particular *ollin* symbol is a ray emanating from a solar eye and a *chalchihuitl* (precious stone) (García Payón 1974:62). The Sun was considered to be the "Shining One," the "Precious Child," the "Jade," and "Xiuhpiltontli" (Turquoise Child). The date Nahui-Ollin alludes to Ollin-Tonatiuh, the

Sun of Movement, the present world that will be destroyed by earthquakes, and to the festival of Nahui-Ollin, described by Durán (1967:Part II:105–108), in which the messenger of the Sun was sacrificed.

To the right of the date Nahui-Ollin, the artist carved the outstanding figure of an *ocelotl* (jaguar) and to the left a *cuauhtli* (eagle), both dancing. These images represent Cuauhtli and Ocelotl warriors, distinguished orders of the Aztec army. These warriors carry the flag of sacrifice (*pamitl*) and wear a headdress with heron feathers (*aztaxelli*), a symbol of hierarchy (Romero-Quiroz 1958).

In the lower sections that support the *huehuetl*, there are two more jaguar warriors and one eagle warrior. From the mouths and beaks of the warriors and around their paws and claws appears the glyph Atl-Tlachinolli, or Teuatl-Tlachinolli, which means "divine water (blood)-fire"; it signals the call of war and is sometimes represented as a song and dance of war (Seler 1960). Atl-Tlachinolli is expressed as a metaphor in sculpture, carvings, and the codices as two intertwined rivers, one of water and the other of fire. The stream of water ends with pearls and conches, while the stream of fire ends with the body of the *xiuhcoatl* (fire snake), who is emitting a flame.

All the warriors depicted on the *huehuetl* have in one of their eyes the sign *atl* (water), which indicates that they are crying while they sing. This sign reveals the duality of feelings before the sacrifice. One of the jaguar warriors has behind a paw the sign *atl* combined with an *aztamecatl* (rope), indicating that he is a *uauantin* (captive striped in red) who will be sacrificed on the *temalacatl* stone (Durán 1967:Part II:Chapter 9). This recalls the image of the warrior carrying a rope in the mural of Temple III of the site. The *cuauhtli* warriors have obsidian knives (*tecpatl*) hanging among their feathers, symbols of human sacrifice.

A band divides the two parts of the *huehuetl* and portrays shields (*chimaltin*) with bundles of cotton and arrows (*tlacochtli*), sacrificial flags (*pamitl*), and a continuous stream of the glyph Atl-Tlachinolli (Seler 1960). All of these are metaphors of war and sacrifice.

Interestingly, the *huehuetl* represents a real event in Malinalco: the festival of Nahui-Ollin, which included eagle and jaguar warriors singing, dancing, and crying. It ended with the dance of the messenger of the Sun who would be sacrificed. This event is depicted in the drum through images of *Cuauhtlehuanitl* (Rising Sun) and *Cuauhtemoc* (Setting Sun) (Durán 1967:Part II:105–108; Romero-Quiroz 1958:155; Sahagún 1975:Book II:Chapter 19:94, Appendix 5:171, and Book VI:Chapter 11:328).

The Sun was considered a young warrior that every day at dawn fought in the heavens to defeat the darkness, stars, and moon (*metztli*), using the *xiuhcoatl* as a weapon. In this way he ascends to the zenith, preceded by Tlahuizcalpantecuhtli, the morning star (Venus).

At dusk, the Sun, preceded by Xolotl, the evening star (Venus), sets in Tlillan Tlapallan, the Land of the Black and Red, and descends to the underground transformed into a jaguar to illuminate the world of the dead. The next dawn, in an endless cycle, he will repeat his cosmic fight to bring a new day to humankind (Seler 1960).

On the center of the *huehuetl,* Cuauhtlehuanitl's face is emerging from the beak of the eagle and he has a turquoise (*yacaxihuitl*) in his nose. Under his chin appears the sign *cuicatl,* which indicates that the deity ascends singing. The feathers of the eagle are stylized in a way that resembles the precious feathers of the quetzal (Seler 1960).

Cuauhtlehuanitl is accompanied by the *xiuhcoatl* (fire snakes), who carry him during his daily cycle. They are also the embodiments of the solar rays. The representation of the heads of the *xiuhcoatl* featuring open mouth with fangs, solar eye, and a horn can be seen (Romero-Quiroz 1958). One of them has a realistic shape, while the other is portrayed with more abstraction, but shows the same characteristic elements.

The quality of the Aztec sculpture and carving applied to this *huehuetl* is so precise and refined that it is comparable to the amazing and powerful expression of the codices. The images shown by this musical masterwork confirm and complement the discussion about the function and uses of the *cuauhcalli* (Temple I).

Teponaztli of a Feline

The *teponaztli,* a horizontal type of drum still in use today, was another popular instrument used by the Aztecs. The drum is a sort of double-tongued xylophone. The tongues are made out of slits positioned in a hollowed piece of wood that works as the sound box. Sticks with rubber tips served as hammers to hit the tongues, thereby producing the tones and melodies of the drum. A *teponaztli* from Malinalco is in the National Museum of Anthropology in Mexico City. After the Spanish conquest, the missionaries prohibited traditional indigenous ritual practices, and they often destroyed artifacts belonging to those rituals, so it is fortunate that this *teponaztli* survives.

The animal carved on this horizontal drum is either a crouching coyote or a type of jaguar with its tail next to its left side. It could represent the *nahualli* (soul or double) of a coyote or jaguar warrior; however, the curls on the head of the animal have led some scholars to identify it as an *ahuitzotl,* or a "water-thorn beast," possibly a water possum (Alvarado Tezozómoc 1944:Chapter LXI:269–270). Amazingly, this horizontal drum still has the original canine teeth and molars placed inside the mouth to make the animal look more realistic and ferocious.

This *teponaztli* points to the military and sacrificial nature of the rituals performed at the site.

Conclusions

The sense of mystery that is experienced at the site of Malinalco is very intense: nowhere else does Aztec architecture provide such a dramatic impression; the visitor is enclosed in an area polarized by overwhelming strength. Mysticism is associated with exaltation. Malinalco is a *cuauhtinchan,* an eagle's nest, where the sacred landscape integrates with the presence of humans who try to understand the meaning of life. Malinalco is the place where the three levels of the Cosmos unite: the Sky, the Earth, and the Underworld. López Austin (1988:I:272) says: "In pre-Hispanic times the world was thought to be divided into two halves. The first was conceived to be the Father, the Sky, luminous, vital, fertile, hot. The other was the Mother, the Earth, dark, humid, the source of winds and rains, at the same time fertile and the place of death. The eagle symbolized the Sky; the tiger, the Earth." It can be seen from this conception, how the Aztec religion was the result of the convergence of two ancient cults: the astral and the agricultural. Thus, the Earth (Coatlicue) and the Rain (Tlaloc) were the supreme deities of the peasants; the Sun (Huitzilopochtli) was the supreme god of the warriors. In this sense, Malinalco is the place where the Sky and Earth meet. Temple I, the *cuauhcalli,* represents a cave in Coatepec (Snake Mountain) that leads to the womb of the Earth, where all fertility, life, and the Sun were born. It is the Earth itself, the place of the force of life, from where the myths about the origin of the Aztecs and the justification of their political power emanated. The Aztecs emerged from caves in the mythical Aztlan-Chicomoztoc region, then started their long migration until they reached Coatepec, the Snake Mountain, where the Sun (Huitzilopochtli) would be reborn from Coatlicue, the Mother Earth, and would establish his supremacy over all the celestial bodies and natural forces. The Sun and the Earth became the main givers of life, and the Aztecs revered and fed them with human blood, through sacrificial death, in order to continue providing their energy to the people and the universe.

Malinalco represents the culmination of the worship of war and death. It was the setting of sacrificial rituals and ceremonies of the eagle and jaguar warriors, as explained in our previous discussions. At the same time, it is the place where life sprouts from death, in the same way that the Sun rises in the sky every morning after he had died entering the earth the night before, and the seed dies in the earth to produce the life of a plant.

The strange silence and the intensity of the sacred landscape of Malinalco inspire to think of the creative power of the earth and the eternity of life. The eagles of the Sky speak about the Sun, and the capricious rock formations reverberate the words of the *Song of Huitzilopochtli:* "Yo soy Huitzilopochtli, el joven guerrero, el que obra arriba, va andando su camino . . . ! Nadie es igual a mí. No en vano me he puesto el vestido de plumas amarillas, porque yo soy el que ha hecho salir el sol" (Sahagún 1975:Appendix II:893). "I am Huitzilopochtli, young warrior chief.

None have equaled me. Not for nothing have I taken the cloak of yellow feathers. Through me had the sun risen." This is my translation based on the English translation of Anderson and Dibble in Sahagún (1951–69:Book II:Appendix:207).

Acknowledgments

I want to thank Jessica Christie for her insightful editing suggestions, and Erika Cabrera for the discussion of some of the arguments of this chapter.

6

The Map of the Province of Maní

A Record of Landscape and Northern Maya Lowland Concepts of Origin

Merideth Paxton

They moved among the four lights, among the four layers of the stars. The world was not lighted; there was neither day nor night nor moon. Then they perceived that the world was being created. Then creation dawned upon the world . . . Then a new world dawned for them.

—*Book of Chilam Balam of Chumayel,* p. 44;
(Roys 1967 [1933]:32, 101)

The Map of the Province of Maní, Yucatán, accompanies the Maní land treaty of 1557, which is the earliest known use of European letters to record Maya text (Roys 1943:175). The compositional organization of the map resembles a spatial diagram painted on pages 75–76 of the preconquest Yucatec manuscript that is known both as the *Madrid Codex* and as *Codex Tro-Cortesianus,* which can in turn be linked to Northern Maya Lowland beliefs concerning the origin of the universe. By studying the map of the landscape around Maní within the contexts of the Maya and European cultural perspectives, it can be shown that the colonial source most likely preserves vestiges of the same system of beliefs.[1] The basis of the comparison for the Maní and *Madrid* images is the characterization of space as a record of the apparent annual motion of the sun, the primary force in the creation of the first dawn and the resulting birth of the Maya world. Additionally, it is possible that this solar-based cartographic motif was applied in the Maya characterization of settlements in the landscape of the late prehispanic Yucatán peninsula.

Yucatec Maya Concepts of Origin

Key aspects of the Yucatec Maya beliefs concerning the origins of the world have endured over a long part of their history. Fortunately, several descriptions from the colonial period have survived to form bridges to prehispanic sources pertaining to this subject. The colonial documents include accounts by Spaniards who recorded their own observations and the comments of informants, and direct statements made by the Maya themselves in their own language. The ethnographic data pub-

lished by a series of investigators working even in recent years have further demonstrated the continuity of fundamental ideas. From these sources it may be inferred that the apparent motion of the sun has long been a primary organizing principle that underlies creation accounts and many other aspects of life in the Yucatec communities (see the contributions to this volume by Christenson and Aguilar-Moreno for examples of the incorporation of similar solar concepts by other Mesoamerican groups).

World Directions and the Creation of the Universe

The colonial Maya descriptions of the creation are found in several *Books of Chilam Balam,* each of which is typically named for the town where it is presumed to have been written.[2] Many more of these works are thought to have existed as late as the nineteenth century, but nine of the books are now available for study. The sources treat historical and religious subjects, including topics on astronomy, and they are regarded as a blend of material copied from preconquest hieroglyphic codices with information learned from Spaniards (Roys 1967 [1933]:3). Passages are repeated in several of the books, indicating the sharing of knowledge among towns (Barrera Vásquez and Rendón 1963 [1948]). Although the extant versions date from the early eighteenth through nineteenth centuries, it is clear that the texts were recopied over many years, as some of the phrasing in them has been traced to the sixteenth century (Roys 1967 [1933]:5–6, 186–187; see Gibson and Glass 1975:379–387 and Paxton 2001a for additional general discussion of these sources).

The clearest description of the beginning of the Maya universe is provided by the *Book of Chilam Balam of Chumayel* and parallel sections identified in the books from Tizimín and Maní (Roys 1967 [1933]:98–103). From this it is known that the Maya world has experienced multiple destructions and recreations that Thompson (1970:280, 338) interpreted as accounts of conflicts between celestial deities allegorically representing light (Oxlahun ti Ku, or Thirteen God[s]) and the gods of the underworld, night, and darkness (Bolon ti Ku, or Nine God[s]). In one destruction, it is stated that "the sky would fall, it would fall down upon the earth, when the four gods, the four Bacabs were set up, who brought about the destruction of the world" (Roys 1967 [1933]:99–100). Although the meaning of this passage is somewhat ambiguous, it can be understood from other information that the function of the *bacabs,* who were placed at the four corners of the earth, was to support the sky (Thompson 1970:276–280). The destruction mentioned here must have occurred because they had ceased to perform their duty. It was this circumstance that had preceded the scene of darkness, with "neither day nor night nor moon," that is described in this chapter's epigraph.

A central theme that runs throughout the discussion of world destruction and re-creation in the *Books of Chilam Balam* is the five Maya directions. Once the new creation had dawned, the directions and their symbolic colors were reestablished. From other parts of the Chumayel (Roys 1967 [1933]:64–65) and this particular

section, it is known that these units consisted of a center sector (green) with perimeter areas: east (red), north (white), west (black), and south (yellow). Along with the *bacabs* mentioned above, each division of the Maya universe was additionally marked by a tree of the appropriate color that was occupied by a correctly colored bird. From his study of colonial Yucatec documents Restall (1997:190) has generally concluded that the cardinal directions were central to the Maya vision of land, and that this outlook has been retained into the twentieth century.

The *Book of Chilam Balam of Maní* is preserved in a work known as the *Pérez Codex,* which is a compilation of old papers that were copied near Maní around 1837 by Juan Pío Pérez. Although the documents he relied on are not precisely identified, it is certain that the assembly preserves at least one fragmentary *Book of Chilam Balam,* and possibly parts of two others (Gibson and Glass 1975:383). From the main Maní CB in the *Pérez Codex,* it is known that the idea of the world directions with related markers was accepted in the Maní area, because all five are mentioned. In the account of the world destruction and re-creation that parallels the Chumayel text, it is noted, for example, that "after this cataclysm the red Imix tree was erected, for it is one of the supporters of heaven and the sign of dawn" (Craine and Reindorp 1979:119). As the red color indicates, this tree would have been associated with east.

Other sources show that use of the world directions is widespread across time and space in Yucatán. The *Relación de las cosas de Yucatán,* attributed to Fray Diego de Landa and dated to around 1566, mentions the four *bacabs* and their function as supporters of the sky, as well as their associations with the directions, colors, and calendar (Tozzer 1941:135–142). This *Relación* does not specifically comment on Maya practices concerning the center direction, but as will be shown in the following discussion, the sector served as the benchmark for definition of the perimeter divisions. The four directional trees are also illustrated on pages 30c–31c of the prehispanic *Dresden Codex,* which is commonly thought to have originated in Yucatán (Paxton 1986; Thompson 1972:102–103, 16). The directions are also basic to the prehispanic *Madrid Codex* (further discussion follows).

As Villa Rojas (1988) has recorded, the definition of the world directions in the modern Maya settlement of Xcacal and many other communities derives from the tracking of the apparent annual motion of the sun, because east and west are regarded as the locations of sunrise and sunset. From the perspective of a stationary observer it seems that these oscillate along the eastern and western horizons between the dates of the solstices. This apparent motion can be represented as an x-shaped pattern in which the observer occupies the crossing point and the solstice limits of sunrise and sunset fall at the four outer corners (Figure 6.1). According to current usage the cardinal points are recognized, but not to the exclusion of the remaining faces of the horizons. While east and west are the segments determined by the solstice sunrises and sunsets, the remaining terrain constitutes north and south. The fifth direction, the crossing point, is also formally recognized.

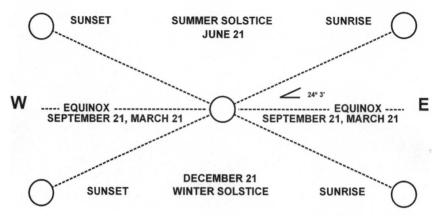

Figure 6.1. The world directions according to the modern Yucatec Maya. After Villa Rojas (1988).

The modern Yucatec Maya directions follow the earliest known Spanish record of the explanation of the Maya concepts for east and west, which was made between 1606 and 1631 by Bernardo de Lizana (quoted in Tozzer 1941:16n94; for further discussion, see Paxton 2001b:17–23). From the statement in the *Book of Chilam Balam* mentioned above, that the red Imix tree was erected in the east as one of the supporters of heaven and the sign of dawn, it is clear that this system was followed in colonial Maní.

The *Tzol Peten* and World Origins

Beyond the direct references to the creation that are found in the *Books of Chilam Balam,* there is a section in the Chumayel CB that Hanks (1988:353–355) has interpreted as pertaining to this event.

Ca Yumil	Our father
Ti Dios	Who is God
Lay tzol peten	It was he who ordered the country
Lay sihes y okol cab t u lacal	It was he who created the whole earth around
La yx tzol xan	They too counted (ordered)
He ob la e	Those ones
Kabansah peten u *cah* ob	They were (in the process of) naming region(s)
Kabansah ch'een u *cah* ob	they were naming well(s)
Kabansah ca cab u *cah* ob	they were naming village(s)
Kabansah luum u *cah* ob	they were naming lands

Hanks (1988:351) views this as a description of parallel performances by God and members of the Maya nobility of the *tzol peten,* a term that he has translated

as " 'counting out, ordering, explaining' [the] 'country, island, region.' " *Tzol* is a component of the word *tzolkin,* the count of 260 days that is one of the basic components of the Maya calendar system. Hanks (1988:354) has pointed out that in this instance the term *tzol peten* is linked with the causative formation of *sih* (to be born, given as a gift).

The context in the Chumayel CB of the section translated above is the description of a survey of land around the town. It consisted of a series of visits made by members of the Maya nobility to places where naming rituals were performed. In a seminal article Coe (1965) some time ago emphasized the importance of the calendar in the political and spatial organization of prehispanic Maya communities. Hanks (1989:100n8) has also noticed that the Chumayel *tzol peten* is related to calendrical cycles, as has Edmonson (1986:27–29), who further saw these surveys as a model for modern ritual observances. Restall (1997:191) has observed that the colonial Yucatec land descriptions he studied list places in circular sequences, and that they show a strong preference for the counterclockwise direction.

Other investigators have also commented on the importance of counterclockwise motion in recent Maya processions. In the modern Yucatec settlement of Yalcobá, for instance, ritual processions are led by a Maya priest who carries a monstrance marked with sunburstlike lines that radiate from a circular center. As he holds the solar symbol he walks a counterclockwise square path, which represents the apparent annual motion of the sun drawn on the horizontal surface of the land, around the perimeter of the ritual space (Sosa 1985, 1989).

Creation and a Map of Ideal Space in the *Madrid Codex*

The painting on pages 75–76 of the prehispanic *Madrid Codex* (Figure 6.2) is often cited as a clear statement of the relationship between components of the Maya calendar and geographic space. The calendrical elements include a sequence of large dots representing the 260 days of the *tzolkin,* arranged to form a motif that resembles a Maltese cross. This sequence is divided into 20 subunits consisting of sets of large dots (the number in each unit varies, but is approximately 12) and a named *tzolkin* day. The x-shaped division of the composition in combination with a center sector resembles the pattern derived from sunrise and sunset observations between solstices, and the glyphs of the perimeter directions are included. The footprints that connect the center area with the outer corners suggest the ritual of the *tzol peten.* Moreover, the principal deities of the scene, paired in three vignettes along the east–west axis, have previously been recognized as a creator couple.

Provenience and Date of Painting

No known documents describe the circumstances surrounding the acquisition of the *Madrid Codex* from the Maya who produced it or its removal to Europe. The

East

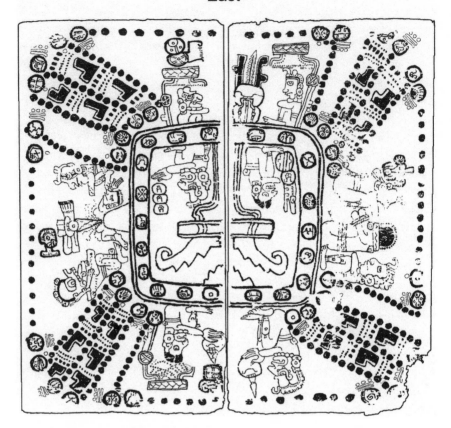

Figure 6.2. Pages 76–75 of the *Madrid Codex,* oriented with east at the top. After Anders (1967) and *Los Códices Mayas* (1976).

theory that was most commonly followed during the twentieth century, developed from a study of the content of the manuscript, is that it came from Yucatán. The leading advocate of the view was J. Eric S. Thompson (1972:16), who had previously considered the possibility that the codex might have been obtained in the Petén around 1697. He thought it could have been collected at Tah Itzá (Tayasal), the last Maya polity to experience military conquest after the general Spanish victory (Thompson 1950:26). However, because of the particular set of yearbearers used in the codex, he subsequently concluded that the most likely place of origin was the west coast region of the Yucatán peninsula. The accompanying working assumption was that the document was also prehispanic.

 Late in the twentieth century the question of Tah Itzá provenience was reopened by Michael Coe (in Coe and Kerr 1998:181), and by James B. Porter (1997:41, 43); both of these proposals have led to a reconsideration of a post-European con-

tact date of painting. Coe remarked on the possible incorporation of European paper in pages 1/57 and 56/112[3] of the screenfold, and Porter identified some of the items in the illustrations as Spanish. It has since been established that the European paper is attached to the codex, not integral to it (Bricker 2004), and that the objects thought to derive from the material culture of the colonial period have prehispanic counterparts (Graff and Vail 2001; Paxton 2004a). Additional reasons for associating the *Madrid Codex* with Yucatán have been provided by Chuchiak (2004) and Paxton (2004a).[4]

Orientation and Basic Structure

Facsimile reproductions of the *Madrid Codex* conventionally show the spatial diagram with the west side at the top. Nevertheless I have proposed that, despite the fact that this places two of the three pairs of deity figures on the east–west line in an upside-down position, it is more likely that the east side of the universe should be at the top. This conclusion is partially drawn from the relationship of pages 75 and 76 to the adjoining pages 77 and 78. These are clearly inverted with respect to the remaining pages on their side of the screenfold, which argues that pages 75 and 76 are also.

The *Madrid Codex* is also known as the *Tro-Cortesianus* because it is broken, between pages 77 and 78, into two pieces that were once referred to as the *Codex Troano* and *Codex Cortesianus*. These were owned separately and thought to be unrelated. León De Rosny realized that the two fragments are from the same source because the last page of one section (*Troano,* now *Madrid* p. 78) lists part of a sequence of 13 *tzolkin* days that is continued on the first page of the other (*Cortesianus,* now *Madrid* p. 77). There is no doubt that the reading of page 78 precedes that of page 77. The content of the double-page illustration of the world directions attached to page 77 is related to the *tzolkin* sequence and other subjects presented in this table of dates, not to the material on the page attached to its opposite side (page 74).

In addition to the sequence of 13 *tzolkin* days, the table on pages 78–77 shows glyphs for the directions. Further, it depicts offerings that resemble one in the center sector (southeast corner) of pages 75 and 76. Page 74 is not apparently related to the page 75–76 diagram, as it shows, in the lower section, deities making pottery and, in the upper register, personages with imbedded numbers that bear no obvious connection with the diagram of the universe.

The thematic relationships indicate that the four pages form a section that should be read in the following order: 78, 77, 76, 75. Since pages 78 and 77 are clearly upside down in comparison with the remainder of the side, pages 76 and 75 are as well. This orientation places east at the top, which is in accordance with other Maya calendrical diagrams, as may be seen from the *Book of Chilam Balam of Chumayel* (Roys 1967 [1933]:Figure 28, on p. 132). The *Codex Pérez* from

Maní also preserves one of these diagrams with east at the top (Craine and Reindorp 1979:176), and its center shows a geometric form that was almost certainly intended as an illustration of the five world directions.

The M76–75 painting follows the pattern identified by Thompson (1970:196), in which east is always the most important Maya direction, and ancient Maya maps usually had east at the top. Perhaps this was for the same reason as that provided by the modern residents of Yalcobá, Yucatán, who regard east as the primary direction because the seasonal rainstorms and everything provided by Hahal Dios (the Sun) moves from *lakin* (east) to *chikin* (west) (Sosa 1985:374, 378).

Madrid 76–75 and Creation Motifs

Although the organization of space on pages 76–75 of the *Madrid Codex* is similar to that derived from observation of the apparent motion of the sun over the course of the tropical year, the correspondence is not exact. The duration of the solar year is 365.2422 days, but the interval of the Maltese-cross-like *tzolkin* representation is only 260 days. Nevertheless, this difference does not cast doubts on the directional interpretation of the M76–75 painting because there is a representation of the *haab* (comprised of a *tun* of 360 days, with a period of five days without names at the end) in the scene. This 365-day interval is the closest approximation to the solar year that is possible in the prehispanic Maya numerical system, which did not include fractions.

There are 18 footprints in the diagram, shown on paths that angle from the center to the corners. These paths are outlined by large dots from the Maltese-cross-like *tzolkin* motif. The 18 footprints symbolize the 18 periods of 20 days each that form the *tun*. A series of small dots outside the line of the Maltese-cross-like form, in the southeast corner, probably indicates the five-day *uayeb* (Paxton 1997, 2001b:33–42). This interpretation is supported in part by the general prehispanic Maya perception of the passage of time as a journey made on foot (Thompson 1950 [1960]:248), and by Yucatec terminology. The word *oc* means not only foot, footprint, and one who travels by foot ([ah] ok),[5] but is also a suffix meaning to count by foot (Barrera Vásquez et al. 1980:594–595). The latter concept, of course, recalls the counting and ordering of the land through the *tzol peten* survey. Álvarez Lomelí (1980:26, 85) has mentioned that the phrase *hun y-oc chek kin* means that the sun is a step from either rising or setting.

Additionally, a description in the Chumayel CB relates how "it was called counting off of the whole earth, *lacha* (12) Oc. This was the count, after it had been created [by the day] 13 Oc, after his feet were joined evenly, after they had departed there in the east" (Roys 1967 [1933]:116). The day Oc is part of the *tzolkin* sequence, and the interval from 12 Oc to 13 Oc is 40 days; hence, each of the two footprints mentioned in the text represents 20 days. Although this Chumayel section on the creation of the *uinal* (period of 20 days) occurs in the calen-

drical context of the *tzolkin,* it is certain from overall usage in the *Books of Chilam Balam* that the concept also applies to the 20-day intervals of the *haab* (see Paxton 2001b:41–42, 2004b for further discussion).

As noted above, the principal deities in three scenes along the east–west axis of M76–75 are the sun god and the moon goddess. This identification is based on the research of Thompson (1970:205, 236–237), who saw the center figures as a creator pair. He recognized one of the deities as Itzamna, God D of the codices, whom he thought of as another aspect of God G, the sun god. Despite the inclusion of male attire, Thompson was certain that the second deity in the center section is female. I have previously argued that this assessment is correct (Paxton 2001b:145–149). Thompson (1970:233–235) reported wide acceptance of the sun and moon as a spousal pair among the modern Maya, and the *Madrid* goddess has been recognized as Goddess O, a deity with lunar associations (Ciaramella 1994; Milbrath 1999:141–147; Vail 1996:148, 150). It is my view that the sun god and the moon goddess probably represent the two most important creative forces in prehispanic Yucatec beliefs. Just as there are reasons to link the *haab* cycle that is fundamentally expressed as footprints with the sun god, the 260-day *tzolkin* can also be associated with the moon goddess (Paxton 2000, 2001b:45–61).[6]

Surviving Yucatec sources do not specifically connect origin beliefs with landscape in the sense that there is no mention of a particular place, such as an actual cave of emergence, from which the original humans populated the earth. As discussed earlier, the world creations and destructions are presented in the *Books of Chilam Balam* as constructions and collapses of the directions (note parallels with Aztec beliefs, Chapter 5, and Navajo beliefs, Chapter 2, both in this volume). Although the *Madrid* spatial diagram does not include written names of individual towns, the same directional orientation of space has been recognized at the ruins of numerous prehispanic settlements in Yucatán (e.g., Carlson 1981:185; Kowalski 1999).

I have recently proposed (Paxton 2001b:115–135) that the solar-based system of demarcation could have been applied on a larger scale to designate regional settlement symbols according to a center sector located at Chichén Itzá. The Sacred Cenote there, which was a major pilgrimage site even after the arrival of the Spaniards, may have functioned with the Castillo to mark the center sector. If such was the case, the marker for the beginning of east (winter solstice) would have been Tulum, and the primary marker for east (vernal equinox) would have been Cozumel Island. This general interpretation is consistent with ethnohistorical and iconographic information pertaining to the three settlements that has been preserved. It is known, for example, that a temple dedicated to Ix Chel, a goddess of fertility and the moon, widely attracted pilgrims to Cozumel (Paxton 2001b:50–51). Because less is known about the occupations of the remaining settlements that may have functioned in the system, it is not now possible to establish unequivocally that

the preconquest Maya recognized it. Nonetheless, the interpretation is consistent with traits associated with the center and two of the three potential markers for the most important direction in Maya thought, the east.

The Map of the Province of Maní

No prehispanic maps that identify geographic locations of the Yucatán peninsula by name are known to survive. However, as the Map of Maní was painted in 1557, only 15 years after the Spanish gained dominance and the capital of Mérida was founded, it may provide insights into the nature of mapping practices in preconquest Yucatán. Unfortunately the original drawing has been lost, but its content has been at least partially preserved through copies. Two of these suggest that some components can be interpreted according to the solar-based directional system incorporated in the map of ideal space found on pages 76–75 of the prehispanic *Madrid Codex*.

Description

Spanish contact with Maní initially occurred toward the end of the first phase of the conquest, around 1528–1529, when the Europeans passed through the settlement and were received peacefully (Chamberlain 1948:41, 60, 137–138). The allegiance of this Maya group was important to the success of the military campaign that established Spanish dominance over a large area of the peninsula and allowed the founding of Mérida in 1542 (Chamberlain 1948:202, 213). At the time of the conquest, territorial disputes, including one between the provinces of Maní and Sotuta, were common. While such divisions may have been expedient in the fight to gain control of the land, the Spanish promoted peace and greater stability once their authority seemed clear (Roys 1943:178).

It was the effort to settle old territorial disagreements that led to the 1557 treaty, including a *tzol peten* and map. Once the consensus had been reached, the resulting treaty was held by the local governor, Don Francisco de Montejo Xiu (formerly Kukum Xiu), and consulted even into the nineteenth century. The *Códice de Calkiní* (1957:112–115), written in Mayan, records a visit made by a group of area caciques on November 20, 1821, to the "great archive of Don Francisco Montejo Xiu" in Maní. There the caciques found the map and "truly saw where their lands and woods ended."

The text of the treaty exists in several variants, and the map is now known through three basic versions (see Riese 1981 for analysis of their relationships). The most detailed map (Figure 6.3) is associated with a July 10, 1596, copy of the agreement now at the Latin American Library at Tulane University (Roys 1943:179, Figure 18). The unit also includes the Maya text of the treaty and a later translation to Spanish. The Tulane copy is circular in format, with a series of perimeter

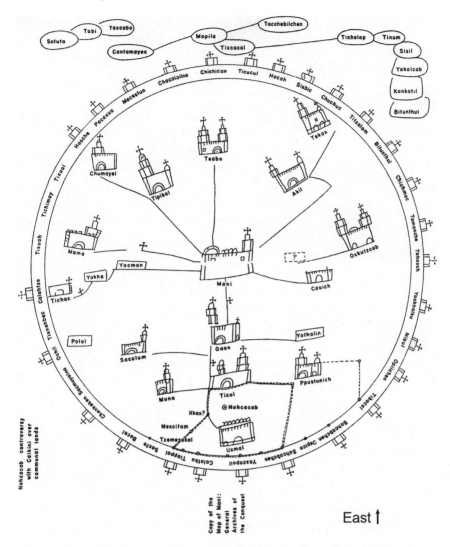

Figure 6.3. Map of the Province of Maní, oriented with east at the top. From drawing and translation published by Roys (1943), made from 1596 copy held by the Latin American Library, Howard-Tilton Library, Tulane University.

features marking the outer edge, and it is oriented with east at the top. The largest town is Maní, shown in the center of the document. It is connected to other settlements by eight lines (roads?), the first of which runs eastward to Teabo. Moving counterclockwise around the circle, the second line angles toward the northeast and Chumayel, and a third (with a slight break) leads toward Mama and the north. The fourth line, which passes through two towns, leads to Tichac, to the northwest of Maní. The fifth goes westward to Dzan and ultimately the archaeological

site of Uxmal, symbolized by a sketch that probably represents part of the Palace of
the Governors. Line 6 extends to the southwest and Cauich. The map most likely
shows a seventh line toward the south that would connect Maní with Oxkutzcab,
but the link is not certain because of the deteriorated condition of the copy. The
eighth line leads to Akil and Tekax in the southeast.

A second copy of the Map of Maní (Figure 6.4), made in the town on March 28,
1842, was published by John L. Stephens (1963 [1843]:2:Plate 25) in 1843. At
the time he saw the document, it was in the local archive at the Casa Real. It had
become detached from a volume that he described as "ancient and venerable in ap-
pearance, being bound in parchment, tattered, and worm-eaten, and having a flap
to close like a pocket-book" (Stephens 1963 [1843]:2:170–171). Naturally this
has led to speculation that the copy published by Stephens is from the now-lost
original.

The illustration printed with Stephens's account of his travels in Yucatán was
drawn by the then-priest (later bishop) from nearby Ticul, Crescencio Carrillo y
Ancona, at the request of Juan Pío Pérez. Pérez had been dissatisfied with the ac-
curacy of the first copy that he had seen, and Stephens (1963 [1843]:2:171) com-
mented that Carrillo had consequently made "exact copies of the map and docu-
ments." The features of the map are generally consistent with those of the 1596
copy, and the missing sections of the road mentioned above are shown as having
been connected. The roads of both copies establish east–west and north–south axes
as well as intermediate angles.

The third copy of the map (reproduced by Gates in Landa 1937:133 and Roys
1943:Map 5, Figures 19 and 20) and a copy of the treaty are in the Xiu Chronicle,
which contains dated entries ranging from 1608 to 1817 (Gates in Landa 1937:
121). Although it is oriented with east at the top, this version is rectangular in for-
mat and does not include the sections of road from Maní to Teabo in the east and
to Akil and Tekax in the southeast. Because it is regarded as more Europeanized in
interpretation, the rectangular copy is not considered further here.

<div align="center">

Comparison of the Map of Maní and
the *Madrid* Map of the Directions
</div>

The first two copies of the Map of Maní have similarities to the *Madrid* 76–75
spatial diagram that suggest extension of the prehispanic definitions of the direc-
tions into the colonial era. Both images have center sectors with perpendicular
east–west and north–south axes extending from them. The eastern halves of the
circular Maní maps additionally have lines (roads?) that recall the paths that on
M76–75 angle toward the corners of the diagram to mark the solstice positions on
the eastern and western horizons. Although they are in some cases drawn at shal-
lower angles, the western halves of the colonial maps also have lines that are remi-
niscent of the M76–75 solstice paths.

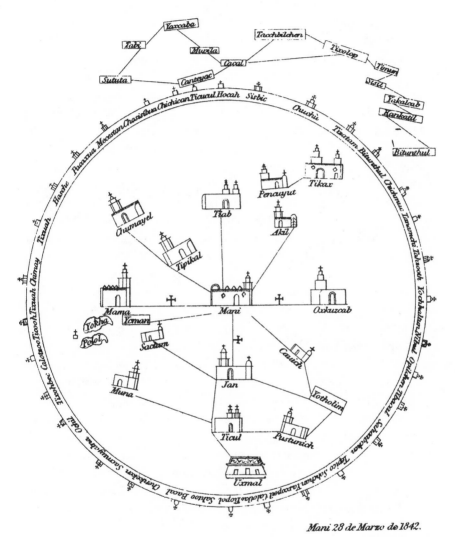

Figure 6.4. Map of the Province of Maní, as published by Stephens 1963 [1843]. Oriented with east at the top.

On the 1842 Stephens map, the southwest line that angles toward Cauich resembles the connection between center and solstice corner more closely than that of the 1596 copy. It is possible that the cartographer for the 1596 map understood that the angles in the western half represent paths to towns marking the solstice corners with respect to a center located at Maní, but shifted them upward to provide more space for symbols of Uxmal and its immediate environs. The oral history of the rulers of Maní, members of the Xiu dynasty, relates that upon arriving in Yucatán they first settled in Uxmal (Roys 1943:175). This suggests that the composition could have been adjusted to allow visual emphasis of a key place in Xiu history.

A further reason for greater elaboration of the lower west area of the map comes from the scribe (notary) who produced the 1596 copy of the treaty. He commented that it was made at the request of two towns, one of which was Ticul (Roys 1943:186). Presumably Maní was the other town to which he referred. The lower portion of the late sixteenth-century copy does seem to present a second cluster of locations centered at Ticul with cardinally oriented lines (routes?) to subsidiary boundary settlements: Pustunich (south), Dzan (east), Muna (north), and Uxmal (west). The related verbal description mentions confirmation of the 1557 boundary survey by Judge Felipe Manrique and his arrival at Uxmal, as well as a 1588 agreement between Ticul and Pustunich (Roys 1943:187, 190). These events are evidently incorporated in the 1596 map copy. Because the secondary boundary information is not drawn on the Stephens illustration, it seems likely that it more closely resembles the original 1557 map. This supports interpretation of Cauich and the line connecting it to Maní in terms of solar-based cartographic convention.

Comparison of both Maní map copies with the locations of settlements as determined by twentieth-century techniques (Figure 6.5) establishes that the colonial sources show differences that apparently reflect Maya perceptions of their surrounding landscape. Teabo is almost due east of Maní, as the early versions indicate. Tipikal and Chumayel are to the northeast, in locations that correspond approximately with the Maya maps, but Mama is in fact built farther east and at a more acute angle. The actual placements of Yacman/Tichac (northwest), Dzan (west), and Cauich (southwest) do correlate reasonably well with solstice boundary symbolism and the west cardinal point. However, Oxkutzcab is considerably farther to the southwest of Maní than the Maya maps indicate. Akil and Tekax are approximately as drawn. Thus it seems plausible that the places surrounding Maní either actually correspond with the cardinal directions and solstice corners, or they are shown in these positions.[7]

Comparison of the actual locations of the second cluster of settlements, drawn around Ticul on the 1596 copy, establishes that Dzan and Uxmal could credibly serve as drawn as markers for the east and west cardinal points. Interestingly, the

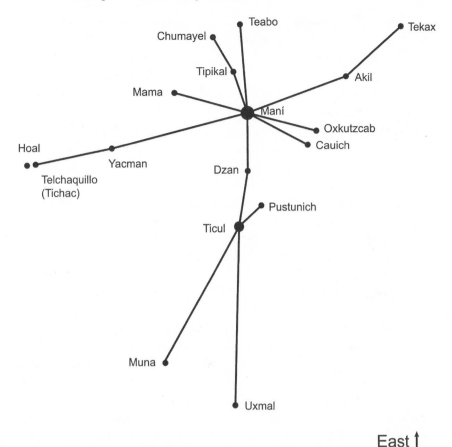

Figure 6.5. Relationships among principal settlements shown on the Map of the Province of Maní, as determined by twentieth-century techniques. After Roys (1943).

depictions of Muna and Pustunich on the map, along a north–south axis, are at considerable variance with their actual placements.

The Circular Map in European Cartography

Although the Map of Maní resembles the plan of the world directions that is painted on pages 76 and 75 of the *Madrid Codex,* a history of circular maps exists in Europe, and the possibility of influence on the document from that direction cannot be overlooked. The European tradition dates from a Babylonian example that has been attributed to the sixth or seventh century B.C. (Brown 1949:right map, opposite p. 38). The greatest popularity of the format occurred during the Medieval period, with the elaboration of T-O maps. These maps are characterized by a T-shaped form, representing the three main waterways of the world, inscribed

in a circle. The areas outside the T are filled by the three continents known at the time, Asia, Europe, and Africa. Although this organization of space was probably developed in the fifth century B.C., its greatest elaboration was by Isidore, who lived from A.D. 570 to 636 and was Bishop of Seville. His conception, as shown by the map of the world from his *Etymologies* (Brown 1949:opposite 103), was oriented with east at the top. Isidore's maps feature biblical as well as secular place names and typically locate Jerusalem in the center of the world.

The placement of the most important Christian city in the center of the map was based in scripture, and additionally followed a convention of long duration. The ancient Greeks placed Greece in the center of the known world and Delphi in the center of Greece. Jerusalem remained in the centers of maps until around 1450, when the discoveries of Marco Polo and others had to be acknowledged. These explorers had established that Asia must be enlarged, and therefore Jerusalem had to be located east of the map center (Brown 1949:96–97). The Christian perception of the world continued to be expressed in circular maps with east at the top as late as the 1475 mappa mundi in the *Rudimentum Novitiorum,* from Lübeck (Wood 1992:illustration on p. 68).

In a remark concerning the possibility of European influence on the Map of Maní, Roys (1943:184) stated his conclusions that the circular format and orientation with east at the top are Maya conventions that predated Spanish contact. The only circular European maps he knew depicted subjects—hemispheres or the entire world—that would have been naturally suited to this form.[8] For reasons other than those discussed here, Mundy (1998:210–212) and Restall (1997:200) have also concluded that the circular form of the Map of Maní is of preconquest Maya origin. My own survey of circular maps generally supports Roys on this point as well, and shows that by the sixteenth century the standard directional orientation was with north at the top. Certainly, I did not find any European maps that feature centrally located towns with roads radiating toward the cardinal points and solstice corners.

Making the Map of Maní: The Land Survey

As noted above, the Map of Maní is the visual record of a boundary-marking process that is also described verbally. The treaty information is known only through copies, primarily those preserved in the Xiu probanzas, the 1596 version at Tulane (with a Spanish translation made sometime during the 1750s), and a copy known as the Calotmul document because of an addendum that focuses on the settlement. The latter has been partially published by Stephens (1963 [1843]:2:172, 174), in the *Pérez Codex* (Craine and Reindorp 1979:182–187), and by Roys (1943:192–194). Although there are slight variations in these texts, Roys's (1943:178–179) comparison established that there is broad agreement regarding purpose. All the documents mention that high-level Maya officials representing various settlements

in the Maní vicinity gathered there to place crosses at the borders of the fields owned by the towns and their residents.

Although the impetus to settle the boundary claims came from the European-oriented colonial government, the survey does not appear to have been strongly influenced by Spanish norms. As stated in the Tulane copy, the Spanish judge, Felipe Manrique, and his interpreter, Gaspar Antonio Chi, went to Uxmal to confirm part of the boundary (Roys 1943:179). The names of the representatives given in the treaty copies are otherwise Maya. The earliest known accounts of the survey are in Mayan, not Spanish. It is stated that the participants (*batabs*) came from the four directions, which are listed in a counterclockwise circuit that began with the east. Further, the presentation of commemorative gifts, including cacao, cotton mantles, red beads, and green stones, is mentioned (Roys 1943:186), and it is notable that none of these items is obviously of European origin. This supports the idea that the maps of Maní incorporate the solar-based prehispanic directions. This is despite the presence of some obviously European traits, such as the portrayal of settlements as Christian churches.

Roys (1943:180) observed that there is agreement among the three copies on the starting location for the boundary survey. This was Hoal, a well just north of Tichac (the modern settlement of Telchaquillo). In the map, this is the winter solstice sunset position of the directional diagram currently under consideration. According to the Tulane copy, the surveyors then proceeded in the counterclockwise direction until they reached the Aguada of Nibul. This place is located about 8 km southeast of Hopelchen, Campeche, as appears to be shown on the map. Nibul is also aligned with the road to Cauich, which possibly symbolizes the winter solstice sunrise position in the directional scheme. However, instead of completing the counterclockwise circuit, the surveyors then returned to the initial point and moved in a clockwise direction to complete the remainder of the effort (Roys 1943:181). The description of the treaty survey is to some extent consistent with the directional scheme suggested by the arrangement of forms in the Map of Maní, but it is not entirely in agreement.

Summary and Conclusions

The prehispanic Maya of the Yucatán peninsula believed that their origins could be traced to a series of destructions and re-creations of the universe that were cast in terms of the ascendance of light over darkness. The most fundamental act of regeneration was the rising of the sun, which signified both a new day and a new world. Another crucial aspect of these creations was the founding of the world directions, with the concomitant erection of colored trees and other related symbols. The definition of the five directions was made in terms of the apparent path of the sun over the course of the tropical year of 365.2422 days (approximated in the

Maya mathematical system as 365 days). The system included the position from which the observations were made (center) and its surrounding perimeter area. The cardinal points were recognized, but the scheme was more expansive. East and west were regarded as the segments of the horizons limited by the places of sunrise and sunset on the dates of the solstices, and north and south were the remaining sides.

The painting on pages 75 and 76 of the *Madrid Codex,* a source that is arguably from Yucatán, provides a clear example of the connection between concepts of origin and the solar-based definition of the directions during the prehispanic period. The square diagram has a center sector and a surrounding area that is divided by four paths extending outward to the corners. Each of the four trapezoidal perimeter areas is labeled with one of the hieroglyphs corresponding to east, north, west, and south. The paths, in positions that emphasize the role of the solstices in making these divisions, carry a total of 18 footprints, each of which portrays a 20-day interval. These are accompanied by marks for another brief interval that probably refers to the *uayeb,* the five-day period at the end of the 365-day Maya *haab.* The divisions of the scene are also shown by a Maltese-cross-like outline of large dots and hieroglyphs that list the recycling sequence of the 260 days in the *tzolkin.* This sequence begins in the southeast (winter solstice sunrise) corner, developing around the image in the counterclockwise direction. Related content on two adjacent pages indicates that the *Madrid* illustration should be oriented with east, the most important direction in Yucatec Maya thought, at the top.

The five directional areas on M76–75 (this reading order follows from the orientation of the pages with east at the top) are occupied by pairs of deities. The most important of these, repeated in all three scenes along the east–west axis of the painting, are the sun god and the moon goddess. The figures have long been recognized as a primordial spousal couple. This illustration associates the 18 footprints that build the *haab* with the sun god and, along with additional evidence from other sources, strongly suggests that the moon goddess was the primary patroness of the *tzolkin.*

It is possible that during the Late Postclassic the directions shown on M76–75 were projected regionally across the Yucatán peninsula from a center sector at Chichén Itzá that was symbolized by the Sacred Cenote and its ritual companion, the Castillo. If this was the case, the cardinal settlement symbol for east could credibly have been Cozumel Island, where there was a temple dedicated to Ix Chel, a moon goddess and patroness of childbirth. This temple attracted pilgrims from a wide area. Tulum may have served as the beginning of the eastern face of the peninsula, the winter solstice sunrise position. Although there is not enough information to show that the remaining regional directional settlement symbols existed, the functions of the Chichén Cenote complex and two of the three places in the most important direction, the east, are consistent with the interpretation.

The prehispanic solar-based directional system, in which the passage of time is

related to the creation of space, continued in use during the Spanish colonial period and fundamentally underlies present Maya religion. The standard colonial land survey, the *tzol peten,* has been related to the directions, the calendar, and concepts of origin. This survey was a circuit of ritual visits made to places around the perimeter of a centrally located settlement that was frequently conducted in the counterclockwise direction. The Maní land treaty and the accompanying map of the province incorporate ideas from the *tzol peten.*

Unfortunately the original treaty and map are now lost. The two copies of the Map of the Province of Maní that preserve the most Maya content have compositions that resemble the spatial diagram on M76–75. Like the *Madrid* painting, they are oriented with east at the top. Further, they feature Maní as the central place and show lines (roads?) connecting the town with settlements in locations that correspond approximately with the cardinal points and the solstice corners. Modern mapping techniques establish that in some instances these Maya maps were apparently skewed to reflect indigenous perceptions of the locations of the subsidiary towns.

It is plausible that the images do incorporate diagrams of the directions. The composition of the treaty and maps occurred in 1557, only 15 years after the Spaniards gained dominance in the Yucatán peninsula and constructed their capital in Mérida. It is known from parts of the *Codex Pérez,* a compilation of copies of old Maya documents that was made near Maní around 1837 by Juan Pío Pérez, that the solar-based world directions were followed there. This evidence is found in a *Book of Chilam Balam of Maní* that describes the placement of the colored markers for the directions during creation and a calendrical diagram that also seems to derive from the solar-based cartographic scheme. Despite the obvious presence of European forms in these Maya maps, seen especially in the drawings of Christian churches and the writing that was used, the composition does not seem to have derived from European sources. By the sixteenth century the circular format with east at the top and the most important settlement in the center was no longer in use there. There was never a European tradition that featured lines from a central place to locations that correlate with the cardinal points and the corner solstice positions.

Comparison of the map copies with the treaty shows that the textual description of the 1557 *tzol peten* is only partially consistent with the images. Although some places listed can be linked to the solar-based directions, the survey procession did not, in this instance, complete the counterclockwise circuit that reflects the projection of the apparent annual motion of the sun on the ground. After part of the circuit was made in this manner, the participants returned to the starting point and proceeded in the clockwise direction. Nevertheless, the text indicates that the members of the procession were assembled according to the four perimeter directions, which are listed as a counterclockwise circuit. The earliest known copies of

the documents are written in Mayan, not Spanish, and the gifts of cacao, beads, and stones that were presented to the survey members seem to follow Maya tradition in that they do not include European objects. It appears that the map copies supplement the verbal information preserved in the treaty.

For the reasons summarized here, I propose that the circular copies of the Map of the Province of Maní incorporate the solar-based definition of the world directions and the Maya concepts of origin they imply.

Acknowledgments

I would like to express my appreciation to Dr. Hortensia Calvo, the director of the Latin American Library at Howard-Tilton Memorial Library, Tulane University, for the pleasant opportunity I had to study the *Crónica de Maní*. I would also like to thank Linzey Powers of the Tilton Library for her generous assistance in obtaining a copy of the document for further study. Mina Yamashita has provided indispensable technical assistance concerning the creation of the accompanying figures.

Notes

1. A preliminary version of this research was presented during the annual conference of the American Society for Ethnohistory that was held November 16–20, 2005, in Santa Fe, New Mexico.

2. As the word *chilam* means "mouthpiece" or "interpreter of the gods" and *balam* can be translated as "jaguar," this title may refer to the books of the jaguar priest. However, *Balam* is also a common family name in Yucatán, and the series may be named for a particular priest who is thought to have lived in Maní during the late fifteenth through early sixteenth centuries (Barrera Vásquez and Morley 1949:10, 12–13). The Maní *chilan* gained wide fame because one of his pronouncements was interpreted as a prediction of the arrival of the Spaniards, as is mentioned in the 1579 *Relación* of the town of Mérida (Garza 1983:69).

3. This notation refers to both sides of the same manuscript page.

4. Vail (2000, and in Vail and Aveni 2004:3, 12–13) has concluded that the predominant linguistic affiliation of the hieroglyphic text is Yucatecan, which includes Yucatec, Lacandón, Mopán, and Itzá. These languages are presently spoken over the Yucatán peninsula and in lowland Chiapas, Petén, and Belize.

5. The source cited here follows a slightly different but equivalent spelling of the word.

6. Hence the meshing of the *tzolkin* and *haab* in the painting symbolizes the Calendar Round. Additional units of small dots, also found on the corner paths, can be interpreted as a second illustration of the *tzolkin* that, with the footprints, forms a second image of the Calendar Round.

7. Roys (1943:181) learned that the places along the border were water sources: cenotes, wells, caves containing springs, ponds, and natural rock tanks.

8. Roys (1943:184) noted that a Spanish reference, made in 1600, to circular Maya maps called them "*pinturas,*" and that in the Maya translation they are "*pepet dzibil,*" or circular paintings or writings.

7 Ancestral Presence at the Navel of the World

Francisco Sojuel and Santiago Atitlán

Allen J. Christenson

The Tz'utujil Maya of the town of Santiago Atitlán believe themselves to occupy *r'muxux kaj, r'muxux r'uwachulew* (the navel of the sky, the navel of the face of the earth). It is one of the most beautiful places in the world, situated at the point where three great volcanoes come together (Figure 7.1). The town is built on a spot of land surrounded on three sides by Lake Atitlán. Far more important than the beauty of their community's location, however, is the profoundly held conviction on the part of the traditionalist Maya that they live in a sacred place. The volcanoes and surrounding mountains are the abode of gods and powerful ancestors (compare with Navajo beliefs, Chapter 2). The lake bears the primordial waters of creation, suffused with animative power capable of regenerating and sustaining life, as well as the capacity to destroy it. Traditionalist Maya priests continue to carry out rituals meant to perpetuate the world as mediators between this world and the world of the sacred. They believe that if they neglect to do this, the world will be unable to sustain itself and sink back into the waters of the lake from which it sprang, and darkness and death will shroud the world as it once did before the first dawning of the sun.

Nearly all world-renewing ceremonies at Santiago Atitlán begin with a long litany of sacred places (the sky, mountains, plains, large bodies of water, and such), sacred beings (Martín, the lord of the sky, the lord of the earth, the lord of the mountains, and many others), important saints adopted from Roman Catholicism into traditionalist theology (including the town's patron saint Santiago, San Francisco who is seen as a lord of the dead, San Gregorio as patron saint of Lake Atitlán, a series of 12–13 Marías who each have a distinct role and personality, and the like), and ancestors who set the pattern for the town's ceremonial observances. Preeminent among these ancestors stands Francisco Sojuel, credited with instituting many, if not most, of the ritual practices currently observed in Santiago Atitlán.

It is difficult to separate the mythic Francisco Sojuel from the man. But to do this is a very non-Maya way of looking at things in any case. For the Tz'utujils of

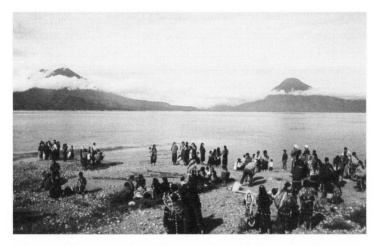

Figure 7.1. View across Lake Atitlán toward the town of Santiago Atitlán, located at the junction of the three volcanoes.

Santiago Atitlán, the life of Francisco Sojuel is inseparable from the myth. He is old enough to have known the ancient kings that ruled the area before the coming of the Spaniards, he contended with the first Spanish conquistadors, he was a renowned traditionalist priest a hundred years later when the Spaniards ruled from the old capital city of Antigua, and yet was also known to the grandparents of living Atitecos at the end of the nineteenth century (Christenson 2001:22–23; Mendelson 1957:488).

In preparation for a book that I was writing on the altarpiece in the town's sixteenth-century colonial church, I spent quite a few days making preliminary drawings of the monument. One afternoon an aged *ajkun,* one of several types of traditional priest working in town, sat down next to me and watched for a time as I drew. We eventually struck up a conversation on the altarpiece's origin. He told me that it was carved 2,000 years ago by Francisco Sojuel himself. He then went on to tell me that his grandfather had known Sojuel, who was a great sculptor and carved the altarpiece as well as many of the carved wood stone ritual paraphernalia and saints in the church and private cofradías around town. He pointed out a number of these around us in the church, including the altarpiece panel that I was drawing in my sketchbook. He added that when Francisco Sojuel worked he did not need to eat maize tortillas or tamales to live. Instead he fasted for long periods, working up in the mountains carving the gods' and saints' images, and weaving the sacred bundles. I asked when Francisco Sojuel had died and he replied 1907. Was the altarpiece and the other images that he had mentioned carved about that time? "Just so, in 1907, two thousand years ago when the Spaniards first came to Santiago Atitlán." This confusion over fixed dates reflects the Tz'utujil view that important events recur periodically (Bricker 1981:3–7; Farriss 1984:333; Mendel-

son 1965:93). For the elderly priest "two thousand years" is simply a way of saying that the altarpiece is so ancient that it predates the founding of Santiago Atitlán. It therefore belongs to mythic rather than historic time, to an age when semideified ancestors like Francisco Sojuel set the pattern of many aspects of Atiteco worship. It matters little that the historic Francisco Sojuel died about 1907, because this was only one of his manifestations. Sojuel the ancestor has the power to endlessly create and re-create sacred objects that give life and meaning to the Tz'utujil people. Because he lived, and continues to exist and influence events in Santiago Atitlán, the place is considered a sacred focal point for life itself. According to Mendelson, "very few names were mentioned as frequently during my stay in Atitlán as that of Francisco Soxuel. . . . Let it be said that scarcely a ritual could be watched, let alone discussed, without some mention of this prophet cropping up (Mendelson 1957:488).

Many people in town tell stories about Sojuel's continued presence in the community as a living person. They've either met him personally, or relate with absolute conviction stories of family members or friends who have met him. He may appear in many guises, often to test the integrity or faithfulness of his descendants. Santiago Atitlán is a tourist town nowadays and strangers are constantly coming and going with the daily boats that arrive at the docks. But in the back of people's minds, strangers who stay longer than a day or so, or who show an unusual interest in the ceremonial life of the town may be Francisco Sojuel in disguise.

Few can compete with anthropologists for oddity. Mendelson, who worked in Santiago Atitlán in the early 1950s was suspected "ominously" of being a manifestation of Francisco Sojuel by some members of the community (Mendelson 1957:492–494, 1958a:125). A Roman Catholic priest named Stanley Rother surprised traditionalists by departing from common practice and showing a great interest in local Maya worship practices. He attended a number of ceremonies, visited with traditionalists in their homes to try to find common ground, and even incorporated some Maya symbols, such as the image of the ancient Maya Maize God, on his vestments and as adornments on the church's ecclesiastical chair, pulpit, and altarpiece. As a result of this, some contended that he was actually Francisco Sojuel, continuing to exert his influence in the religious life of the community.

Similar suspicions were directed at me when I lived for an extended period of time in the community while doing research on the altarpiece. I was interested in the relationship between traditional religious practices and contemporary ritual paraphernalia and iconography. Because I had worked in K'iche' areas since the 1970s as an ethnographer and translator, I had intended initially to do something in the area of Momostenango or Totonicapán, K'iche' communities where I had lived and developed relationships with local traditionalist priests. I soon discovered, however, that although the K'iche's practice elaborate ceremonies incorporating the ancient Maya calendar and ritual prayers, they produce little in the way of ceremo-

nial sculpture or other visual art forms. The Tz'utujil Maya of Santiago Atitlán are unique in that there is a thriving tradition of wood carvers, painters, and weavers who produce objects specifically for use by traditionalist priests and confraternity workers in their ceremonies and ritual houses. The massive central altarpiece in the town's colonial church is only the largest example of this living artistic tradition.

When I expressed an interest in living in the community and studying the altarpiece and other ritual objects, I was initially met with a great deal of mistrust. The caretakers of the church would keep a close watch on me at all times, turn off electric lights in areas that I was working, and generally make it plain that I was not welcome. I later learned that the church had recently been the victim of an elaborate robbery in which thieves lowered themselves inside through a hole in the roof and stole a quantity of colonial era silver from one of the retablos. My interest in the objects in the church suggested to some that I might be planning a similar heist. In any case, I had determined to abandon my research in the town, as I did not want to impose on the people there. I very much regretted this as I had no good alternatives for the kind of iconographic analysis that I had planned, and had by then become good friends with one of the carvers, Nicolás Chávez Sojuel, who had incorporated traditional Maya imagery into the altarpiece during its reconstruction in the 1970s.

The day before I had planned to leave Santiago Atitlán, I made what I expected was my final visit to the church to say my goodbyes to the altarpiece and mourn over my bad luck in not being able to establish a good relationship with the guardians of the church. To my surprise, I was greeted warmly by the caretaker on duty and we struck up a congenial conversation. He offered to find me a comfortable chair to sit in near the altarpiece so that I wouldn't have to suffer long hours on the stone steps of the narthex. He also turned on all the lights available so that I could see the altarpiece to its best advantage. Other caretakers proved to be similarly kind and encouraged me to come as often as I liked. They also offered to speak to older relatives and acquaintances who had participated in the reconstruction of the altarpiece so that I could get their firsthand accounts. I was overjoyed by the change in atmosphere, but bewildered as to its cause until one day several weeks later I happened to mention it to Nicolás. He laughed and told me that he knew all about it. A few days after I arrived in town, the church committee met to discuss my unusual interest in the altarpiece and what should be done about it. Some said that I was likely a thief looking for colonial-era artifacts. Another suggested that I might be what I said I was, an academic interested in the altarpiece, but that he didn't like having a foreigner spend so much time in the church and that I should be charged a large enough fee that I would become discouraged and go away. After some discussion, one of the members of the committee said that they should be very careful in this matter, because I might turn out to be Francisco Sojuel in disguise. He felt that it would be sacrilege to charge someone money who has come so far away

to honor the altarpiece and the ancestors who had created it. If they did this, the ancestors would be offended and might very well strike them all with some misfortune in business, illness, or even death. As a result, the committee voted to offer me every courtesy as long as I was respectful and showed proper honor to the altarpiece and the ancestors, including Francisco Sojuel. I asked Nicolás if he thought I might be Francisco Sojuel. He laughed heartily and said that having gotten to know me well over the past several months, he knew for a fact that I was in no way such a powerful ancestral figure. But, he added that if the committee chose to think of me in that way it certainly was advantageous for my work, and he had no intention of persuading them otherwise since I was now a friend. He added that Francisco Sojuel had told him in a dream that I had come to honor the altarpiece and that he approved of the work I was doing. Having received such ancestral approbation I felt much more comfortable doing the research.

For those residents of Santiago Atitlán who believe in the traditional Maya worldview of their community, ceremonies are not metaphors for a theoretical spiritual theology, they are the very real expression of a present and tangible reality. If these ceremonies are not carried out in the proper way at the proper moment, the world may very well cease to be. For most faithful Christians of the European tradition, failure to attend Mass, or partake of the Eucharist, or attend Sunday services may be personally damaging, but would have very little effect on the continued existence of the deity or the world He created. This is not true of traditionalist Maya. They consider themselves essential to the continued survival of all things (the Southern Paiutes express similar concerns, see Chapter 3). No wonder then, that those who are responsible for such rituals consider themselves to be bearers of a great burden. One of the most powerful of the life-generating ceremonies founded by Sojuel is conducted by a living Maya priest called the *nab'eysil,* who dances a slow and stately dance bearing a cloth-wrapped bundle, called Martín, on November 11. The dance is oriented to the four cardinal directions and is meant to rebirth the world, a reenactment of the act of first creation itself (consistent with Yucatec Maya beliefs, Chapter 6). Francisco Sojuel is believed to have been instrumental in setting the pattern for this ceremony. The Martín bundle is one of the most sacred objects in the community and is only removed from its chest on special occasions during the year when the world stands in crisis and must be given new life to continue. Prior to one such ceremony that I attended in 1997, the *nab'eysil* knelt to the four cardinal directions, at each turn of the compass kissing the ground that he hoped to regenerate through ritual dance and prayer. As part of this lengthy prayer, the *nab'eysil* declared: "My children think I am a fool for dancing. My family tells me that I should stop, and that I'm too old and sick. They are now all protestants and catechists.[1] But they do not understand. I dance for the world, for the sky, for the mountains, for the lake. I will never stop dancing until I am dead myself. They do not understand. I must dance Martín. Who else can do it? What would happen if I did not do it? I must dance Martín."

Following the performance of the Martín dance, the *nab'eysil* told me that the bundle was so heavy no one could have lifted it unless they were aided by the ancestors, specifically Francisco Sojuel. But because he was filled with ancestral power in his body, he could lift it easily and dance with it all night. Because he did, "the world is now new again" (Christenson 2001:24). He went on to say that if anyone else had tried to do it they would have died from the crushing weight of the bundle. Physically, the Martín bundle likely weighs no more than four or five pounds, but that is of course not the point. It is the burden of its sacred power that makes it cumbrous. The presence of such objects as the Martín bundle, and those sanctioned to possess and bear them, gives sanctity to the town and its surroundings in the eyes of those who practice the traditional Maya faith, despite the fact that the number of these adherents continues to dwindle each year (Carlsen 1997).

Although the entire community is considered sacred, there are specific locales associated with Francisco Sojuel and his activities that are venerated as particularly powerful for ritual prayers and offerings. Each is still the object of pilgrimages to venerate Sojuel as a *nuwal* ancestor,[2] and to call upon him for desired aid in times of crisis. The following are some of the major sites around Santiago Atitlán associated with Francisco Sojuel.

Old Cemetery

Today the principal cemetery of the town is in the hills to the southeast, but prior to this it was located farther north in the piedmont at the edge of the community to the east of the colonial-era Roman Catholic church. The spot is still venerated as a place where *nuwal* ancestors overcame death. The following is one version of the story as told by Nicolás Chávez:

In the days of Francisco Sojuel there were only two families of ladinos living in Santiago Atitlán. They hated our ancestors, the Tz'utujils. They mistreated them, stole from them, and even killed them. Francisco Sojuel was the *nab'eysil* at the time and tried to get all of the people of Santiago Atitlán to live together peacefully. He knew natural medicines, and could bring rain, and helped people which angered the ladinos. When there were wars and the government would come to take away our people to fight, Sojuel would give them photographs instead and these would fight the wars for them so that they wouldn't be killed in battle.

For a time there was no rain, and the people asked Francisco Sojuel to help them. He told them that in two days the rain would come. Sojuel used the leather strap that people use below the tail of a horse to secure its saddle. He stood on it and pulled up hard, which allowed him to rise into the sky into the rain clouds where he made the rain to fall in a heavy downpour. Yet even though it rained heavily, Sojuel was always completely dry, as if no rain had

fallen at all. He was a powerful *nuwal. Nab'eysils* today are good men, but they don't have power like in ancient times to call on the rain.

Because Sojuel was able to bring the rain, the ladinos became angry and arrested him to investigate, led by members of the Villagran family. The Villagrans hated our ancestors because they were poor and uneducated. They tried to arrest Francisco Sojuel at his house to kill him but they only found three dogs there.

They tried again, and the soldiers found him in his house. The army arrived on the day of Martín in November to arrest him and take away his power. But he called on the power of Martín to help him. The first tunic inside the bundle flew out and transformed into a deer. It had painted deerskin all over. The soldiers were frightened and asked Sojuel if he would give them some of his power, but he would not. Next came out the second tunic that was like a jaguar. This is used when there is war or conflict in the town. The soldiers saw this tunic as well flying and transforming into a jaguar, though this isn't really true as with the first where it really became a deer—they only thought they saw it. Then the soldiers carried Francisco Sojuel to the top of a high canyon and threw him off a cliff, but he did not die.

Finally the Villagrans called on the governor of Solola to deal with him. He had his soldiers arrest him and throw him into jail. In jail, they interrogated him to see if it was true that he could work miracles. They asked him if he could bring rain. He told them that if they liked, he would give them rain. Soon it began to rain heavily and didn't stop until many were killed by the floods and they asked him to stop the rain. Great clouds came from the mountains with wind and lightning and hail. Houses fell for the flood and people demanded that something be done to stop the rains. Finally the authorities approached Francisco Sojuel and asked him to stop the rains. He asked them why they were so amazed by the rain since they themselves had asked him to bring it. But he stopped the rain so the floods ended.

Soon after they tried to kill Francisco Sojuel again by throwing him into a fire, but he did not burn. They crucified him in the town square, but he caused it to rain, thunder and hail, while great baskets of fruit, cacao, pataxte, and gourds appeared all around him and he did not die. This is why we decorate the church's altarpiece with the same fruits, cacao, and gourds in honor of Francisco Sojuel and what he did for us. When we see the fruit during Holy Week in the church we are reminded that he is not dead.

Finally they cut him into little pieces and sprinkled them with lemon juice and salt. They buried the pieces in the old cemetery in a coffin and told everyone that now he was dead and could not come back to life. But when they came back the next day they found that his coffin was empty and from it grew a giant zapote tree filled with fruit. People still sometimes plant zapote

trees over the graves of their family in memory of Francisco Sojuel because he did not die. After this, Sojuel appeared many times to the governor and his soldiers, so they knew that he was powerful and stopped persecuting him out of fear.

Three days after the disappearance of Sojuel, he appeared at the place where the gazebo is now in the market plaza. He was surrounded by baskets of fruit of all kinds, just like the fruit used to decorate the altarpiece in the church during Holy Week. He left the fruit behind so that the people would remember him and know that he wasn't dead.

Another version of the tale was recorded by Mendelson in the early 1950s:

One day [Francisco] Soxuel was put in prison on some excuse by the Governor of Solola, who in those days was called Jefe. Before he went Soxuel asked the people of cofradía of San Juan to lend him one of the San Martín shirts from the bundle and, in prison, he put this on underneath his clothes.

The Jefe said that this brujo had to be executed and one morning sent a group of soldiers to do away with him. But when they were about to shoot him there came big clouds and a strong rain and blobs of water formed on the end of the rifles and the shots failed to come out.

Then the Jefe gave orders that a huge fire should be built. So one morning the soldiers came and threw Soxuel with all his clothes into the fire; they even poured oil all over him, but the fact is that he did not burn.

Without the soldiers knowing it he came out of the fire leaving his representative [*representante*] behind and escaped to Atitlán. He did not burn because the shirt of San Martín is not only for rain but for asking for the sun back after the rain [Mendelson 1957:488].

A particular type of atole called *much'* is eaten in honor of the history of Francisco Sojuel on ceremonial occasions. In life, it is said that Sojuel ate only maize atole, particularly when he was engaged in carving sacred images. This is made of toasted maize, mixed with ash gathered from the cooking fire, and boiled. The mixture is then poured over the top of normal maize atole. The ashes mixed with life-giving maize represent Sojuel's victory over death, particularly by fire, and is appropriate as a meal taken prior to life-generating ceremonies.

Paq'alib'al

Myths surrounding Francisco Sojuel are replete with references to the ways his enemies tried to kill him. But all insist that they could never succeed in finishing him off. Sojuel simply went away to a place called Paq'alib'al (Place of Appearance

or Manifestation) where he continues to hear petitions and prayers. Paq'alib'al is a cave high in the mountains south of Santiago Atitlán (compare with Aztec Malinalco and their origin cave Chicomoztoc, Chapter 6, as well as with Inka Pumaurqu, Chapter 9). It is said to be the principal home of the ancient kings of the Tz'utujil, as well as the most powerful ancestral figures of the community. Few go there, partly because of the distance, and partly because it is considered a particularly dangerous place. Some of the most popular stories in town are tales of disrespectful young people or strangers who go there without the proper ceremonies and offerings necessary to obtain permission and are chastened for their lack of respect. The following is an account by Diego Chávez:

> On a Wednesday a friend of mine went up into the mountains to cut *pacayas*. When night fell he looked for some shelter because it had begun to rain. In front of a cave there was a large stone that jutted out like the roof of a house so he lay down under it for shelter. He didn't know it was the entrance to Paq'alib'al because his family are all protestants and they don't tell their children about our customs anymore. While he was sleeping he had a dream in which he heard a voice saying, "Get up and go find another spot because this is my door and my house. I want to go out with my dog but you're in my way." He woke up immediately and realized that it wasn't just a dream, so he got up and moved away from the cave entrance. About 10 or 15 minutes later an old man walked by wearing the headdress of a *nab'eysil*. He wore traditional Aiteco clothes, even the traditional shirt that is hard to find now. He had very white hair and a white beard. With him was a puma on a leash walking along beside him. The puma was his "dog." He wore a belt around his neck with the image of Santiago around it as if it were his leash. This was Francisco Sojuel. He told my friend to go back to sleep, but he wasn't tired anymore. Early the next morning he came back down and told us that we need to be very careful about that place because it was a sacred spot.

Germans and Japanese are mistrusted in the community, likely a holdover of dim recollections of World War II. They often appear in stories of strangers coming to harm the community or steal its secrets. Many of these stories are centered on Paq'alib'al. Here is a recent example:

> Soon after Hurricane Mitch in 1998, some Japanese and German scientists came to Santiago Atitlán looking for a guide to take them to Paq'alib'al. They paid Q3000 to a friend of mine to take them. As they were climbing the mountain they asked my friend if the cave was truly the navel of the region and did it have power to create winds and rain. My friend said yes, but he didn't know why they had asked.

When they were about five minutes away from the cave, they took out some boxes and opened them. They contained great bombs and dynamite that they wanted to use to destroy Paq'alib'al. They prepared the bombs, saying that they had proven with their scientific experiments that all the hurricanes, earthquakes, and great winds in the world were born from this spot and to prevent more hurricanes they had to destroy the cave. They went inside the cave all linked together by a rope that they looped around their waists. Once inside they saw thick clouds and mist. They brought flashlights but found that inside they didn't need them because there was plenty of light. At this point my friend refused to go further because he was frightened. He went back with the other guides and lit candles for protection.

Three days later the guides decided that the foreigners must have died because they hadn't come out. But just as they were about to leave, the Germans and Japanese scientists came running out of the cave. They said that they had seen an old man with white hair inside seated on a wooden throne surrounded by two pumas and a very large snake. The old man told them to leave or he would have his pumas kill them. The guides asked them what they were doing in there so long, but the foreigners claimed that they had only been gone a few minutes.

Sacred places such as Paq'alib'al are considered liminal places that exist in this world but are also part of the world of the sacred. Such places are particularly appropriate for approaching deities and ancestral figures directly, although they are also extremely dangerous when not approached with proper respect and offerings. In this account, the foreign scientists were gone for days though they thought that only a few minutes had passed. This is a common story. The interior of the cave does not follow the conventional rules of our mundane world. It is suffused with light although no source is apparent. Time is skewed in that its passage is miraculously slowed or stops completely. Traditionalists claim that if a person's heart is *saq* (white, pure), they may enter deep into the interior of Paq'alib'al and find that there is an entire community of ancestral persons living there. They describe it as very much like the Santiago Atitlán of the living, complete with mountains, the lake, fields of maize, and such. The only difference in this parallel world is that the inhabitants dress as they did more than a hundred years ago and there are no Protestants, electricity, or modern inventions.

In a conversation I had with members of the cofradía of San Juan a few years ago, I was told that all the great bundles containing sacred relics in town came originally from Paq'alib'al in the days of Francisco Sojuel. Sojuel's actions in leaving the Martín bundle in the keeping of his descendants follows ancient highland Maya precedent. In the Popol Vuh, the principal founding ancestors of the K'iche' Maya left behind a sacred bundle as a token of their power and continued existence

among their people. Like Sojuel, the progenitors did not really die, but went to live among "our people" in the mountains (Christenson 2007:254). Prior to their disappearance, the ancestors, led by Balam Quitze, established many of the ritual practices that would become central to K'iche' worship in much the same way as had Francisco Sojuel among the Tz'utujils:

"We go to our people. Our Lord Deer is now established, mirrored in the sky. We shall thus return, for our work is accomplished, and our day is now finished. Remember us. Do not forget us. Do not sweep us away. You shall surely see your homes and your mountains where you will settle. Thus let it be so. Go therefore, go to see the place from whence we came." This was the counsel they were given.

Then they left behind the sign of the existence of Balam Quitze:

"This is the token of my memory that I shall leave with you. This is your glory. These are my instructions, the result of what I have pondered," he said when he left behind the sign of his existence. Bundled Glory, it was called. Its contents were not clear for it was truly bundled. They did not unwrap it, nor was its stitching clear. No one had seen it when it was bundled.

This, then, was their counsel when they disappeared there atop the mountain Hacavitz. They were not buried by their wives, nor their children. Neither was their disappearance clear when they vanished. But their counsel was clear. Thus the Bundle came to be precious to them as a memorial to their father. Straightaway they burned offerings before it as a memorial to their father. . . .

The people had become numerous by then, and all of them gathered together each day to remember their father. The Bundle was precious to them. They did not open it. It remained bundled. Bundled Glory they called it when it existed. They also named it their Wrapping. It had been left behind by their fathers as the true sign of their existence. Thus was the disappearance and end of Balam Quitze, Balam Acab, Mahucatah, and Iqui Balam, the first people who came from across the sea in the East [Christenson 2007:254–255].

In this passage, the ancestors call on their people to "remember us." The K'iche' phrase is *kojina'*, literally, "sense/feel us." This is much stronger in the K'iche' language than to merely have memories of someone they once knew. It means to feel their presence within them as part of who they are. To an extent, traditionalist Maya do not consider powerful individuals of the past to be dead in the worldly sense.

Nicolás Chávez Sojuel carved an image of Diego Kihu, a powerful *nab'eysil* he knew in his youth who died in the 1970s, on a panel of the central altarpiece in

the church. In this panel, Kihu is walking at the head of his own funeral cortège. When I asked how this was possible, Nicolás said that he hadn't really died, just gone to live with the ancestors in Paq'alib'al. He then related the following story:

> Diego Kihu could work many miracles. He had the face of a saint's image. He had power over water and rain. He could make it rain whenever he wished, and yet when he walked in the rain he never got wet. . . . He was very old when he died—about 128. But he didn't die of illness, he just decided to leave because he wanted to be with the other *nab'eysils* in Paq'alib'al. He told people that he would leave at 6:00 pm on a Wednesday and said goodbye to everyone and gave them his blessing. Everyone placed candles around his bed and he left right at 6:00, as he had said. That evening he visited many people in dreams and told them not to worry about him because he was in Paq'alib'al. When his body was buried a great wind and earthquake passed through the cemetery to prove that he was not dead [Christenson 2001:211].

The highland Maya frequently tell stories about visitations from ancestors who continue to work on behalf of their community whenever necessary. Recently I gave an old photograph taken in the late nineteenth century, depicting a group of elders from Santiago Atitlán taken by the English photographer Alfred P. Maudslay, to a friend of mine who is the son of a prominent elder in that community. He immediately named a number of the individuals in the photograph. When I asked how he knew them, considering that they had died long before he was born, he replied: "We all know them. They still visit us in dreams and in person. We know their faces. They are still very powerful—the soul of the town. Their minds and their souls are white [*saq*—white, light, pure, clear, clean]. This is our heritage. These people are still alive because I live. I carry their blood. I *remember*. They are not forgotten" (Christenson 2007:254n681, italics added).

Atitecos, like my friend, believe that some essential part of the ancestors continues to live within the blood of their descendants. Living Maya are in a sense embodiments of their ancestors who retain the ability to manifest themselves in the present through "memory." Powerful ancestors like Francisco Sojuel are a living part of the community, partly because he continues to live in Paq'alib'al, and partly because his descendants bear his blood. The *nab'eysil* who described dancing the Martín bundle to me (as I mentioned earlier) said that the ancestors had filled his body with their presence and he danced in their steps. To a certain extent the *nab'eysil* understood this quite literally, because the ancestors continue to exist within him and become manifest during important ceremonies.

Like the "Bundled Glory" of the ancient K'iche's, the Martín bundle in the cofradía of San Juan is also the principal object of veneration left by a departing an-

cestral figure, in this case Francisco Sojuel, as a token of his continued existence in the community. Traditionalist priests come from all around the region to petition the bundle for favors and blessings, often beginning with a litany that refers to Francisco Sojuel. In many of these prayers, the name of the bundle, Martín, is compounded with the names of ancestral *nab'eysils* who established the structure of its associated ceremonies. Here is one such prayer: "I call upon you, Ajq'alb'al acha [man of Paq'alib'al], Ajq'alb'al ixoq [woman of Paq'alib'al], Juan Martín, Diego Martín, Francisco Martín [a reference to Francisco Sojuel], Marco Martín [a reference to Sojuel's successor as *nab'eysil*, Marco Rojuch], ajchucruz [the four corners, the four stations of the cross where ancestral spirits often appear], ajq'alib'al [they of Paq'alib'al], ajxe'ulew [they of the underworld], nawal a q'ab' [powerful ones of the night], nawal a jolom [powerful are your heads], nawal saq a wi' [powerful are your white hairs], saq a metz' [your white eyebrows]."

Birthplace of Rilaj Mam

One of the principal cult images in Santiago Atitlán is a carved wooden figure known locally as Rilaj Mam (Ancient/Revered Grandfather), or alternatively Maximon (Ancient One Who Is Bound). The place where the tz'ajte' tree (coral tree; *palo de pito*) from which the Rilaj Mam figure was carved is known in the hills to the east of town and is the object of pilgrimages to leave offerings and ask for petitions (Figure 7.2). In highland Guatemala, the wood of the tz'ajte' is still considered to have extraordinary power, including the ability to speak (Orellana 1984:98). Its seeds are used in divination ceremonies and are a standard component of shamanic bundles.

The trunk of Rilaj Mam is approximately 2.5 feet in height and 6–8 inches thick, with separate pieces of wood attached to form the head and legs. A carved mask with a roughly hewn face is tied about the head, and there is nearly always a lit cigar inserted into its mouth (Figure 7.3). This effigy is said to be more ancient than Christ, having been created "in the beginning of time, or of the world" (Mendelson 1959:58, 60).

Francisco Sojuel is closely tied to the creation of the Rilaj Mam image. In some variants of the tradition, he participated along with other ancestral figures in the formation of the image (Christenson 2001:179–180; Mendelson 1957:490). In others, he merely carved one of his principal masks (Mendelson 1957:490, 1959: 57). In nearly all of the myths associated with the figure, however, Sojuel was instrumental in establishing the role Rilaj Mam plays in the community.

Rilaj Mam is considered old, and sometimes malignant, standing in opposition to the established order of the community. He is thus associated with forgetfulness (Tedlock 1982:101), hunger, sterility, sexual depravity (Mendelson 1958b:9; Thompson 1970:299), and opposition to life deities. He presides over the sterility

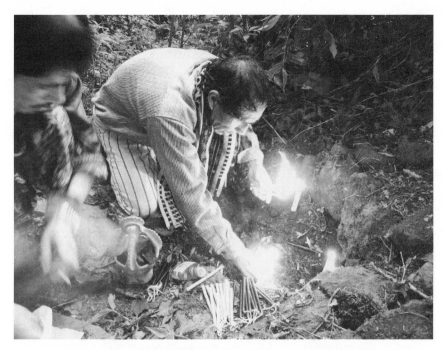

Figure 7.2. Traditionalist priest placing offerings at the site of Rilaj Mam's birthplace.

of the dry season and the bitter cold of the winter months (Tarn and Prechtel 1986:178–179). As maize ripens, he causes the plants to weaken and turn brown and decay. Although elderly and sterile himself, he is characterized by hypersexuality, seducing women about town disguised as a handsome young man (Tarn and Prechtel 1990:75). His wife, Yamch'or (Virgin-Whore), is a prostitute whose sexual escapades match his own. Yet their extreme sexual appetites do not produce healthy children. Stillborn babies or infants with severe congenital malformations are sometimes thought to be the result of the Mam's dalliances. Other Atitecos insist that a woman could never become pregnant by him because his touch would either kill her outright or cause her to die soon afterward of insanity.

In rituals, Rilaj Mam represents the power inherent in death and sacrifice to transform and renew. As such he is particularly prominent during Easter celebrations, in which he presides over the death and entombment of Jesus Christ (Christenson 2001:176–191; Mendelson 1959, 1965; Tarn and Prechtel 1997). Cook suggests that his opposition to Christ represents a kind of "underground survival of powers from earlier, superseded epochs" (Cook 2000:139–140). As a "god-slayer," he is sometimes addressed as Pedro de Alvarado (the Spanish conqueror who defeated the highland Maya early in the sixteenth century), Simon Peter (known in Santiago Atitlán principally as the saint who denied Christ), or Judas Iscariot (Lothrop 1929:20; Mendelson 1958b:1–5, 1959:59).

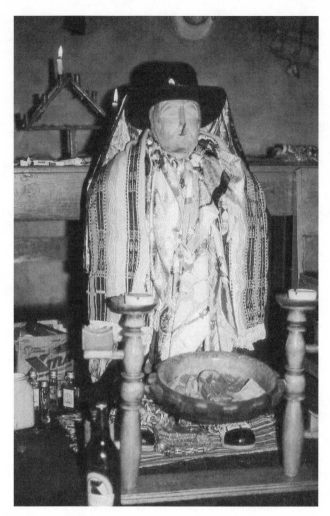

Figure 7.3. The carved figure of Rilaj Mam in the cofradía of
Santa Cruz.

Despite his malevolent nature, Maximon is not shunned by Atiteco society. Sel-
dom have I been in the Confraternity of Santa Cruz, where the figure is kept, when
there haven't been at least one or two petitioners waiting their turn to approach him
in prayer. Tz'utujils believe that for Martín or Jesus Christ to be renewed, they must
undergo sacrificial death. Maximon can hardly be blamed for fulfilling a necessary
role that ultimately benefits everyone. As Fernando Cervantes writes, "European
notions of good and evil, personified in the concepts of god and devil, implied a de-
gree of benevolence and malevolence that was totally alien to MesoAmerican dei-
ties" (Cervantes 1994:42). Both death and life must dance together on the world's
stage or neither could exist for very long. If a person wishes to be cured of a severe
illness, witchcraft, or madness, it is eminently reasonable to approach the deity who

causes such things and thus has power to heal them. Nevertheless, Rilaj Mam is invoked with far more caution than used with other saints, and his power has a negative ring to it. Rather than ask for a good harvest, as they would when praying to Martín, Atitecos plead with Rilaj Mam that their crops will not be destroyed by some blight or other disaster.

Rilaj Mam was originally formed by the ancestors to guard their community and protect its moral standards and institutions. Once formed, however, Rilaj Mam rebelled against these strictures and reveled in breaking the rules he was charged with enforcing (Carlsen 1997:26). He thus came to personify the instability inherent in nature that inevitably destroys what it seeks to build. This version of Rilaj Mam's origin comes from Nicolás Chavez:

The great *nuwals* Francisco Sojuel, Marco Rohuch, and others were once merchants and periodically left town to go to Antigua. One of their companions named Juan No'j had a wife. One day when he returned from business in Antigua a neighbor told him that his wife was seeing another man while he was away. Other merchants and farmers had the same problem. So Francisco Sojuel went into the mountains accompanied by the ancestors who created the world to find a tree that would be willing to watch over the town while they were away. They first asked the Cedar [*Tioxche'*], but it refused saying that it could only work a few miracles. Next they asked Mahogany [*Q'anxul*], but it was too hard and stiff to walk. Next they asked Breadnut Tree [*Iximche'*], but it was too heavy to work. Finally they consulted the Coral Tree [*Tz'utujil Tz'ajte';* Spanish *palo de pito*] who agreed to work for the ancestors. So they cut down the tree which laughed as it fell. They then carved the body of Maximon from the tree. But they did not have to hold the tools as they worked. Three women accompanied them named María Castellana, María Salome, and María Tak'ir. The women played the split log drum and danced in front of the tree. María Castellana would give the wood a drink of liquor and sing, and Francisco Sojuel would strike it with a machete. The machete would then carve the wood by itself.

Once Maximon was finished, Francisco Sojuel told him to find out if it was true that the wife of Juan No'j was unfaithful. Now Juan No'j had a maize field near Chukumuk and he had a boy that worked for him there tending the crops. At noon, the wife of Juan No'j used to go to the maize field to deliver lunch for the boy and there they made love. So Maximon disguised himself as the wife of Juan No'j and went to the field to deliver lunch. But instead of meat, he took cow droppings instead. When the boy saw Maximon coming he thought that it was the wife of Juan No'j and called, "my love, come with my food." While he ate, Maximon cried out and said, "Ha, I caught you and you will now be punished." Soon after, the boy became insane and died.

But Maximon soon got tired of keeping a watch over the people of the town and began to wander far away over all the mountains and all the countries without permission. He was supposed to protect the town from theft and adultery but he started to cause problems, doing whatever he wanted to do. He started to look for beautiful young girls and seduce them. But he could also appear as a beautiful woman himself and drive men crazy who followed "her." So Francisco Sojuel cut away his head, arms, and legs to stop him from wandering everywhere and to make him more obedient. He then tied the pieces back together again with cords. That is why he is called Maximon [He Who Is Bound], but his real name is Mam [Grandfather, Ancient One]. He can appear in many forms, but when you see him in town at night he is always at a crossroads smoking a cigar. He has a high-pitched voice and pronounces Tz'utujil like a foreigner. When you shake his hand it feels cold like wood and he only has four fingers because he doesn't have a thumb. He also has the smell of a skunk so when you smell this, you know he is near and offerings should be made to him or he may harm you or drive you mad.

When he was first created, Francisco Sojuel kept Maximon in his house. But after he went away to live in Paq'alib'al, the people decided that they did not like what Maximon did and left him on the south side of the church where he killed Jesus Christ at Easter. But Maximon did not like being near the church because he was not a Christian. One night he appeared to an *ajkun* where the town road branches off to go up to the cemetery. He said that if the people didn't treat him with more respect he would find a pretty girl as a wife and really cause trouble. So they took him to the Confraternity of Santa Cruz where he lives during the year and watches over the dead body of Jesus Christ.

The shrine where Rilaj Mam was carved consists of three shallow openings in the ground lined with stones and surrounded by offerings. The tree stump from which the wood for the figure was taken is no longer there, having been taken away by the protestant owner of the land. But many traditionalists continue to go there to pray and leave offerings for Rilaj Mam. Others come because it is a principal access point to the otherworld and therefore appropriate for ceremonies involving the ancestors, particularly Francisco Sojuel, who is said to appear there frequently.

Cofradía Francisco Sojuel

The house, or at least the site of the house, of Francisco Sojuel is still known and venerated as a shrine where relics that once belonged to the prophet are kept by his descendants. The man who currently owns the house said that when Francisco Sojuel was growing up he already showed great power:

He could live on very little food or drink. He could fill a small little gourd with water and live on that for a month. He had a book filled with powerful words, but he never had to read the books. He just knew what was written there. His parents considered him lazy because he never seemed to be out working, though the work was always done. His clothes were always clean though he never seemed to wash them by hand.

His mother marveled at the boy and asked her husband if it was really true that their son could do these things, and he told her that it was true. Once when he was six years old his father found him weeping out in the fields. When he asked what was wrong, the young Sojuel said that he knew he could protect the people but that his parents were always criticizing him for not working even though all the work was done. From that day his father gave him permission to go about his work without criticism.

Within the house complex of Francisco Sojuel is a room set aside as a private cofradía house. On a long table set behind the altar of the cofradía are several stones that Sojuel either found or carved with crudely rendered faces (Mendelson 1957:488). The family says that at night they often hear these stones, and other images carved by Sojuel, talking late into the night. When there is trouble in town, the stones have meetings in which they discuss how to solve the problems (compare with the Andean concept of life force in stone, Chapter 9). They also plan punishments for those who make trouble or violate the laws of the community. Often they are able to make those who are guilty go crazy or die from sudden illness.

It is a commonly held belief that although there are still good people who carry on the traditions established by Francisco Sojuel, they do not have the power held by the ancient ancestral figures. Mendelson recorded this description:

> In the old days when the village needed rain, there was a ceremony to ask for rain. The people went with Francisco Sojuel, Jacobo Coo, Gregorio and Francisco Rianda, and some others. Santiago, San Antonio, and San Juan were clothed in cloaks of rain [capas de lluvia] green with flowers, and a thin yellow border at the base, altogether very old and torn. The Martín bundle was brought out in the cofradía of San Juan and placed on the table, no more: people did not dance clothed in the shirts in those days. Then a procession came out and the rain came. Nowadays there is no procession, because the people do not know what to do and there is no one who has the fine words and the complete prayers of the ancients [Mendelson 1957:460].

Much of the traditional ceremonial life in Santiago Atitlán takes place in the cofradías, a network of voluntary associations dedicated to the veneration of individual saints and associated deities. Although the confraternities are ostensibly Christian organizations, their administration is wholly indigenous and indepen-

dent of the official Roman Catholic Church's control. Indeed, the ceremonies conducted in the confraternity houses retain significant elements of ancient Maya cosmology that run counter to European notions of Christian orthodoxy.

Many traditionalists claim that the cofradía system was founded by Francisco Sojuel, while others suggest that although they existed before his time, Sojuel set the pattern for cofradía worship and provided many of the sacred objects housed in the cofradía houses. Here is one variant of the tradition as told by Nicolás Chávez:

> Before the days of Francisco Sojuel, people didn't think of having cofradía houses. When there was a problem, people just came together in the house of the *nab'eysil* to discuss how best to provide for the people and protect them. Then they would sacrifice a turkey or a rooster. Now they don't do this very often unless they want to follow the old ways.
>
> But when Francisco Sojuel and Marco Rohuch became old, they decided that they couldn't leave the people without protection. If they were to die and go away, how would the town be protected by Martín? What would happen to their customs and ceremonies? So they formed ten or twelve cofradías, each dedicated to one of the saints. But each of the cofradías needed an image or a bundle to give it power to help the people, and these were all in Paq'alib'al then. Not everyone could go to Paq'alib'al because this is where the ancient kings and *nuwals* live. Francisco Sojuel could go there because he was a powerful *nuwal* himself. He often went there to consult the *nuwals* that live there and ask for rain. So Francisco Sojuel and Marco Rohuch decided that it was best to go to Paq'alib'al to retrieve the things that would be needed for the protection of the community and bring them down to be kept inside the cofradías.
>
> First they made sacrifices and offerings of candles, incense, and other things while they prayed for permission to bring these things back from Paq'alib'al. Once they received permission, they went to Paq'alib'al where they made more offerings of incense, candles, and seeds. Then they went inside Paq'alib'al where they met with the ancient kings of the Tz'utujils who live there and watch over the sacred bundles and images kept there. This was on the Day of Martín, on November 11. Each of the twelve cofradías was given its image from the kings at Paq'alib'al. The bundle of Martín was also given to the cofradía of San Juan, but Francisco Sojuel didn't give to them the bundle himself. The deer and jaguars came and carried the bundle down to the town carrying the bundle on one of the deer's back. When they arrived at the home of Juan Pakay, who was to be the new *nab'eysil* for the cofradía of San Juan, the deer and jaguars circled three times around the house, and then went in. Other animals came as well from the mountains to accompany the Bundle of Martín. Now when hunters go up into the mountains and kill an animal, they bring the skins to the cofradía of San Juan and hang them from

the rafters. Sometimes when times are hard, you can hear these animals crying out at night inside the cofradía house. Or sometimes they'll come down from the rafters and have discussions on how to solve the problems in town while the jaguars stand guard outside. On those nights no one can enter, but once the meetings are over you can enter again.

After all of the images and bundles had been given to the cofradías, Francisco Sojuel and Marco Rohuch chose who would be the leaders—for each there would be an alcalde, and a certain number of workers who would watch over the things brought from Paq'alib'al. Juan Pakay was chosen as the *nab'eysil* to watch over the Bundle of Martín and the garments held inside. This is how the cofradías began and each one has a list of alcaldes and other cofrades that succeeded since the days of Francisco Sojuel.

Today people claim that the living *nab'eysil* and other traditionalist priests aren't as powerful as they were in the days of Francisco Sojuel. One of the elders in the cofradía of San Juan told me:

> In the days of Francisco Sojuel, the *nab'eysil* could call on the rain, but now he doesn't know how. Because he doesn't know the words or what to do, he calls on Francisco Sojuel and he helps by bringing the rain. The tunics inside the Bundle of Martín were brought by Francisco Sojuel. By wearing the tunics inside, he could fly up into a whirlwind and make prayers in the clouds. The *nab'eysil* still wears the tunics on the Day of Martín, but he does it only inside the cofradía house so the winds won't escape and hurt people. He doesn't know how to control it. Once a young man came and took out one of the tunics from the bundle and wore it. Immediately he flew up high into the sky, but he couldn't get back down again. He flew up into the clouds and would have died if he hadn't asked the *nuwals* to help him. Finally they helped him to get down and put the tunic back in the Martín bundle. Still, the boy went crazy and died soon after.

Crossroads

Many in town claim to have seen Francisco Sojuel in the town itself, generally at one of the major crossroads either near the center of town or at the edge of town at one of the four cardinal directions (Mendelson 1957:493–494). There is a large cross situated in the church plaza marking the symbolic center of the community and which is purportedly a common place for ancestors to appear to Atitecos. Colonial-era crosses were also placed at each of the cardinal directions marking the principal entrances to town. Although these no longer exist, their locations are still known and are used by traditionalist priests for ritual offerings and prayers.

Mendieta wrote in the early colonial period that crossroads and town entrance

crosses were venerated in Mesoamerica as the focus of divine power. Native people placed carved images that once stood in their ancient temples at these spots: "And as the friars sent them to make crosses and place them at all crossroads and entrances to the towns, and in some of the tall hills, they placed under or behind these crosses their idols. And pretending to worship the crosses, they did not worship them but rather the figures of demons which they had hidden. This occurred after their own sanctuaries and public idols were destroyed (Mendieta 1993:233–234; translation by author).

The following was told to me by Diego Chávez Ajtujal:

> My grandmother was gravely ill and asked for a friend to come and visit her. At midnight, the friend passed by a crossroads and saw an old man with very white, curly hair and dressed in the kind of clothes that people wore many years ago seated on a chair. The old man asked her where she was going, and she replied that she was on her way to visit a friend who was ill. He said that he had some medicine and that he should give it to her friend. He gave her the medicine and sent her on her way without asking for any payment. She thanked him and asked who he was. He said that he was Francisco Sojuel and that he liked to help people when they are sick. When he said this she became frightened but he was so kind that the fear soon left her. As she walked down the street toward my grandmother's house, she looked back to see if he was still there but he had disappeared.

Nicolás Chávez claims that when the church's altarpieces were being reconstructed during the late 1970s, Francisco Sojuel would leave baskets of food and fruit for the workers to eat to show that he approved of their work. During the violence of the civil war that reached its climax in the 1980s, many say that Sojuel and other ancestors helped them by causing the soldiers' food to mysteriously become infested with worms, or would cause terrible thunderstorms that would frighten the soldiers into staying in their compound rather than coming out to fight, or would cause their weapons to jam and become useless.

Those who claim to have seen him describe Francisco Sojuel as a short, elderly man with long, white, curly hair. Although generally kind to those in need, he is also seen as serious and stern. He is said to have large, dark, intense eyes that can be very intimidating and even frightening. Sojuel is also recognizable by his unique clothing. He wears a hat made of petate, plaited reeds that are water resistant. It is said that Sojuel could call for rain in times of drought and therefore always wore this hat to protect him from the heavy rains that he brought. He wears the typical short pants embroidered with birds that is still worn by Atitecos today. His shirt is red, but instead of buttons, it is a pullover type that was worn long ago, fastened at the neck with little cords. He also may be seen wearing the unique *tzut*, or cloth

headdress, and wool overgarment worn by cofradía elders. Nicolás Chávez's father claims that when Francisco Sojuel appears to people in town, he is reluctant to reveal his name. If people ask for his name, he'll reply that he doesn't remember, unless it is someone who believes in him or knows him already. Because there are now so many catechists and Protestants in the community, Sojuel appears less often, or at least does not reveal himself as he once did.

Conclusion

Among the traditionalist Tz'utujil Maya of Santiago Atitlán, their community is a sacred place, situated at the very center of the world where the first mountains emerged from the waters of the primordial sea. Lake Atitlán is a remnant of those original waters that once covered everything. Powerful ancestors who set the pattern for the ceremonial life of the town are associated with specific locales in and near the community. Atitecos believe that the rituals they carried out in their lifetimes, particularly those associated with Francisco Sojuel, were capable of restoring the life-generating powers of the world. Without these rituals the world would age, deteriorate, and eventually die without the capacity to be reborn, just as a mortal human being would. Because of this ability to help the world to regenerate itself, Sojuel is a liminal figure—partly a mortal person who lived in Santiago Atitlán approximately a hundred years ago, and partly an ageless person who was one of the founding ancestors at the time of creation, and who continues to live today. Specific places associated with Francisco Sojuel serve as foci for approaching the ancestors in order to perpetuate these life-giving ceremonies and are themselves liminal places where the separation between this world and the world of the sacred becomes less of a barrier.

Notes

1. In Santiago Atitlán, the Maya often use this term to refer to Orthodox Roman Catholics. Traditionalists consider themselves to be the "true" Catholics and that *catequistas* who foster a European form of orthodoxy are really "protestants" with no authority to meddle in the practice of their faith.

2. The term *nuwal,* according to contemporary usage in Santiago Atitlán, refers to a semideified ancestor with extraordinary power (Carlsen and Prechtel 1994:94–95; Mendelson 1957:484). The *nuwal* ancestors, particularly Francisco Sojuel, continue to influence affairs in the community and are called upon in prayers and ceremonial litanies.

III

South America—Region of the Andes

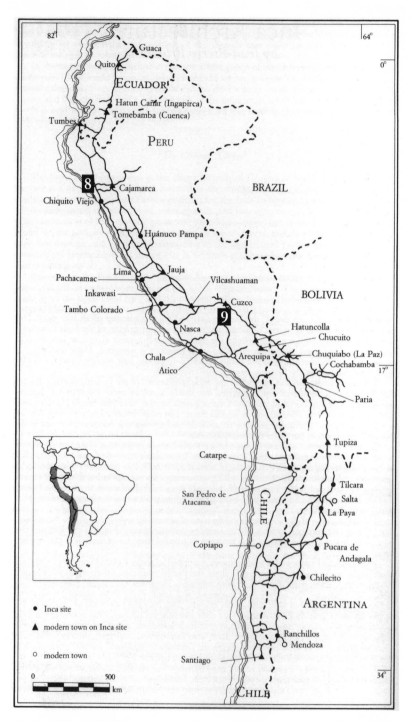

Map 3. Andean region indicating the areas and cultures discussed in Chapters 8 and 9 (adapted from John Staller).

8 Landscapes as Metaphor

Resources, Language, and Myths of Dynastic Origin on the Pacific Coast from the Santa Valley (Peru) to Manabí (Ecuador)

Patricia J. Netherly

Landscapes of Relation

The complex polities of the late prehispanic period (Chimu, Inka, Manteño) on the Pacific Coast of South America, from the Santa Valley in the south to Manabí in the north, have been intensively studied by archaeologists over the past thirty years. For the most part, such study has concentrated on specific sites (structures or concentrations of structures) or surveys of particular river valleys on an approximate east–west axis. Consideration of north to south similarities, differences, or even relations of exchange is rare and seldom attempted (Netherly 2005). The research that has been carried out for this period has emphasized what is seen as political centralization leading to larger and more powerful polities. Specialization in long-distance exchange, which appears to have predominated in Manabí on the Pacific Coast of Ecuador and in Piura and Lambayeque on the North Coast of Peru, has received little attention that links both the source and the destination of the goods with the modality of exchange (Netherly 1977; Paulsen 1974).

Archaeological study of this region in the late prehispanic period can call upon limited written sources produced by early Spanish eyewitnesses and administrators that, when used with due care, can supplement the material record of these societies that left no writing of their own. The culture of traditional Andean societies of the present day is less relevant than it would be in other areas of the Andes because these societies were in continuous contact with the Europeans and their diseases and thus suffered the consequent demographic catastrophe and cultural reorganization. Nevertheless, there are clues that may be found in the ethnographic record that permit the framing of questions about the culture of the late prehispanic past.

In this chapter I propose a longitudinal examination of this region and the societies inhabiting it during the late prehispanic period, with the ultimate purpose of understanding the relations implicit in the myths of social and political origin

current on the North Coast when the Europeans arrived. I begin with a review of the physical world—the environment. Then both longitudinal and transverse cultural landscapes defined by the political economy in this environment will be considered. A separate landscape of language distribution appears to contradict these relations but, as we shall see, deepens our understanding of the multiplicity of the relationships present. Finally, the relationships implicit in the landscape of the myths of political origin, found on the North Coast and expressed at different levels of social and political organization, will be shown to be linked to others expressed in landscapes defined in different terms.

Relationships are the glue that binds individuals together into a society at whatever scale. This is as true today as it was in the past. Relations are also the means by which societies are connected to the physical world. Human groups may differ in how they obtain resources for survival, but the means by which they obtain them are ordered by relationships. In like fashion human societies order the social contacts among individuals and among groups through relationships (A. Smith 2003:69–73). Culturally defined imagined relations extend the social order. As A. Smith puts it (2003:72), "If spatial relationships are established within social practices, then inquiry must go beyond formal description to understand the physical space of the environment, the perceived space of the senses, and the representational space of the imagination as interconnected domains of human social life."

The Natural World

The environment or natural world that forms the substrate upon which human societies establish relationships and create landscapes of relation does not of itself constitute a landscape. This would appear counterintuitive for those who first encountered landscape in the painterly tradition until one realizes that the painter chose and shaped what purports to be a natural scene. Nevertheless, it is helpful to understand the constraints and advantages offered by the natural world, remembering that resources do not become such except through human agency.

Environments of the Western Pacific Coast

The region between Santa and Manabí ranges from arid to semiarid. Manabí, on the Pacific Coast of Ecuador, has a semiarid climate (see Figure 8.1). Rainfall occurs between December and March, and during that period it is possible to grow crops without irrigation. Between late May and September, a fine rain called *garua* falls at night and makes a second harvest possible. Most rivers head in the coastal hills and do not have a large discharge. Water storage in tanks or *albarradas,* seen on the Santa Elena Peninsula, was not essential, although there are tanks at the large late sites near Machalilla. Large-scale canal irrigation was not widely feasible in this region. The natural vegetation is semixeric with tall hardwoods occurring along the

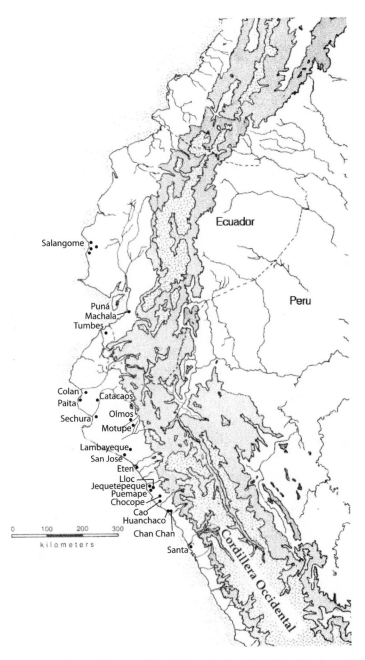

Figure 8.1. The Pacific Coast of South America from Manabí in Ecuador to Santa in Peru.

rivers and at higher elevations on the hills, which receive more moisture. Along the coast, mangrove was found near the mouths of the small rivers, and in aboriginal times the vegetation would have included the tall tree species characteristic of the mangroves. The rivers would have had abundant fish and mollusks. Shellfish were found in the sands of the beaches and on the rocky headlands. Inshore and pelagic fishing were both possible with simple watercraft. This coast is bathed by the warm waters of the southward flowing Ecuador Current. Fish are abundant but these waters lack the extraordinary productivity of the cold Humboldt Current. This current veers to the west just north of the Gulf of Guayaquil and passes to the south of the Galápagos Islands. The warm Ecuador Current also turns west and flows to the north of the Galápagos. The presence and disappearance of these currents affects the climate of the region, but the effects in this northern region are less dramatic than they are to the south.

In the region of the Santa Elena Peninsula and the northern shore of the Gulf of Guayaquil, the climate is somewhat drier except for the higher elevations inland that capture moisture and support more mesic vegetation. Tree species such as balsa grow on these elevations here and in Manabí. There are fewer small rivers and some water management techniques were used in cultivation. The eastern margin of the Gulf of Guayaquil and the valley of the Guayas River both have a seasonal rainfall regime. The abrupt slopes of the western cordillera of the Andes capture more rainfall; water management practices included raised fields in flooded areas as well as small-scale irrigation. Nonetheless, by late pre-European times all of these areas had developed sufficient complexity to support small- and intermediate-sized regional polities.

In general, the disposition of resources was linear, paralleling the general direction of the rivers. The human societies of the region appear to have been organized so that each segment of the society had access to the major resource zones, but less is known about how this was accomplished in the late prehispanic period than is known for the coastal valleys of northern Peru.

The Transverse and Longitudinal Environments of the North Coast

Conditions on the North Coast of Peru from Piura to the Santa River were more xeric, the valleys and rivers larger, and rainfall nonexistent in normal years (see Figure 8.1). The rivers head high in the Andean cordillera and their discharge is determined by rainfall in their highland watersheds. Before human intervention, the riverbanks supported canebrakes and a gallery forest of more mesic trees. The valley bottoms were covered with spiny scrub, grading into cactus near the littoral. The littoral supported salt-tolerant vegetation in the back swamps behind the beach ridges. Mollusks and other fauna were found in the sandy beaches and on rocky headlands. Wetlands were found around the estuaries and elsewhere along

the littoral. Fishing was possible from the shore and from small watercraft. Lack of rainfall limited the growth of plants in the areas between the valleys. However, scrub vegetation was found along dry watercourses at the foot and in the gullies of the dry coastal hills, outliers of the Andean cordillera. These areas continued to support wild fauna even after the valley bottoms came under cultivation.

The North Coast valleys are very roughly triangular in shape. Without rainfall, farming on the coast must be supported by water management techniques: flood-water farming, capture of moisture from a high water table, or canal irrigation. Long contour canals extend the riverine vegetation across the valley plain. In the larger, more open valleys of the Jequetepeque-Zaña and Lambayeque-La Chira-Zaña complexes, much broader areas came under irrigation and the shape of the ecozones was somewhat different. Nevertheless the general alignment of environmental zones in these valleys was transverse from the mountains to the sea. Thus the economic landscape was also linear in a transverse pattern. The resources of the littoral and sea, while not perfectly linear, were treated as if they were. Each major section of the society had access—through component corporate groups or *parcialidades*—to the resources of each zone.

It has been suggested that the marine environment constituted a longitudinal landscape for fisher folk (Rostworowski 1970, 1977), and it is true that in disturbed times these people had the means to move around. However, for the most part, corporate groups of fishermen were joined with agricultural groups in higher-level sociopolitical units through which they had access to agricultural produce in exchange for marine resources.

The marine resources themselves were divided into those living on sandy bottoms and those living on rocky substrates. There were more profound differences between the fauna from cold waters and those living in warm waters. Guano, important for fertilizer, was found on offshore islands (Netherly 1977). The longitudinal landscape is not a feature of the natural world.

Landscapes of Language

The dispersal of human groups over large territories necessarily raises the question of how the groups relate to one another. The unspoken expectation for North Coast societies seems to have been that a landscape of language would be longitudinal. Recently, the distribution of cultural elements has raised some questions about cultural heterogeneity, but these have not been framed in terms of linguistic differences (Bawden 1996; Shimada 1990). Thus, language is a topic that has received very little attention from students of the late prehispanic period on the Pacific Coast of South America. Conventional wisdom has recognized the presence of a language, called Yunga, in the valleys of the North Coast of Peru and has assumed that Quechua was the language of the highlands adjacent to the coastal val-

leys. There are no early records for the languages of the region around the Gulf of Guayaquil and along the Pacific coast of Manabí, nor have the surviving place names been fully studied by linguists.

However, a closer examination of the data shows that a landscape of the languages spoken in the valleys of the North Coast and in the immediate highlands presents a more complex configuration—one that contradicts the conventional linguistic paradigm. After careful study, the late Peruvian linguist, Alfredo Torero, found there were four discrete languages on the North Coast (Torero 1986). Further, in addition to Quechua, there were at least two languages in the western highlands, Culli and Den (Torero 1989). In effect, the language panorama on the North Coast was both confusing and complex. From a landscape perspective, it offers new insights into the cultural dynamics of the region.

The information that follows has existed in scattered publications for decades, but it has never been fully integrated. The linguistic analysis of the fragmentary evidence for these languages has greatly advanced this enterprise and makes it possible to set out the evidence with greater confidence (Torero 1986, 1989, 2005).

Beginning in the first decades after 1532, there are accounts, written by Spanish religious officials, soldiers, and administrators, that attempt to describe the languages of the North Coast. The earliest is that of a cleric, Agustín de Zárate, who traveled from Paita to Lima in 1544.[1] As it happens, the single most useful account was compiled under the direction of the eighteenth-century bishop of Trujillo, Don Baltasar Jaime Martínez de Compañón (Martínez de Compañón [1782–1788] 1978). In the centuries between these two sources Europeans and creoles alike struggled to describe and distinguish between unfamiliar languages with varying degrees of success. This effort will be traced chronologically, since each increment in understanding makes the picture clearer.

Sixteenth-Century Descriptions of North Coast Languages

Zárate's observations of the geography and ethnography of the region are acute and seem to be the product of firsthand observation. He commented on the linguistic situation as follows: "The indians of these plains are divided into three classes, because some are called yungas and others tallanes and others mochicas; in each province there is a different language, except that the caciques and lords and nobles, in addition to the language native to their district, know and speak among themselves a single language which is that of Cuzco [i.e., Quechua]"[2] (Zárate [1555] 1944:Book I:Chapter VI:31; author's translation; inclusions in brackets added). Zárate is very clear: the valleys of the North Coast formed three distinct language provinces. In later accounts the Tallanes are consistently associated with Piura, including the area around Paita, the port used by the Spanish to disembark and continue their journey south by land. However, Zárate gives no clue as to where the other two languages—those of the Yungas and the Mochicas—were spoken. *Yunga*

is a general highland Quechua term for lowlander. In later sources, *Mochica* was associated with the region from Jequetepeque to Lambayeque not with the present-day Moche Valley around Trujillo.

More importantly for the Spanish administrators in the first decades after 1532, as Zárate notes, the rulers and high-ranking individuals of the coastal polities spoke the Quechua of Cusco—the administrative language of the Inka—and in the first decades after their arrival, the Spanish emphasis was on increasing the number of European Quechua speakers for administrative purposes and the divulgation of the Christian faith.

Miguel Cabello Valboa came to the New World as a soldier and later became a secular priest but remained a campaigner all his life, undertaking numerous missions and journeys of inspection at the request of the ecclesiastical authorities. He arrived in Bogotá in 1566 and was ordained in Quito in 1571. In 1580 or 1581 he began a journey to Lima, passing through the valleys of Piura and spending some time in Lambayeque and Trujillo before continuing on to Lima, where he was present during the Council of Lima in 1582 and 1583. Cabello sought information from the indians themselves as well as referring to the published works and manuscripts available to him. He provides information about Quito and northern Peru found nowhere else. His *Miscelánea Antártica,* was begun in 1566 and completed in 1586. However, it was not published in full until the mid-twentieth century (Valcarcel 1951:xvii–xl).

Cabello makes only one reference to the languages spoken on the North Coast and then only in reference to the northernmost valleys in a rather confused statement on the origins of these populations, who traced their origin to the highlands.

> . . . we have already said how these plains begin to be desolate beginning in the territory of Tumbes, and from that region they were populated by people who came down from the highlands and the same can be said for all the Valley of Pohechos and the banks of the Luchira [La Chira] River; the rest of the Valleys of Catacaos Tangarara and Piura, were also established by highland peoples (as they admit); the people of Olmos (although in language and style of life have been and are very different from their neighbors and those living in the region) are also from the highlands from which the other Tallan peoples descended. The rest of the Valleys (from Motupey [Motupe] Layanca [Jayanca] Lambayeque Callanca [Collique]) have different versions of their origin[3] [Cabello Valboa (1586) 1951:326–327; author's translation; inclusions in brackets added].

Cabello, in addition to providing information about the origins of the residents of the lower La Chira and Piura valleys, sets up a clear distinction between these peoples and those of Olmos, whom he states are different in language and customs

from the Tallanes. Thus we have now definitively located the Tallanes as a cultural group and by default as a linguistic group as well (non-Olmos). This seems to be the earliest mention of Olmos as speaking a distinct language.

The first observations about the other two language groups mentioned by Zárate are roughly contemporaneous and come from the last decades of the sixteenth century.

Fray Reginaldo de Lizárraga was brought to Peru as a youth and spent time in Guadalupe in the lower Jequetepeque Valley. In his *Descripcion breve de toda la tierra del Peru,* he did not comment much about the language situation, but he did note in reference to the indians of Chicama, that "the indians of this valley speak two languages: the fishermen speak one, very difficult, and the other is not so hard; very few speak the general language of the Inga [Quechua]." He goes on to note that Benito de Jarandilla, a Dominican priest, "knew both, and the more difficult [one] best"[4] (Lizárraga [1603–1608] 1968:Chapter XV; author's translation; inclusions in brackets added). This brief passage packs a lot of information, but is not very clear. There were two languages spoken in the valley of Chicama. One characterized as very difficult (for a Spanish speaker), the other less so. This is the first identification of a particular language with fisherfolk, but it would appear to have been common at the time. It seems that the use of Quechua as a lingua franca of government and administration was in frank decline on the coast fifty years after the defeat of the Inka.

In 1593 the archbishop, Toribio de Mogrovejo, began his second personal inspection tour of the area north of Lima from the coast to the Amazon forest, which was part of the archdiocese. The records of this inspection tour indicate the presence of various languages: *yunga, pescadora, yunga pescadora,* and *mochica,* without specifying much about any of them except whether the parish priest spoke the same language as his parishioners.

Mogrovejo did find that a language he called *yunga* was spoken on the coast from Huarmey to Lima and noted the weak presence of Quechua from Ancash to the north (Mogrovejo [1593–1598] 1921:51–58). *La lengua pescadora* was reported from both Magdalena and Santiago de Cao; these villages were in the lower Chicama Valley to the north and south of the river respectively. The priest at Magdalena de Cao was reported to speak "*las lenguas pescadoras*" ("the fishermen's languages"). However, the report of the Mogrovejo *visita* also locates a language referred to as *la lengua pescadora* in Magdalena de Eten on the coast north of the mouth of the Chancay (Reque) River (Mogrovejo [1593–1598] 1920:238). The language of Chepen in the valley of the Chaman River, between the Pacasmayo and Chancay (Lambayeque) valleys, is given as *yunga* as was that of Callanca and Monsefú in the Chancay Valley as well as Chiclayo, "la lengua materna yunga de estos valles" ("the native *Yunga* language of these valleys") was spoken, but the language of nearby Lambayeque is given as *mochica,* "*la lengua mochica que se habla en*

estos valles" ("the Mochica language which is spoken in these valleys") (Mogrovejo [1593–1598] 1920:51–81) (see Figure 8.2).

Despite the geographical parameters implicit in a parish-by-parish ecclesiastical tour of inspection, the Mogrovejo records are less helpful than might be expected. Mochica is mentioned only once, for Lambayeque. Yunga, which broadly simply refers to the speech of lowlanders, could refer to one or more different languages, particularly if the reports of *yunga* speakers at Huarmey and points south almost to Lima are taken into account. What is to be made of the *lengua pescadora?* This tongue (or tongues) appears to reflect an established reality on the littoral of the Chicama Valley with a northern extension to Eten. Again, a socially identifiable group is linked to a specific language. Are there three language groups in the region from the La Leche to the Santa rivers: *mochica, yunga,* and *la lengua pescadora?* Or is the same language being called by different names? One part of the confusion reflected in these data is the apparent breakdown of the linguistic territories noted by Zárate.

Reports on North Coast Languages, 1630–1651

The period between 1630 and 1651 brought renewed interest in the languages of the North Coast of Peru, particularly on the part of the new regional bishops, created at the Council of Lima in 1583 but invested in their offices decades later (Torero 1986:533). The first record of this interest is a report, called *Corregimientos y Doctrinas de los llanos y los que saven la Lengua,* which lists the languages spoken in each of the coastal parishes of the bishopric by *corregimiento,* a secular administrative unit. It was originally transcribed and published by the Peruvian scholar Josefina Ramos de Cox (1950); it is also available in Netherly (1977:Appendix 1). Using internal evidence, it is possible to refine the date of this document to 1631–1632 (Netherly 1977:92n1). There are also two important works by priests living in the area, Antonio de Calancha (1638) and Fernando de la Carrera ([1644] 1939). The first is a chronicle and the second a grammar of the Mochica language (called "*Yunga*" by Carrera). Finally, a second ecclesiastical report in 1651 assessed the language needs of the archdiocese.

The first report to the bishop of Trujillo lays out the basic architecture of the linguistic landscape (Netherly 1977:Appendix 1; Ramos de Cox 1950). It lists all the Indian parishes or *doctrinas* of the North Coast and the languages spoken in each. It begins in the Viru Valley south of Trujillo, followed by Moche and Guaman, Sanc Esteva[n] (an urban parish in Trujillo), Mansiche and Guanchaco—all in the Moche Valley—and includes Santiago [de Cao] and [Magdalena de] Cao in the lower Chicama Valley. The *lengua pescadora* was spoken in all of these parishes. Two additional parishes were mentioned for the Chicama Valley: Chopope [*sic* for Chocope] and Licapa. Here the language spoken was "the language of the valleys which is called Quichua [*sic*] or Mochica."[5] The following parishes in the Jequete-

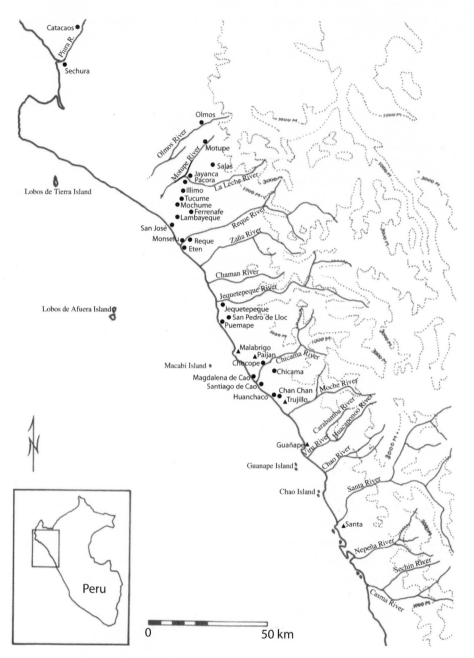

Figure 8.2. The North Coast of Peru.

peque Valley also spoke Mochica as a native language: San Pedro de loco [Lloc], Jequetepeque, Guadalupe, and Pueblo Nuebo [Nuevo]; Mocupe in the Zaña Valley; and Reque, Monsefu, Callanca, Chiclayo, and Sanc Miguel [de Farcapa] in the Chancay Valley. Lambayeque and the *doctrinas* of the La Leche Valley: Ferriñaphe [Ferriñafe], Mocchumi [Mochumi], Illimo, Tucume, Motupe, Jayanca and Pacora, all had Mochica as their mother tongue (see Figure 8.2). Finally, the document lists the four northernmost parishes in the Province of Piura: Sancto Domingo de Olmos, Cathacaos [Catacaos], Sechura, and Payta where "a singular and very difficult language is spoken which is spoken nowhere else in Peru"[6] (Netherly 1977:Appendix I; Ramos de Cox 1950).

The language landscape indicated by this list has a language territory in the south from the Viru Valley to the southern half of the Chicama Valley where a language called *la lengua pescadora,* the fishermen's language, was spoken. Mochica was the native tongue of the largest territory, comprising the Jequetepeque Valley and the Lambayeque complex of valleys, and probably the most speakers. No language is referred to as *yunga* in this document, which reinforces the idea that *yunga* was a descriptive term, lowland language, and not the proper name of a particular language. A lack of familiarity with the Piura parishes is evident in the comment that the same language was spoken in all of them.

In any event, the pattern laid out by Zárate can now be further refined and made much more precise. There was one language group to the south in the region between Viru and Chicama who spoke a language called *la lengua pescadora*. A larger territory, from the northern Chicama Valley to Motupe to the north of the La Chira Valley, spoke Mochica. The Piura parishes make up the third group, although the report lumps the languages of these parishes together. The Quechua speakers on the coast, noted in passing by Zárate for the middle of the sixteenth century, and their declining number noted in the Mogrovejo *visita* at the end of the century, do not appear in this account.

The second source for the linguistic landscape at this time is the Augustinian, Antonio de la Calancha, who spent time at the Augustinian convent in Guadalupe in the Jequetepeque Valley during the first third of the seventeenth century. His *Crónica moralizada del orden de San Agustín en el Perú* was published in Barcelona in 1638. He offers information not found anywhere else as a result of his residence in the Jequetepeque Valley. He had this to say of the languages spoken north of Guadalupe: "in the other valleys of the plains they spoke the Muchic language, which today is found as far as Motupe, and another called Sec; and the one of those from Olmos changes the letters and endings, even so each town and even each family has its own language or different words"[7] (Calancha 1638:550; author's translation).

Calancha here distinguishes between the speech or language of Olmos from another he calls Sec and also from the Muchic spoken in Lambayeque. This is not so

different from Zárate's comment made a century earlier, but Calancha does not say where Sec is spoken.

Elsewhere, Calancha mentions two other languages in an account from Guadalupe in the Jequetepeque Valley that is not found in any other author. He links these languages with the Chimu expansion centuries earlier.

> A ruler of what is today called Trugillo, called the Chimo, . . . as he conquered the Yunga indians [i.e., indians of the coast] . . . from Paramunga, [Paramonga] to Payta and Tunbes [Tumbes] . . . he would introduce in preeminence his native language, which is the one spoken today in the valleys of Trugillo [Trujillo]; it was Quingnam, the native [language] of this petty ruler; and thus to celebrate his memory, the Province [realm] was called Chimo [and] the vassals of Pacasmayo began to speak his language, and all the rest as far as Lima, although some words were corrupted[8] [Calancha 1638:549–550; author's translation; inclusions in brackets added].

Calancha here gives for the first time the indigenous name for the language spoken in the south: Quingnam. He indicates that, just as the Inka imposed their native tongue on conquered provinces as an instrument of governance, the rulers of Chimor did the same. Perhaps, by referring to the Chimu ruler as a "petty ruler," "*reyzuelo*," this account reflects the disdain of the natives of Pacasmayo for the Chimu conquerors who were subsequently defeated by the Inka. Nonetheless, Calancha gives Quingnam as the language of the southern culture area centered on the Moche Valley, seat of the Chimu capital of Chan Chan. He suggests that the language was adopted in the Pacasmayo Valley as a consequence of expansion and indeed followed Chimu conquest as far as away as Lima.

Calancha returns to this point again, "the language they speak [in San Pedro de Lloc and Jequetepeque] is Muchic and Quingnan, difficult [to learn] and hard to pronounce. *La [lengua] pescadora* is in general the same but more guttural"[9] (Calancha 1638:606; author's translation; inclusions in brackets added). The locus of Pacasmayo as a valley of language transition is made clear here thanks to Calancha's greater familiarity with the area. Muchic [Mochica] and Quingnam are both spoken in the parishes of San Pedro de Lloc and Jequetepeque on the south bank of the Pacasmayo River. Calancha does not mention the Mochica speakers at Chocope and Licapa in the northern Chicama Valley immediately to the south, noted in the more detailed report to the bishop of Trujillo, but the Chicama Valley was clearly also a zone of linguistic transition (Netherly 1977:Appendix 1; Ramos de Cox 1950). Thus, the language of the southern area noted originally by Zárate was indeed distinct and called Quingnam. Phonetically, this term appears consistent with the names and place names from the region; it is not a Mochica term. The nature of *la lengua pescacdora* is now revealed as a variant of Quingnam spoken on

the littoral by the fisherfolk in the heart of the southern area now expanded to include the Viru Valley. This explains how the southern language came to be referred to by this term in Mogrovejo's report ([1593–1598] 1920:238) and in the report to the bishop of Trujillo as well (Netherly 1977:Appendix 1; Ramos de Cox 1950).

The grammarian Fernando de la Carrera was born in Lambayeque and spoke the local language from childhood. He published his *Arte de la Lengua Yunga* in 1644. Carrera, as Torero notes, was partial to the Mochica language and, by calling it "*yunga*" sought to expand its territory and squeeze out the competition as it were, indicating for example, that "*yunga,*" that is, Mochica, was spoken in all the parishes of the Chicama Valley, with no mention of the Quingnam speakers in Santiago and Magdalena de Cao (Torero 1986:538). The *Arte* provides the largest vocabulary and most extensive grammatical treatment of any of the coastal languages. Torero has recently published an extensive linguistic analysis of Mochica that offers greater depth than his initial study (1986, 2005:299–368).

Finally, there is the report written in 1651 for the bishop of Trujillo, found in the Archivo General de Indias in Seville by the Peruvian scholar Maria Rostworowski de Diez Canseco, which offers another indication of the decline of Quingnam (Rostworowski 1975b:320). Unlike the earlier report, which was an account of the parishes, the languages spoken in them, and the language competence of the parish priests, this report discusses which languages in the diocese require the appointment of a specialist to examine the candidates for a particular parish where Spanish is not spoken. Thus, it is a question of spending money: "if in this bishopric of Truxillo [Trujillo] a professor were necessary, there would have to be five because of the diversity of the languages, one for the general [language] of the Inga [Quechua] for the highlands, one for the town of Olmos which has its own language, and another for Sechura, which has another language; and another for Catacaos and Payta which speak a different language; and another for the rest of the towns in the valleys, where a language called Mochica is spoken; and for the examiners who know what the appropriate language would have to be called"[10] (AGI Lima 55, f. 6, 1651; in Rostworowski 1975b:320; author's translation; inclusions in brackets added). What is remarkable here is the complete absence of Quingnam (or its variant, *pescadora*). This was the language spoken in the valleys around Trujillo. The language had not disappeared in a span of only 20 years. However, it is clear that in these valleys around the Spanish center several processes were probably in play. The first is demographic loss. Cultural loss and pressures for assimilation brought about by exposure to European culture would also have been a powerful incentive toward bilingualism. Thus, it was less necessary for the Spanish to invest time and energy learning a language they perceived as difficult if there were a sufficient number of Quingnam speakers, who could speak or at least understand Spanish.

The information about the languages of the Piura region is much more detailed than in any of the preceding accounts. The much-commented speech of Olmos is

counted as a separate language. Catacaos and Payta are credited with another distinct language. A different language is spoken in Sechura. The much more thinly populated province of Piura would appear to have two discrete languages in addition to the speech of Olmos.

This review of the sixteenth- and seventeenth-century written evidence for the autochthonous languages of the North Coast of Peru, rather than revealing a cultural landscape with a coherent and comprehensive pattern of linguistic and social distribution, reveals flickering and unstable images, a product of the limited understanding, experience, and intentions of the foreign observers. This perspective will be clarified and stabilized by a consideration of the final landscape of language and how it fits into the palimpsest of landscapes we are endeavoring to recover.

The Comparative Study of Martínez de Compañón

The final source for information about North Coast languages to be considered is information from the comparative language lists compiled for the Archbishop of Trujillo, Baltasar Jaime Martínez de Compañón. In the eighteenth century the archiepiscopal diocese included northern Peru from Zarumilla to the middle and lower course of the Huallaga River. Thus it included the province of Jaen. Between 1782 and 1788, parish priests from different areas of the diocese with knowledge of the local language were asked to complete a word list using the native terms from their locality. The results of this extraordinary endeavor were compiled as a table; copies were sent to Spain and others remained in archives in Peru and Colombia.

Archbishop Martínez de Compañón was an intellectual of the Enlightenment, an *Iluminado*. He employed a cadre of priests and clerks to draw maps, illustrate local customs and dress of all classes of people, excavate ancient tombs, and inquire into the languages spoken in the archdiocese. The result of the latter endeavor was a comparative word list from all the languages spoken in the archdiocese laid out in the form of a table. This table was first published in Peru (Zevallos 1948); subsequently, it was included in the second volume of a handsome facsimile edition of all the maps, plans, and drawings produced under Martínez de Compañón, which was published in Spain (Martínez de Compañón [1782–1788] 1982). Comparative equivalents are given for 43 terms in nine languages: Spanish, Quechua, Yunga "of the provinces of Trujillo y Saña," Sechura "of the province of Piura," Colan "of the province of Piura," Catacaos "of the province of Piura," Culle "of the province of Huamachuco," Hivito "of the missions of Huailillas," and Cholon "of the same missions." This table was studied by Paul Rivet (1949). Alfredo Torero is the only other linguist to consider this pre-Swadish comparative list (Torero 1986:527).

Torero makes the point that the Quechua list is in the Quechua of Cusco, rather

than in either of the two northern dialects of Quechua: Ferreñafe or Chachapoyas. He also identifies the *Yunga* on the table as the Mochica language described by Carrera and notes that these words recorded at the end of the eighteenth century are intermediate in form between the language recorded in the seventeenth century by Carrera and the more recent word lists recovered in the nineteenth and early twentieth centuries from living speakers (Torero 1986:530). The other languages on the Martínez de Compañón table include three from Piura: called Sechura, Colán, and Catacaos respectively for the parishes in which they were spoken. Culli, a language spoken in Otuzco and Huamachuco in the highlands east of Trujillo until the end of the nineteenth or the first decades of the twentieth century is also given. Finally, there are two languages, Hivito and Cholón, spoken to the east of the cordilleras. Absent from this late eighteenth-century list is Quingnam, or *la lengua pescadora.*

Analyzing the words from the different languages in the Martínez de Compañón table, Torero was able to make a first determination of the degree of independence between these languages and the degree to which they shared vocabulary—a criterion for length of contact. The results indicate that Quechua is an independent language that shows no influence from or on the coastal languages and some shared vocabulary with Culli. *Yunga,* or Mochica, is also an independent language with little or no lexical mixing with neighboring languages. Of the three languages given for Piura, Colan and Catacaos are either closely related languages or divergent dialects of the same language. Torero calls this language group "Tallán." Sechura is an independent language that shares some 30 percent of its vocabulary with the Tallán group, which is not surprising given their proximity to each other (see Map 8.1). It is instructive to compare the names in the seventeenth-century documents from Sechura and Catacaos published by Rostworowski in *Curacas y sucesiones: Costa Norte* (1961); it is very clear that these are different languages. The same can be said for the names in the documents cited from the Lambayeque and Chicama regions in Netherly (1977). The phonology is distinct.

There is no language given for Olmos in the Martínez de Compañón table. Torero concludes that the speech of Olmos was probably a mixed language with words from Mochica and phonology and morphology from Sechura (Torero 1986: 544–545). The population of the Olmos region appears to have been mixed. There is ethnohistorical evidence that the area was settled by groups from the highlands (Cabello Valboa [1586] 1951:326–327), probably repeatedly and certainly in the course of the sixteenth century. Brüning published colonial records that indicate that at least some of the original inhabitants of Olmos came from Sechura (Brüning 1922:11–15). The inhabitants of Olmos were famous as muleteers in the sixteenth century, transporting Spanish goods from Paita around the great Sechura desert to Lambayeque (Huertas 1991; Netherly 1977). These circumstances offer some explanation for the mixed nature of Olmos speech.

Languages of the Gulf of Guayaquil and Manabí

Unfortunately, Torero could not extend his study to the region around the Gulf of Guayaquil, including Tumbes, the Island of Puná, and the Pacific coast of Manabí; in these regions place names are the best remaining linguistic evidence along with statements that there was a lingua franca used by traders. It is possible that the Tallán language group may have included the language spoken in Tumbes. My personal impression is that a related language may have been spoken along the eastern shore of the gulf, but the analytical study remains to be done. There may have been more than one lingua franca in the region and traders were probably multilingual.

Landscape of Language on the North Coast in 1528

The trajectory of Spanish attempts to understand and deal with the languages of the North Coast ends at the end of the colonial era with the comparative lists of the Martínez de Compañón table. This long and complex review of the colonial references to the linguistic situation on the North Coast of Peru was necessary to disclose the underlying landscape configurations. The results have important implications for understanding the prehistory of the region (see Figure 8.3).

The linguistic landscape in the first decades of the sixteenth century before the arrival of the Spanish can be summarized as follows. The language of the Chimu heartland—the Viru, Moche, and Chicama valleys—was Quingnam. As the Chimu state expanded to the south to Casma and beyond, Quingnam followed as the language of administration. However, it is by no means clear whether the *yunga* language reported in the report of Archbishop Mogrovejo in Huarmey and other areas of the coast was Quingnam or some other language spoken by coastal peoples. As Chimor expanded to the north to the Pacasmayo Valley and into the Lambayeque complex of valleys, Quingnam was imposed by the conquerors on the very large population of Mochica speakers as the language of administration. The native language of the valleys from Jequetepeque on the south bank of the Pacasmayo River to Motupe on the northern rim of the Lambayeque complex of valleys was Mochica (Carrera's *yunga*). However, in 1528, before the arrival of the Spanish, the whole North Coast region was under Inka domination, and the language of administration was Quechua. Quingnam had disappeared from everywhere in the Mochica language area in the period between the Inka conquest and the arrival of the Spanish, with the exception of the polity of Jequetepeque.

Farther north, in Piura, there were two discrete autochthonous languages: Sechura, which was surely spoken in communities around the Bahia de Sechura from the south side of the mouth of the Piura River south to Punta Aguja; and Torero's Tallán group (Martínez de Compañón's Catacaos and Colan). The large

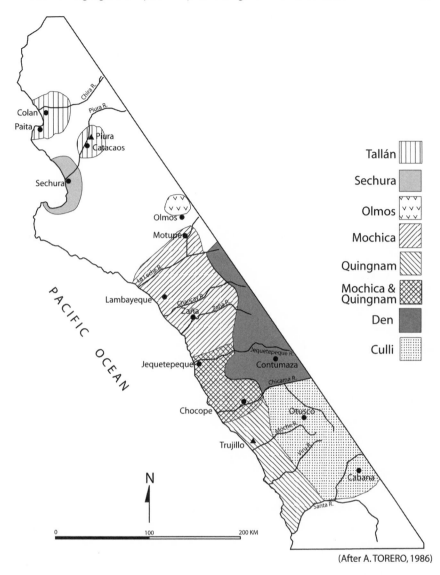

(After A. TORERO, 1986)

Figure 8.3. Language areas of the North Coast of Peru during the early colonial period.

number of loan words suggests that Sechura and the Tallán group of languages had a long history of contact. It is probable that the speech of Tumbes was related to Tallán and possible that some form of Tallán may have served as a lingua franca in the Gulf of Guayaquil region. This far northern region had been conquered by the Chimu with consequent exposure to Quingnam prior to the Chimu defeat at the hands of the Inka. The distinctive speech of Olmos, which appeared to be a

separate language to the Spanish traveling from Paita to Lambayeque, is better described as a mixed language (Torero 1986:544–545) and may well be a development of conditions after 1532.

There were two areas of linguistic transition between Quingnam and Mochica during the Spanish colonial period: on the north bank of the Chicama River, specifically in Paiján and Chocope where Mochica was spoken in addition to Quingnam; and on the south bank of the Pacasmayo River in Jequetyepeque, where Quingnam was spoken as well as Mochica. A glance at the map will show that these are adjacent regions separated by the Contumazá massif. The colonial ecclesiastical reports make it clear that this is not a question of bilingualism. Rather, there were groups of people speaking either Quingnam or Mochica united in what had been a pre-Inkan political unit. The circumstances under which each linguistic group got there may well be different.

The language landscape of the North Coast macroregion lacked a longitudinal linguistic unity as might be inferred from an uncritical use of the notion of a "yunga" language in all the coastal valleys or an uncritical application of *lengua pescadora* to include the speech of all fishermen. Quingnam was located in the block of valleys to the south made up of Viru, Mochey, and Chicama. The extension of Quingnam through Chimu conquests to the north and to the south was ephemeral at best. In contrast, the large and complex group of valleys from Jequetepeque to Motupe, where the Mochica language was spoken, reflects a political reality of long standing; the people of this region survived defeat by the Chimu and then by the Inka without ever relinquishing their cultural and linguistic distinctiveness. Archeologists have recognized the cultural distinctiveness for some time without reference to the reinforcing linguistic difference of which they have been unaware (Bawden 1996; Dillehay 2001; Shimada 1990, 1994). The small polities of Piura with their different languages in 1528 may have been relatively recent or, more probably, had incorporated relatively recent migrants into a long-standing coastal culture.

The linguistic divisions of the North Coast landscape into blocks of valleys would appear to reinforce the transverse configurations seen in the local political economy at a somewhat larger scale. Even the fishing populations would appear to participate in a transverse east–west landscape dynamic rather than a longitudinal north–south one. The language differences between Mochica speakers in the Lambayeque and Jequetepeque complex of valleys and the Quingnam-speakers in the Moche, Chicama, and Viru valleys did not prevent cultural interaction. However, they go far to explain why the cultural trajectory of Lambaeque and Jequetepeque differed even in Moche times from that of the Moche and Chicama valleys and why there was a late Moche center in each region. The Lambayeque polity (or polities) in the early Sican period influenced the southern valleys at the end of the Moche V and during the early Chimu periods. Was there a longitudinal landscape

joining the North Coast valleys to the Gulf of Guayaquil and the Pacific coast of Manabí? The evidence for such a landscape will be examined in the next section.

Longitudinal Landscapes of Political Validation

Transverse Maritime Landscapes

The natural environment suggests two regions arrayed south to north that offer potential as longitudinal landscapes expressing human relationships: the mountains and the sea. The cordilleras between Loja in modern Ecuador and Cajamarca, east of the North Coast valleys in Peru do not present the geographic barriers they do to the south. There were roads before the Inka highway system. It is not clear how much longitudinal movement there was over land during the late prehispanic period.

The second is the sea. Pelagic fishing is abundantly illustrated on early Moche pottery, where not only naturally occurring marine creatures but also marine deities are illustrated. The sacralized figures are seen in watercraft made of bundled reeds. There are also depictions of fishermen on smaller craft similar to the *caballitos de totora* used by coastal fishermen today (McClelland 1990). Like the land, the marine environment was considered to be made up of discrete fishing grounds and resource areas of different kinds. These were apportioned among the corporate groups of fisherfolk in a manner analogous to the apportionment of particular resources on land among the different sections of the farming population in a particular polity. Thus the landscape, in the sense of the political economy, of a particular segment of a valley—a moiety or section of a moiety—would have access to both terrestrial and marine resources through specific component groups or *parcialidades* (Netherly 1977, 1990). This is an extension of the transverse landscape of the larger valley and subvalley sociopolitical units.

The *Spondylus* Transformation

If this is the case, where, then, does the notion of a longitudinal maritime landscape come from? The archaeological record provides important clues. Shimada reports that in Moche V times the quantity of shell from the sacred warm-water mollusks, *Spondylus calcifer* and *Spondylus princeps,* found in burials and caches within adobe platform mounds increased exponentially in the Lambayeque Valley at the large Moche V site at Pampa Grande and in the Batan Grande complex of mounds (Shimada 1990, 1994).

Spondylus sp., the thorny oyster, is found only in warm waters such as the Ecuador Current off the Pacific Coast of Ecuador. It is not found in the cold waters of the Humboldt Current off the North Coast of Peru or in the Gulf of Guayaquil whose waters are also cooled by the Humboldt Current. It grows at depths of up to 20 m and must be harvested by trained divers. Mature specimens are protected

from fish predation by long spines, which are absent in immature specimens (Keen 1971:96–98; Paulsen 1973). The inner rim of the shell of *Spondylus calcifer* Carpenter is a reddish purple; that of *Spondylus princeps* Broderip is coral red in color. *S. princeps* grows singly and in small numbers at a greater depth than *S. calcifer,* which grows in larger numbers and is more easily harvested (Keen 1971:96–98). *S. calcifer* was made into beads and other artifacts (Pillsbury 1996:317).

On the Pacific coast of Manabí during the fourth millennium B.C., beginning in early Valdivia times, *Spondylus* sp. was harvested, eaten, and the shell worked into ornaments and tools. However, at this early date, there is no evidence that it was traded any distance (Paulsen 1973; Raymond and Burger 2003). The sea snail *Strombus* sp., which lives in the intertidal zone, was also taken; the shell was used as a trumpet and fashioned into other objects as well. Later, in the Chorrera period in the late Ecuadorian Formative, during the last millennium B.C., quantities of *Spondylus* and *Strombus* were traded to the southern highlands of Ecuador and appear at sites like Cerro Narrio and Pirincay (Bruhns 2003:361). During this period there were extensive trade routes through the highlands to the north and to the south into Peru along which the shell and other materials, particularly obsidian, moved. The ideology that may have accompanied the shells south or that was devised around them is not known directly, but their sacrality is clear. Both *Strombus* and *Spondylus* appear in the hands of the Smiling God on the Tello Obelisk at Chavin (Lathrap 1973; Paulsen 1973). More interesting is the presence of a cache of *Spondylus* beads and small fragments of shell weighing some 2.5 kg in total among other valuable offerings in the grave of an old woman at Kuntur Wasi (Bruhns 2003; Kato 1993). Kuntur Wasi, a Chavin-related site, lies to the north of the Pacasmayo River not far to the east of the Jequetepeque Valley. This movement of shell through the highlands was longitudinal, north to south. As might be expected, the amount of shell involved was small.

The quantity of shell seen in the North Coast valleys continued to be small until the end of the early intermediate period, when it suddenly increases during Moche V times. As noted, increased amounts of *Spondylus* were reported at Pampa Grande (Shimada 1994). However, by middle Sican times (A.D. 900–1100), scenes depicting diving for *Spondylus* bivalves appear on ear spools and other ritual objects in precious metals, at least eight of which Cordy-Collins has traced to Batan Grande in the La Leche Valley of the Lambayeqye complex (Cordy-Collins 1990; Shimada 1990:299). The depictions are realistic and show an individual on a balsa raft holding lifelines for two divers, who are below the boat harvesting *Spondylus.* This scene is also found on other ritual objects: an engraved plaque, the handle of a ritual *tumi* knife, and a silver cylinder (Cordy-Collins 1990:404–407). A well-known wooden bowl inlaid with stone and *Spondylus* depicts the same scene, and on the interior, the outer register depicts crops including maize, reinforcing the association of *Spondylus* with agricultural productivity first seen on the Tello Obelisk

at Chavin (Cordy-Collins 1990:405; Paulsen 1973; Pillsbury 1996:329). The exception is a gold ear spool, one of a pair, that depicts a procession of individuals in different dress carrying *Spondylus* bivalves (Cordy-Collins 1990:407). If the diving scene reiterates the arduous work of diving for *Spondylus* and by association magnifies the power of the lord or priest who was able to command the precious shell, it answers no questions about who the *Spondylus* divers were or how the shell was brought to Lambayeque. It is worthy of note that all these depictions are from the period *before* the Chimu conquest of Lambayeque.

Depictions of *Spondylus* divers appear in the Moche Valley in what appear to be early Chimu or perhaps early middle Chimu times. The recently recovered relief in the Uhle compound at Chan Chan called *Los Buceadores* (The Divers), excavated and described by Pillsbury, depicts *Spondylus* divers (Pillsbury 1996). Persons carrying *Spondylus* shells are depicted in a later fragmentary relief on the *Plataforma de las Vírgenes,* also in the Uhle compound. There is another, later, relief fragment in an area of access to storerooms in Ciudadela Squier that appears to depict a *Spondylus* diver. In a late relief at Huaca Esmeraldas *Spondylus* bivalves are depicted as elements in a border panel (Pillsbury 1996).

Depictions of *Spondylus* on portable objects were not recovered at Chan Chan. However, the caches of wooden figurines recovered from the Huaca Dragón and the Huaca Tacaynamo, located to the northeast of the Chan Chan palaces and about 500 m distant from each other, are early Chimu in date, but Tacaynamo may be slightly later. The small-scale wooden figures may well have depicted a ritual and included not only litter bearers but also miniature litters. Of the three litters recovered, two from Tacaynamo and one from Dragón, one from each location had a backrest inlaid with shell. The litter from Tacaynamo depicts a central figure with a crescent headdress holding the ropes of two divers with weights and what may be a *Spondylus* bivalve. In the backrest from Dragón, there are four figures with crescent headdresses in a central cartouche, surrounded by anthropomorphized waves and abundant marine life (Jackson 2004:307). On the basis of my own research (Netherly 1977), I would suggest that the burial platforms at Huacas Dragón and Tacaynamo are not part of Chan Chan proper. Rather they represent the resting place of great lords allied with and probably related to the early Chimu rulers, and particularly those who occupied the Uhle palace. The appearance of the *Spondylus* divers motif at Uhle reinforces this supposition. The depictions are in the Chimu style and lack watercraft.

From a landscape perspective, in Lambayeque, during Moche V and early Sican times, several conditions appear to have come together. First of all, the societies of the Pacific coast of Manabí had the manpower with the skills needed to engage in a large-scale *Spondylus* fishery for which there was an external demand as well as a sociopolitical structure to sustain large-scale trade, perhaps over long distances. In like fashion, the societies of the Lambayeque region had reached a

level of complexity such that there were dedicated specialists who could engage in long-distance trade as corporate groups (i.e., *parcialidades*) under the aegis of a sanctuary or a great lord. It is important to note here that there is no blueprint in the archaeological data to suggest this organization, nor does the organization have to have been similar in Manabí to what it was in Lambayeque, a much larger society.

A third development is that of watercraft. Moche fine-line drawings on pottery depict quite elaborate vessels made of bundled reeds (McClelland 1990). The problem with reed vessels of any size is that they quickly become waterlogged and must be allowed to dry before being used again. Thus, coastwise movement for purposes of exchange in such vessels would be limited by the need to put in to shore frequently.

The balsa log rafts used in the far north of Peru in Piura and Tumbes and in the Gulf of Guayaquil and off the Pacific coast of Manabí were made of balsa wood, which lost its buoyancy much more slowly. Extra logs could be incorporated into the superstructure and removed as needed. Additionally, while these craft may have had sails, navigation was by means of centerboards, a series of vertical boards inserted between the logs of the raft that allowed the raft to make headway against the current (both the northward flowing Humboldt and the southward flowing Ecuador Current), something the Spanish sailing vessels were unable to do (Netherly 1977). The development of these craft was an achievement in marine engineering, which is too often underappreciated.

Finally, there was evidently a redefinition of the sacred importance of *Spondylus* from a scarce, ritual item to what was called the "food of the gods," required in quantity as grave goods, in caches, and as beads in impressive quantities (Jackson 2004; Murra 1975; Shimada 1990, 1994). These developments took place first to the north in the area of Mochica speakers and the ambit of Lambayeque culture. By the middle Sican period in Lambayeque, great lords, in their roles as living (and dead) ancestors and intermediaries with the divinities on behalf of their people, gathered large quantities of *Spondylus* shell in the form of whole bivalves, and worked ornaments and sacred objects. They also ground the shells into dust to reinforce their own sacred nature. Not only did *Spondylus* represent sacred power; it also represented wealth, a store of value. In the form of beads, called *chaquira*, *Spondylus* came to be a medium of exchange, so necessary for the next life that they were included as grave goods by the kilo.

The lords of the valleys of the Quingnam heartland shared these beliefs but found themselves at a disadvantage because of distance and perhaps because of language. Surely one motive for expansion into the Lambayeque complex of valleys was in part a desire to obtain easier access—through the traders of the Lambayeque lords—to larger quantities of the precious, and essential, shells. The resentment of the Lambayeque populations is perhaps well illustrated in the maladroit execution

of the reliefs at Chotuna, which copy Chimu themes present at Huaca Dragón in the Moche Valley, or in the characterization of the principal Chimu ruler as "a petty lord," centuries after the conquest of the Lambayeque region by the Chimu as noted above.

The Imagined Landscape of Myths of Political Validation

An examination of myths of sociopolitical origin and validation from the North Coast shows how myth functioned in these societies as a means of conserving memory and sociopolitical cohesion within a landscape that is entirely congruent with the foregoing. There are three myths to be considered from different societal levels: the myth of origin for the community of Eten, a fishing polity at the mouth of the Chancay River in Lambayeque; the well-known myth of origin of the Lambayeque polity; and the truncated myth of origin of the Chimu rulers. Structurally, they share many features, which—given the differences in scale—is testimony for the strength of the concepts expressed.

The Myth of the Origin of Eten

The first myth is an account of the establishment of Eten as an ethnic polity. This oral tradition was collected and published by Jacinto Liza, himself an Etenero, in 1967.

> The Mochica tradition of Eten states that: It is known that in this place in a very remote time there came from the sea a flotilla of balsa rafts carrying many men who came from the North with their families. [And] that the crew of the raft that carried their leader, seeing that night was falling without their finding a place to land, asked him "*Angas nerren, inis tuch?*," which in their Mochica language means "It is time for prayer [Vespers?] Where are we going?" or "It is getting late. Where will we land?" To which their leader replied, "*Ynis atin, atin az nerren*," which means "Where we are at dawn, there we will stay until prayers" or also "There where the sun rises, there we shall land." And in fact the next day at dawn or sunrise on seeing the beautiful hill and the muddy waters [the Morro de Eten and the Reque River], they shouted "*Atin! Atin!*" . . . which means "The sunrise! The sunrise!" . . . And they all disembarked at the mouth of a swift and wide river near which there were a large number of "tumis" (sea lions). [And] that from that time they called this place Atin and the river Tumi. [And] that all the families of the great Mochica tribe scattered and took possession of the whole immense, rich valley, building huts and constructing tall pyramids of adobe bricks for worship of their idols and as fortresses[11] [Liza 1967; author's translation; inclusions in brackets added].

In this myth a mass migration of men and their families under a leader came by balsa raft from the north and ultimately landed between the rocky headland called the Morro de Eten and the mouth of the Reque River (the lower course of the Chancay River). The ecological advantages of the point of landing—a rocky headland at the mouth of a large river—would provide access to several important resource zones: the sea lion rookery, the estuary, the beach zone, and offshore fishing zones. The mode of transport was by balsa raft—a craft that was common from Piura northward. The place of origin is clearly stated to be to the north. The Mochica words included in the account, particularly *nerren,* afternoon, and *inis,* which appear in several of the nineteenth- and twentieth-century Mochica word lists with meanings consonant with Liza's translations (Altieri in Carrera 1939:xi–xvii; Kosok 1965:248–249; Netherly 1977). The natural world becomes a landscape of the sea and littoral with resources important to a fishing population. Despite speaking Mochica, the travelers come from the north as witnessed by the use of balsa rafts made of a wood that grew inland in Piura (perhaps), in Tumbes (certainly), and around the Gulf of Guayaquil and on the coast of Manabí, evoking a landscape still familiar to Lambayeque fishing populations in the first decades of the twentieth century, contemporary with this oral history of ethnic origin.

The Myth of the Origin of Lambayeque

This legend for the origin of Lambayeque, the Naymlap account, is found in Cabello Valboa. As a myth it offers an account of the establishment of a major polity and its component parts cast in the form of a migration from afar and a genealogy. Such myths serve to validate the status quo (or a remembered time of greatness) and important cultural principles. The landscapes evoked in this account are both local and extensive and entirely coherent with those presented in the previous section. Cabello, who spent time in the town of Lambayeque on his journey from Quito to Lima, probably recorded this myth there from members of the Lambayeque polity. Cabello states:

> The natives of Lambayque say (and the rest of the neighboring peoples of this valley agree) that in very ancient times that they do not know how to count there came from the frontier of this Peru with a great flotilla of balsa rafts a father of companies, a man of much courage and rank called Naymlap and he brought with him many [secondary] wives in addition to his principal wife who is said to have been called Ceterni he also brought many people in his company who followed him thus as a captain and leader but those who were most distinguished among them were his functionaries who were forty in all, such as Pita Zofi who was his trumpeter or sounder of giant snail [shells], which are greatly esteemed among the Indians another [was] Ninacola who was the one who had special charge of his litter and Seat, and

another Ninagintue who had charge of the drink of that Lord as a butler, another called Fonga sigde who was charged with scattering seashell dust on the ground where his Lord was to walk, another Occhocalo was his Cook, another had charge of the ointments and color with which the Lord decorated his face—he was called Xam muchec Ollopcopoc was charged with bathing the Lord, another principal [person] highly regarded by his Prince was Llapchiluli who made tunics and clothing with feathers, and with these persons (and an infinity of other functionaries and men of rank) he had his person and his household adorned and validated[12] [Cabello Valboa (1586) 1951:327; author's translation; words in brackets added].

Again, an acknowledged leader heads a large company, including his own principal and secondary wives (*concubinas* is a code for secondary wives in Spanish colonial religious parlance), forty individuals associated with positions of responsibility (*oficiales*) of whom eight are named. Eight ranked lords, divided into two moieties and two cross moieties, making a total of four sections is an almost universal feature of North Coast sociopolitical organization (Netherly 1977, 1984, 1990). We should not be deceived by their titles of honor as attendants upon Naimlap's person; these are great lords in their own right. Further, as we come to understand that rule and authority on the North Coast was a performance art—a point made by Moore for Chan Chan, it can be seen that each of these titleholders contributes to that performance (Moore 1996; Rowe 1984; Shimada 1994). Division into forty is congruent with this organization but we do not know in what circumstances it came into play.

Translators must always make choices when going from one language to another, translating the meaning rather than the literal words. In retranslating this passage, I have made a number of choices. It is very clear from the internal evidence that Naymlap and his company came from the north. The Spanish phrase *la parte suprema* here does not mean the top, or the top of a map, or the most preeminent part. The Spanish word *suprema* can be glossed as "last, final" (Note 12; Real Academia Española 1956:1227) so that the phrase *la parte suprema de este Piru* can be understood to be the "end" or "final part" of the region culturally similar to the North Coast region. Further, the flotilla of balsa rafts points strongly to the circum Gulf of Guayaquil region and the Pacific coast of Manabí.

Why would it be so important for a great lord in Lambayeque to come from somewhere else, from the land of balsa rafts? He comes with two subordinate lords charged with the care and performance of *Strombus* shell trumpets and with the preparation of a surface of sacred ground shell, presumably *Spondylus,* since this is the kind of ground shell that has been recovered archaeologically (Shimada 1994). To walk on a prepared surface of sacred shell is to proclaim the sacredness of the lord. Thus the landscape of rule as outlined in the origin myth for Lambayeque ex-

tends the view to the north beyond the confines of the Mochica cultural and linguistic area to the region from which comes the sacred shell. Extensive archaeological work in southern Manabí and the Santa Elena Peninsula has not turned up colonies of Mochica fishers using Sican pottery. By the same token, the extensive archaeological work in the Lambayeque region has not turned up sites with Manteño, or Huancavilca, or Milagro-Quevedo pottery in testimony of a mass migration from the north (Shimada 1990). A sacred lord must surround himself with sacred things: *Strombus* trumpets and *Spondylus* shells, artifacts inlaid with *Spondylus* and shell dust to establish his sacred nature. The only other sumptuary goods mentioned in the myth are the feather clothing; the feathers may well have come from a distance, most probably from the east.

The final myth to be considered is that of Tacaynamo, the founder of the royal dynasty of Chimor. The account is fragmentary and lacks the beginning. But the founding lord is presumed to have come by from the north by balsa raft from across the sea and was sent by a great lord to rule in the Moche Valley (Vargas Ugarte 1936:231). The clothing and the yellow powders he used in his rites seem to have been consonant with Chimu cultural practice, but Tacaynamo spoke a different language from the inhabitants of the Moche Valley. He was said to stay in a "house." But there is no mention of his being buried there. This myth seems derivative and our understanding is hampered by its fragmentary nature. Clearly the name or title, Tacaynamo, is Quingnam (Netherly 1977; Torero 1986), but the landscape relations appear less clearly.

Landscapes of Relation on the Western Pacific Coast

Landscapes, as cultural creations, impress upon the observer elements of memory, imagination, and relation (A. Smith 2003). By using relational landscape as a heuristic strategy it has been possible to bring to light a number of unexpected relationships in a field where most of the information has been lying around for decades. Even a consideration of the natural world results in a more complex panorama than initially expected. By looking at transverse landscapes, following the rivers from the mountains west to the sea, local strategies for equalizing access to unequally distributed resources become apparent. The sea, in these landscapes, far from being a longitudinal north–south highway, becomes a horizontal extension of the littoral.

To create a landscape of language that reflects the relations existing between the populations living on the North Coast of Peru, it has been necessary to reexamine the sources and evaluate the information to be found in them with fresh eyes. An assist from the discipline of linguistics emphasizes the need for interdisciplinary approaches in these studies. The final linguistic landscape seems counterintuitive in terms of our expectations for more nearly homogenous cultures, at least on the Peruvian North Coast. Two large, fairly discrete, blocks of speakers of unrelated

languages would seem to present major obstacles, yet make it easier to understand elements of difference, competition, and hostility. Two distinct languages within much smaller areas in Piura, with the possibility of yet a third in Tumbes, appears to have been resolved through multilingualism, given the large number of loan words. The Tallán group of languages may be related to languages spoken around the Gulf of Guayaquil, particularly at the eastern end, but the analytical work on this problem has yet to be done. The precolombian languages on the Pacific coast of Manabí are simply terra incognita. The possibility exists that there were members of these language groups who made it a point to acquire competence in three or four languages. It suggests also that down-the-line contacts may have been more common than a pattern of very long distance trade.

Thirty-five years ago the late John Murra raised a series of questions about what he called "the *Spondylus* trade," most of which have yet to be answered. The relations of the trade elude us yet. It is easier to trace the immense volume of shell moving into the Central Andes after A.D. 700, which apparently corresponds to a religious reformulation of the importance of *Spondylus,* not only for ensuring harvests but also to validate authority in return for sustaining the well-being of the subjects of a ruler. It would appear from the evidence that a number of strategies were followed by different groups. In the Lambayeque complex of valleys rulers had subject to them bounded social groups (*parcialidades*) of persons whose expertise was in long-distance exchange. While the lords were undoubtedly ranked among themselves and their dependent traders may have been as well, the impression from Lambayeque is of a broadly organized system of exchange with shell beads and thin sheets of copper possibly serving as small-scale media of exchange. It remains unclear, however, whether exchange was by sea or overland to Piura and then by sea. Were the ports of Tumbes and Piura entrepôts for maritime traders from around the Gulf and the western Pacific Coast? Were these specialists likewise organized into corporate groups dependent on a lord? This seems probable, but within that organization there may have been another of trading partners, which would simulate independent trading to the eyes of the first Spanish observers. These suggestions are not mutually exclusive and a number of these modalities may have been in operation at the same time.

The case for the Chimu is somewhat different. At a greater distance and without watercraft capable of navigating long distances without becoming waterlogged, the Chimu faced more limited options. It is unclear whether the great (nonroyal) Chimu lords had corporate groups of traders subject to them. In contrast to Lambayeque, there was no trace of this in the Spanish colonial documentation. Chimu exchange may well have been administered trade, which did not survive the double conquest by the Inka and the Spanish. What is clear, however, is that access to *Spondylus* and the supernatural and political validation its possession afforded was undoubtedly a strong motivation for the Chimu expansion to the north. Initially,

this expansion was to Jequetepeque and Lambayeque. There, access to the sacred shell may have been indirect—through tribute required of the Lambayeque lords who had perfected their means of procurement. However, expansion farther north into Piura and Tumbes was probably motivated by access to the points of entry of *Spondylus*. Here, the presence of Chimu facilities suggests that administered trade and direct control of the shell was a strong motivation for expansion at such a great distance.

The structure of the myths of political origin identifies them as related. Most scholars have focused on the purported genealogical succession they offer (the Eten myth has lost its genealogy). However, what has been of interest to the discussion here has been the consistent attribution of a northern origin found in all these myths for the rulers of North Coast polities at different scales. The explanation for this insistence on a northern origin would appear to be that north is the direction from which *Spondylus* is brought, and that possession and ritual use of this sacred shell was the ultimate validation of the legitimacy of North Coast rulers at all levels. Thus the longitudinal landscape derives not from the sea or maritime adaptations in an economic sense; it is an *imagined* landscape for the societies of the North Coast. It is interesting to speculate what the landscape perspective would have been for the trading societies of the western Pacific coast of Manabí, for whom *Spondylus* was not a core sacred feature of their religious practice. Their longitudinal landscape was based on commerce and extended north beyond the Esmeraldas River, perhaps to Panama. Southward it reached the Gulf of Guayaquil, the ports of Piura, and possibly Lambayeque from time to time.

A landscape perspective has made it possible to uncover a series of relationships that have gone far to raise some questions and settle others with regard to the societies and cultures of the North Coast of Peru. Language divergence does not create cultural divergence, but forces us to consider cultural heterogeneity. The amplification of the sacrality of *Spondylus* to include the legitimization of rulers whose political and religious attributes included the preservation and increase of their subjects gave extraordinary importance to a seashell that may have had little or no sacred importance to the primary producers and distributors. Societies are bound together in different ways and at different levels by relational landscapes. These landscapes offer an important tool for the understanding of the complexity of human culture.

Notes

1. The *Contador* Agustín de Zárate, an accomplished and well-connected Spanish administrator, traveled to Peru in 1544 as part of the retinue of the unfortunate Viceroy Blasco Nuñez Vela. He undoubtedly traveled overland from Paita to Lima. After a

year's stay, he returned to Spain with messages from the rebels, fell out of favor, and was incarcerated. During his time in prison he completed his account of the conquest of Peru, using the firsthand accounts of others as well as his own observations. The outstanding Peruvian historian of the chroniclers, Raúl Porras Barrenechea, rated Zárate's history as the best of the early accounts (Porras Barrenechea 1986:215–219). Zárate's account was read in manuscript by the king, Phillip II, and was published by his order in 1555.

2. *Dividense en tres géneros todos los indios de estos llanos, porque a unos llaman yungas y a otros tallanes y a otros mochicas; en cada provincia hay diferente lenguaje, caso que los caciques y principales y gente noble, demás de la lengua propia de su tierra, saben y hablan entre sí todos una misma lengua que es la del Cuzco* . . . (Zárate [1555] 1944:Book I:Chapter VI:31).

3. . . . *ya dejamos dicho como estos llanos comienzan a mostrarse intractables desde la tierra de Tumbez, y por aquella parte ya estauan porblados de gentes bajadas de la Sierra y lo mismo se puede decir de todo el Valle de Cohechos y riberas de el Rio Luchira, los demas de los Valles de Catacaos Tangarara y Piura, ansi mesmo lenguaje, y estilo de vivir, an sido y son muy diferentes de sus vecinos, y comarcanos ser procedidos de la Serrania de donde tanbien descienden las demas gentes Tallanas. Los demas Valles [desde Motupey Layana Lambayeque Callanca Collique] tienen diferentes opiniones en su origen* . . . (Cabello Valboa [1586] 1951:326–327)

4. . . . *los indios de este valle tienen dos lenguas que hablan, los pescadores una, y dificultisima y la otra no tanto; pocos hablan la general del Inga* . . .
. . . *las sabía ambas, y la más dificultosa, mejor* . . . (Lizárraga [1603–1608] 1968: Chapter XV).

5. . . . *la lengua de los valles que es la que llaman quichua o mochica* . . . In Spanish usage the phrase *la lengua general del Inga* or sometimes just *la lengua general* is used to refer to the Quechua language (known as runa simi by its speakers). It would appear that the lexeme "quechua" may have had a meaning congruent with *lengua general*—that is, it designated a language in general use. It is here used as a synonym for Mochica.

6. . . . *una lengua particular y muy oscura que no se habla en otra parte ninguna del Perú* . . . (Netherly 1977:Appendix I; Ramos de Cox 1950).

7. . . . *los demas valles de los llanos hablaban la lengua Muchic, que oy conservan asta Motupe, i otra que llaman Sec; i la de los Olmos mudan letras i finales, si bien cada pueblo, i aun cada familia tiene lengua propia o vocablos diferentes* . . . (Calancha 1638:550).

8. *Un Cazique de lo que oy se llama Trugillo, llamado el Chimo,* . . . *fue conquistando los Indios Yungas* . . . *desde Paramunga, asta Payta y Tunbes,* . . . *fuese introduciendo en majestad su lengua natural, que es la que oy se abla en los valles de Trujillo, era la Quingnam propria dese Reyezuelo; i asi por lisonjearle su memoria, se llamo la Provincia del Chimo los vasallos de Pacasmayo dieron en hablar su lengua, i los demas asta Lima, aunque corrompidos algunos vocablos* (Calancha 1638:549–550).

9. *es la lengua que hablan* [in Jequetepeque and San Pedro de Lloc] *la Muchic i la Quingnan, escura i de escabrosa pronunciación. La pescadora es en lo general la misma, pero usa mas de lo gutural* (Calancha 1638:606).

10. . . . *si en este obispado de Truxillo fuera necesario catedrático, avia de aver sinco por la diversidad de lenguas, uno para la general del Inga para la sierra, y otro para el pueblo de Olmos que tiene lengua particular, y otro para Sechura, que tiene otra lengua; y otro para Catacaos y Paita que hablan diferente lengua; y otro para los demás y pueblos que llaman de los valles, donde se habla una lengua que se llama la Mochica; y para los examenes se llamen examinadores que sepan la lengua necesaria . . .* (AGI Lima 55, f. 6, 1651; in Rostworowski 1975b:320).

11. *Dice la tradición moochica etenana: "Se sabe que por este lugar en una época muy remota, pareció por el mar una caravana de balsas tripulados por muchos hombres que con sus familias vinieron del Norte. Que los tripulantes de la balsa en la que venía su jefe, al ver que ya atardecía sin encontrar el lugar por donde debían desembarcar, le preguntaron a aquél: "Angas nerren ¿inis tuch?, que en su idioma mochica quiere decir: Ya es la oración ¿a dónde vamos?, o también: Ya es tarde ¿a dónde desembarcamos?—Y que el jefe les contestó: Ynis atin, atin az nerren," que quiere decir: Donde amanezcamos, allí estaremos hasta la oración, o también: Allí por donde nazca el sol, allí desembarcaremos. Que en efecto, al día siguiente al amanecer o nacer el sol y ver el hermoso cerro y las aguas turbias* [the Morrode Eten and the Reque River], *exclamaron "!Atin! ¡Atin!" . . . , que quiere decir: ¡Amaneció! ¡Amaneció! . . . Y que todos desembarcaron en la desembocadura de un torrentoso y ancho río cerca del cual deslizaba gran cantidad de "tumis"* [lobos marinos].

Que desde entonces llamaron Atin a este lugar y Tumi al río. Que todas las familias de la gran tribu mochica se posesionaron diseminadas del inmenso y riquísimo valle, levantando chozas y procediendo a construir elevados pirámides de adobes para la adoración de sus ídolos y para sus fortalezas (Liza 1967; words in brackets added).

12. *Dicen los naturals de Lanbayeque* [y con ellos conforman los demas pueblos a este valle comarcanos] *que en tiempos muy antiguos que no saben numerarlos vino de la parte suprema de este Piru con gran flota de Balsas un padre de Compañas, hombre de mucho valor y calidad llamado Naimlap y consigo traia muchas concubinas, mas la muger principal dicese auerse llamado Ceterni trujo en su compañía muchas gentes que ansi como a capitan y caudillo lo venian siguiendo, mas lo que entre ellos tenía mas valor eran sus oficiales que fueron cuarenta, ansi como Pita Zofi que era su trompetero ó Tañedor de unos grandes caracoles, que entre los Yndios estiman en mucho otro Ninacola que era el que tenía cargo especial de sus andas y Silla, y otro Ninagintue a cuio cargo estaua la vevida de aquel Señor A manera de botiller, otro llamado Ponga sigde que tenia cargo de derramar polvo de conchas marinas en la tierra que su Señor auia de Pisar, otro Occhocalo era su Cocinero, otro tenia cuidado de las unciones y color con que el Señor adornava su rostro-a este llamauan Xam muchec tenia cargo de bañar al Señor Ollopcopoc, labarava camisetas y ropa de pluma otro principal y muy estimado de su Principe llamado Llapchiluli, y con esta gente* [y otros infinitos oficiales y hombres de cuenta] *traia adornada y auturizada su persona y casa* (Cabello Valboa [1586] 1951:327; words in brackets added).

9 Inka Pacariqtambo

It Depends Which Eyes Are Looking at It

Jessica Joyce Christie

In this chapter I plan to look at Pacariqtambo, Maukallaqta, and Pumaurqu as possible origin places of the Inka. First I will discuss the chronicles that narrate the story of emergence and its locations, such as Pacariqtambo; second the archaeological evidence that might support an identification of the archaeological sites of Maukallaqta and Pumaurqu with Pacariqtambo; and third, I will explore the relationship between the origin sites and the capital in Cusco and how the mythohistory of origin was interwoven with state ideology. My methodology is grounded in ethnohistory and ethnography, perspectives that squarely match with the archaeological record of Inka state formation that has gradually been emerging as a result of the seminal survey work conducted by Brian Bauer and his colleagues (Bauer 1992, 2004; Bauer and Covey 2002). Such contradictions raise the debate about the nature and definition of historical truth in which it always depends "which eyes are looking at it." These issues will be taken up in the conclusions.

The Textual Evidence in the Chronicles

The Inka honored two places that, in their belief, were connected with their origins: one was the Island of the Sun in Lake Titicaca, which was recognized by most Andean peoples as the birthplace of the sun, and the other was Pacariqtambo/Maukallaqta/Pumaurqu (Pacariqtambo is the place name of the origin site mentioned in the chronicles; Maukallaqta and Pumaurqu are two adjacent archaeological sites that researchers think functioned as the Inka Pacariqtambo) situated in the province of Paruro to the southwest of Cusco, which related specifically to the mythological origins of the Inka state (Urton 1999:34–37, 45–54). Both sites exhibit special rocks with cavelike openings from which Manqo Qhapaq and Mama Oqllu, two mythic-historical founders of the Inka, emerged, but the Sanctuary on the Island of the Sun was a pan-Andean pilgrimage site with multiple layers of symbolic implications while Pacariqtambo/Maukallaqta/Pumaurqu appear to have

been the *paqarina,* or special personalized origin place, of the Inka dynasties. Many Spanish chroniclers intended to write a complete history of the Inka and thus began with their origins and the first ruler Manqo Qhapaq, but since they struggled to reconstruct a remote and quite possibly mythological past, their accounts differ and are not consistent among one another. A detailed comparison of the 40 or so versions of the Inka origin stories recorded between 1542 and 1653 would go well beyond the scope of this chapter, and I refer to other writers who have done just that (Bauer 1991, 1992; D'Altroy 2002; Pardo 1946; Urton 1990, 1999).

What follows is a paraphrased summary leaning heavily on the version given by Sarmiento de Gamboa whom Urton as well as Pardo select as the principal source. Sarmiento's history was written relatively early in 1572 for Viceroy Francisco de Toledo, and according to his word, much of his information was obtained from *khipu kamayuqs* (officials responsible for keeping records on knotted strings) who later verified his story. Further, Sarmiento was the first writer who described Pacariqtambo in more precise geographical terms and added toponyms that can be linked to locations existing today. The Inka first appeared at a place called Pacariqtambo (house of dawn) located approximately 33 km south of Cusco. At Pacariqtambo, there was a mountain named Tampu T'oqo (the house of openings/windows) with three windows or caves. The two lateral windows were called Maras T'oqo and Sutiq T'oqo, and the Maras and Tampu people came out of them. The ancestors of the Inka emerged from the central window, Qhapaq T'oqo, which means "rich window." These ancestors were four brothers and four sisters paired as husbands and wives: Ayar Manqo—Mama Oqllu; Ayar Awka—Mama Waqo; Ayar Kachi—Mama Ipakura/Kura; Ayar Uchu—Mama Rawa. While all accounts say that the ancestors originated from Tampu T'oqo at Pacariqtambo, Martin de Murua, Guaman Poma de Ayala, and Garcilaso de la Vega add that Manqo Qhapaq and Mama Oqllu first appeared on the Island of the Sun and then traveled underground from Lake Titicaca to the cave at Pacariqtambo. According to Sarmiento, the Maras, Tampu, and Inka were born from the caves of Tampu T'oqo by the will of the creator god T'iqsi Wiraqocha who functions as the founder of lineages. The newly emerged or "newborn" peoples allied themselves with the local inhabitants and the eight Inka ancestors quickly assumed leadership. They prepared to go in search of fertile land where they would settle down and to conquer any groups who would get in their way. As a reward for loyalty, they promised conquered lands to their followers and divided them into ten *ayllus* (an *ayllu* is a localized descent group and landholding corporation). These ayllus are very important for a number of reasons: they are known by name (see D'Altroy 2002:51, Table 3.2; Pardo 1946:24; Urton 1990:22–29); their existence in Cusco has been documented historically; and five have been associated with Hanan Cusco and five with Hurin Cusco.

The Ayar brothers and sisters began to walk northward in the direction of the Cusco Valley together with the ten ayllus they had founded. Along the way, they

tested the hardness or softness of the earth by plunging a golden bar into the ground, which they had carried with them from Tampu T'oqo. The Inka ancestors made several stops that help researchers to reconstruct their route during their journey that ended up in Cusco. At Waynakancha, which may be a small Inka site called by this very name today located in the Yaurisque Valley near the Hacienda Waynakancha, Manqo Qhapaq and Mama Oqllu conceived a child. The group moved on to Tamboquiro where Mama Oqllu gave birth to a son whom they named Sinchi Ruq'a and who would succeed his father as the second Inka ruler. The next stop of the ancestors and their accompanying ayllus was Haysquisrro, which may correspond to the present town of Yaurisque located on the dirt road that leads to the archaeological sites Maukallaqta and Pumaurqu. There, three brothers and the four sisters conspired to rid themselves of Ayar Kachi who was cruel, made trouble in all the villages they passed through, and disturbed peace among the ancestors. They sent Ayar Kachi with a companion back to retrieve some items from the cave at Tampu T'oqo, which they said they had forgotten. As Ayar Kachi and the companion arrived at Tampu T'oqo, Ayar Kachi entered the cave, and immediately his companion shoved a large boulder across the entrance, leaving Ayar Kachi trapped inside for all time.

The remaining ancestors and their ayllus continued walking north in the direction of Cusco and came to a mountain with the name Wanakauri. Ascending Wanakauri, they looked down upon the valley of Cusco for the first time. A rainbow[1] stretching over the valley was one of the signs that this was supposed to become their home. The ancestors prepared to descend and take possession of it. At this point, Ayar Uchu was transformed into stone and became one of the principal Inka wak'as. They took time approaching Cusco, testing the soil again and again with their golden staff until it remained stuck in dense fertile ground. When they finally arrived at the place that would become the center of the capital city, Ayar Awka was transformed into a stone pillar.[2] Thus only Manqo Qhapaq, his four sisters, and the young Sinchi Ruq'a were left to found and build the city of Cusco.

The Material and Archaeological Evidence

Scholars such as Pardo (1946), Urton (1990), and Bauer (1992) have identified Pacariqtambo with the archaeological site of Maukallaqta and Tampu T'oqo with the sculpted outcrop Pumaurqu (Figure 9.1) The main reasoning underlying such an identification is the fact that the chroniclers who specify the location of Pacariqtambo place it seven or eight miles (11 or 13 km) to the south or southwest of Cusco and the only major site in this direction and at this distance is Maukallaqta/Pumaurqu. Maukallaqta is situated near the village of Mollebamba, which is politically annexed to the present town of Pacariqtambo in the province of Paruro, Department of Cusco. The present-day town of Pacariqtambo was founded in 1571

Figure 9.1. Pumaurqu, distant view. (Photograph by the author.)

as a *reducción* (reduction) of 11 previously dispersed ayllus into a single, nucleated settlement. The policy of creating such nucleated settlements throughout the Andes was initiated by Viceroy Francisco de Toledo in 1570 and was practiced for about five years. Urton (1990:32) notes the curious historical coincidence between the founding of the town of Pacariqtambo in 1571 and Sarmiento's completion of the *Historia de los Incas* in 1572. Surely, the khipu kamayuqs whom Sarmiento interviewed would have more likely responded with historical constructions based upon their most recent history rather than with a reconstruction of the remote history of the Inka empire.

The name Maukallaqta means "old town," which suggests that it was given to the archaeological site that was the "old Pacariqtambo" after the present-day or "new" Pacariqtambo was established. It is grouped into three sectors separated by dry *quebradas* (ravines) (Pardo 1946:5–9). Bauer (1992:111–114) further divides the sectors into seven zones, and his surveys registered more than 200 structures. All the buildings of this large site are aligned along grid systems established within each zone. With regard to construction materials and techniques, finely cut stone masonry is found in the lower portions of walls and at principal doorways; adobe blocks were often placed on top of stone foundations; and quishuar wood was used for interior lintels. Many room interiors display a clay lining. In 1986, Bauer (1992:114–116) conducted excavations in Zone 1 of the Maukallaqta or western sector. Of special interest in Zone 1 is the central court constructed of well-fitted

stonework reminiscent of Cusco styles and framed by large triple-jamb niches as well as the peculiar design element in which one of the niches on the north side constitutes the entrance into an inner chamber. Bauer (1992:116–123) argues that Maukallaqta was built by the Inka in affiliation with the origin myth and likely was the original Inka Pacariqtambo. The absence of extensive storage facilities speaks against its role as an administrative center; instead, the central court may have denoted a ceremonial center. Bauer (1992:122) speculates, and I think with good reason, that this courtyard could have functioned as an oracle complex or temple for Manqo Qhapaq. The inner chamber might have housed an image or idol of the first mythical Inka, which would have appeared through the niche-entrance on ceremonial occasions, dramatically reenacting Manqo Qhapaq's emergence from Tampu T'oqo.

It is also important to note that Bauer (1992:116) found pre-Inka walls and ceramic fragments in Zone 1, which he tentatively dated to the middle horizon or Wari period. The question remains whether the people—Wari or other—who lived at Maukallaqta before the Inka regarded the area as sacred ritual space and especially whether they performed any ceremonial activities at Pumaurqu or perhaps even began to carve it.

The outcrop of Pumaurqu may have contained the cave, the actual Tampu T'oqo, from which the Inka believed their ancestors first appeared on earth. It assumes monumental and towering dimensions in the eyes of the visitor who walks up from the Rio Yaurisque valley and thus approaches it from below and from the north. When viewed from Maukallaqta, it is situated several kilometers to the east and looks smaller and less formidable or intimidating. Since this outcrop sits on a slope, only its north side appears towering high while access to the top can be gained from the south.

Most of the carvings are concentrated on the top (Figure 9.2). As the visitor enters from the south, he or she finds two rounded felines sculpted in high relief and closely together (Figure 9.3). Their heads are now missing but they have given the site its popular name: Pumaurqu translates as "hill of the puma." From the location of the felines, the carvings extend to the northwest and northeast in gradually descending levels. There are large and small seats, most of them rectangular but some rounded or semicircular, wide and narrow platforms and planes, as well as steps. The stone is limestone and weathering is responsible for sharpening the edges and some grooves and small depressions amid the sculptures. Along the northwestern to the northeastern edge of the outcrop, there is a series of steps and shallow square depressions that likely constituted the foundations of a wall that once enclosed the sculpted top. The north flank is the tallest and steepest and nobody from below was able to see the carvings or any activities performed on top. However, the wall would have been well visible and it would have signaled to anyone that the top of Pumaurqu was sacred and secluded space to which access was strictly controlled.

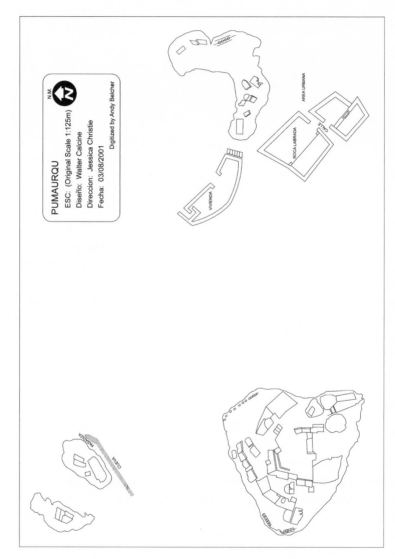

Figure 9.2. Pumaurqu, plan of outcrop and surrounding structures. (Drawing by the author; digitized by Andy Belcher.)

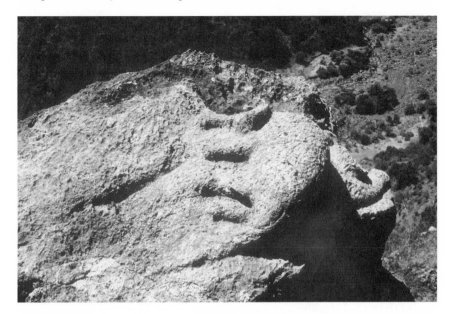

Figure 9.3. Pumaurqu, reliefs of felines. (Photograph by the author.)

Below the almost vertical north and northeast side of Pumaurqu lies a rockfall area with large strewn boulders. Some of them are carved with precise vertical and horizontal cuts; others form cavelike spaces with the foot of the outcrop. The irregular manner in which these huge chunks of rock are distributed suggests that they may have split off the northern flank during an earthquake. How long ago such a specific earthquake took place is a tricky question even though earthquakes are common in this area. Pardo, who wrote in 1946, describes the rockfall area; yet his description of the south side and a *chincana* (cavelike passageway) as well as his drawing of the structures on the northeast side do not correspond with the present condition of the site (Pardo 1946:30–31). The evidence shows that there have been some modifications between the time Pardo initially reported on this site and today; whether seismic activities were dramatic enough to cause the rockfall is not certain but unlikely. I think it is possible that the appearance of Pumaurqu has not changed substantially since Inka times, which is emphasized by the fact that the wall foundations along the edge of the top confirm that the drop-off was there in ancient times as well. In the following discussion, I will assume that the form of Pumaurqu today represents Inka Tampu T'oqo with the expected deteriorations caused by weathering and by the Spanish.

The visitor has to crawl through a cavelike space formed by fallen rocks to exit on the east side of Pumaurqu. After a short walk on a narrow trail at the base of the outcrop, the terrain widens somewhat and the visitor stands between the foundations of three—likely Inka—houses and a carved boulder (Figure 9.2). The walls

were constructed of fieldstones and the masonry is coarse and unrefined. The two southern structures have two and one rooms and open onto a shared trail between them. The southwest wall of the one-room structure is formed by a sloping worked bedrock surface. The north structure opens to the northeast where the ground drops off quickly and sharply. One opening is a regular doorway while the other consists of two interlacing L-shaped walls with a passageway between them. The rear or southwest wall curves and displays three niches. This building may have served special ritual purposes because of the unusual L-shaped entrance/exit and the fact that the openings lead to a drop-off from where the eastern horizon and sunrise can be observed. The carved boulder sits at the drop-off and exhibits vertical cuts, horizontal planes, and seatlike and semicircular sculptures. Below the houses and the carved rock descend a series of terraces and crude retaining walls, suggesting that Pumaurqu extended to the east and that the eastern side was a principal sector.

When I asked different people from Mollebamba where Tampu T'oqo was, they pointed to three irregular holes high on the rock wall on the northeastern side. Pardo (1946:10–11) adds two caves to the three openings on the northeastern facade and thus accounts for five t'oqos. According to Garcilaso de la Vega (1963:30 [1609:Book 1:Chapter XVIII]), the central window from which the Ayar siblings emerged was decorated with gold plates and precious stones; the side windows out of which the Maras and Tampu groups climbed were only lined with gold.

In an interesting turn of events, a new Tampu Toq'o was created in the late sixteenth century. In 1571, the Spanish founded the present town of Pacariqtambo approximately 6 km south of Maukallaqta/Pumaurqu as a *reducción* (reduction) of 11 dispersed ayllus into one nucleated settlement. Today the residents of Pacariqtambo identify a small cave to the northeast of their town as Tampu Toq'o. In 2003, a young man from Pacariqtambo showed me this cave and I did not see any remains of offerings or burned *pagos* (colorful offerings to the earth and the mountains assembled by contemporary shamans, which are wrapped and burned). As Urton (1990:37) has indicated, the people of the new Pacariqtambo may have attempted "to take the origin place of the Inka and its inherent power away" from the small community of Mollebamba and to appropriate it for themselves by recreating it close to their town.

Discussion

The question begging for an answer is why would the Inka select such an obscure outcrop in a region that was relatively unimportant—when compared, for instance, with the Urubamba Valley—as their paqarina, their place of origin? What kind of relationships may have existed between Pumaurqu/Maukallaqta and Cusco?

Pumaurqu/Maukallaqta are located in Kuntisuyu, which falls into the Hurin division of the empire and is of somewhat lower importance than the Hanan *suyus*.[3]

It strikes me as noteworthy that both Inka origin places, the pan-Andean pilgrimage site on the Island of the Sun in Lake Titicaca where the Sun was born and according to some versions, Manqo Qhapaq and Mama Oqllu first emerged as well as Pacariqtambo, were situated in Kollasuyu and Kuntisuyu and thus in the lower Hurin half of the empire. Why did the Inka not choose a location in Chinchaysuyu in the prestigious Urubamba Valley? It is further significant that both origin places are sacred rocks: the Sanctuary on the Island of the Sun is a natural outcrop that was covered with gold sheets and finely worked *cumbi* textiles, while Pumaurqu was sculpted. On the other hand, in the immediate Cusco region, there were no wak'as in the form of carved rocks on the zeq'e lines leading to Kollasuyu and Kuntisuyu. These observations might suggest that one reason for locating the origin sites there was to establish an Inka presence in these "underrepresented" suyus, and the markers of such a presence were highlighted sacred rocks. To my knowledge, the area of Pacariqtambo and the Province of Paruro in general do not contain any significant natural resources and agricultural land is of poor quality (see Bauer 1992:53–61), which would make the region economically unattractive. Thus, clearly, the selection of both origin sites was ideologically motivated. Bauer's systematic surveys in the area have shown that settlements were small, widely scattered, and unprotected, and that occupation of major sites was continuous from the late intermediate into the Inka periods, which indicates that the Province of Paruro was absorbed quickly and early into the developing Inka state (Bauer and Covey 2002:852).

Sarmiento de Gamboa provides us with a specific reference:

[S]ince he (Pachakuti) was curious to learn about the past and to memorialize his name, he went in person to the hill of Tambotoco or Pacaritambo, which is all the same thing, and he entered the cave from which they fully believe Mango Capac emerged together with the siblings who came with him to Cuzco for the first time, based on what has been said. And after he had seen everything thoroughly and given it some thought, he worshipped at this place with fiestas and sacrifices. He turned the window Capactoco into a doorway of gold and mandated that from here on, this site should be highly venerated and that all should comply with it. And to make this happen, he classified it as sanctuary and guaca, where they were supposed to ask oracles and to offer sacrifices [1942:107 (1572:Chapter 30) translation by the author].

This reference states that it was Pachakuti who instituted Pumaurqu as an official wak'a and that he embellished the cave of origin with gold. This could further imply that he also commissioned the sculptures. I have argued elsewhere (Christie n.d.) that Pachakuti possibly initiated and certainly supported and spread the style of Inka rock art developing from vertical and horizontal cuts. If this is so, then

Pumaurqu likely becomes another Pachakuti commission. The two puma reliefs could further tighten the connection with him since it is said that he went to war with a puma skin over his head to claim ownership of the feline as his totemic ancestor (Salazar 2004:36). Thus Pachakuti may have been the one to turn a powerfully charged ancient site whose history and myths were passed along in oral traditions into a prestigious state-sponsored wak'a.

From the royal claims we are moving to those of lower status individuals. In an impressive and very cogent study, Urton (1990) has documented how individuals from the Pacariqtambo area successfully petitioned the Spanish for noble status, arguing that they descended from Manqo Qhapaq. The main source Urton (1990:46–57) uses is the Callapina Document, the original 1569 version of which contains testimony by eight witnesses that Rodrigo Sutiq Callapina indeed was a direct patrilineal descendant of Manqo Qhapaq. His argument was so successful that his grandsons and great-grandsons copied it to support their own claims for noble status and thus exemption from taxes and *mit'a* labor obligation in 1692 and 1718. I will take the opposite approach and look more closely at the Cusco perspective in the relations between Pacariqtambo and the capital. How did the origin myth continue to impact the social organization of Cusco and even more, its position as the symbolic center of the empire?

Sarmiento (1942:62–64 [1572:Chapter 11]) tells us that the Ayar brothers and their sisters formed ten ayllus among the people who emerged with them from the lateral windows and among the people who already lived in the Pacariqtambo region. These groups moved to Cusco together with the eight siblings and in 1572, at the time of Sarmiento's writing, descendants and members of these ayllus still lived in Cusco. Thus there appears to have been a "living" connection between Cusco and Pumaurqu/Pacariqtambo at least up to the late 1500s. Sarmiento lists the ayllu names as follows:

Chauin Cuzco ayllo, of the lineage of Ayar Cache; . . .
Arayraca Ayllo Cuzco-callan; . . . of the lineage of Ayar Uchu—
Tarpuntay Ayllo; . . .
Guacaytaqui Ayllo;
Sanoc Ayllo; . . .
These five bands are Hanancuzcos, which means the group from the higher Cuzco.
Sutic-toco Ayllo, which is the generation that emerged from the window called Sutic-toco . . .
Maras Ayllo; these are the ones who say they came out of the window Maras-toco; . . .
Cuycusa Ayllo; . . .
Masca Ayllo; . . .
Oro Ayllo; . . . [Sarmiento de Gamboa 1942:63–64 (1572:Chapter 11)].

Urton (1990:25) stresses that Sarmiento's account is unique among the chronicles that talk about the origin myth in that he is one of two writers who address the creation of ten ayllus at Tampu T'oqo. The other text was written by Viceroy Francisco de Toledo who mentions three ayllus. I concur with Urton (1990:25) that the names of the ten ayllus and their organization into Hanan-Hurin may have been information directly obtained from Sarmiento's 100 khipu kamayuq informants who lived within the Cusco moiety system and may have known in person some of the ayllu members whom Sarmiento lists by name.

Further, it is very important that Sarmiento classifies the ayllus into Hanancuzcos and by implication Hurincuzcos, which reflects the moiety system of the capital and of the Andes in general. The eight Inka ancestors and ten ayllus in Sarmiento's as well as in other versions of the origin myth are not treated as equals but are subjected to concepts of ranking. I now turn to these ranking categories because certain aspects of them seem to be reflected in the social organization of Inka Cusco and its relation to the periphery of the empire. Ranking begins with the emergence of the Ayar brothers and sisters. Sarmiento (1942:62–63 [1572:Chapter 11]) presents them in two clearly defined groups: males and females. As he lists their names, the order of the brothers is based upon age and authority and the order of the sisters on age alone, with the oldest always coming first and receiving the highest authority. Sarmiento also divides the ten ayllus into two groups: those of Hanan Cusco and those of Hurin Cusco; and one would suspect that the order of their names is not arbitrary but builds on those categories used for the Inka ancestors. Therefore Chauin Cuzco ayllo and Sutic-toco Ayllo were likely the most influential while Sanoc Ayllo and Oro Ayllo were given the least authority. The latter formed a fifth rank in each moiety as opposed to the four members in each gender group of the ancestors and thus would have placed low in the hierarchical system. Urton (1990:25–26) argues that "the fifth ayllu of the moieties represent the incorporation of low-prestige outsiders into the imperial sociopolitical and territorial organizations." He identifies Sanoc Ayllo, or Sanuq Ayllu, as people living in Sanu, which is now San Sebastian situated at the southeastern periphery of the city of Cusco. He interprets Oro Ayllo as a Spanish corruption of the Aymara word *uru*. Uru could designate pre-Inka populations of the valley of Cusco as well as lower-class people within the city in general. Further, Uru was the name of an ethnic group of fishermen and agriculturalists who lived around Lake Titicaca and whose descendants continue to occupy the floating islands that have become popular tourist spots. In the organization of ayllus in the town of Copacabana located on the shores of Lake Titicaca, there was also a group called Uru Ayllu. According to Zuidema (cited by Urton 1990:26), this ayllu was the fifth of the upper moiety in Copacabana and was referred to as *sullka ayllu*, meaning "youngest, least." Therefore Uru seems to have designated low-status and junior groups of people in various spatial settings.

There thus seems to be compelling evidence that the ten ayllus of the Hanan

and Hurin moieties were ranked according to an "age lending authority" classification similar to the ranking system of the four ancestral brothers and sisters. The critical distinction between the two cases is that the eight ayllus within Cusco are juxtaposed with two ayllus of outsiders forming border groups who lived outside the city and could be non- or even pre-Inka peoples. Garcilaso reinforces such a dichotomy between the civilized center of Cusco and wild barbarian people outside when he describes how Manqo Qhapaq instructed the residents of the towns and villages he had founded how to make their living: "and that they [Manqo Qhapaq's subjects] owed worship and service in particular to the Sun and to the Moon because they [Sun and Moon] had sent them their two children [Manqo Qhapaq and Mama Oqllu] who had liberated them from the uncivilized life they had led up to that time and had brought them back to be fully human which they were now" (Garcilaso de la Vega 1963:34 [1609:Book I:Chapter XXI]).

According to the origin story, the ranking system was established by the eight ancestors at Pacariqtambo and then transferred and adapted to the social and political organization of Cusco. This mythohistorical reconstruction raises some interesting issues about the relationship between Cusco in its role as capital and center of the empire and powerful sacred sites at the periphery. As discussed above, it is very unlikely that the relations between Cusco and Pacariqtambo were economic in nature.

Instead, the interactions between Cusco and Pacariqtambo must have been non-market-based and related to ideology and cosmological principles. John Staller (n.d.) has discussed Andean interaction models between a core and the periphery based upon acquisition or trade and exchange and how geographic horizontal relations with certain sites, or wak'as, in the periphery can raise social status in the core/center in terms of a vertical hierarchy (see also Helms 1993). Trade and exchange represent two-way interactions between two sociopolitical units that, in the Andes, are typically housed in different ecological zones. Both units are of compatible social status and exchange products they have in surplus for products they are lacking. Acquisition, in contrast, constitutes a one-way interaction between a more powerful cultural center and a weaker peripheral sociopolitical unit. In the acquisition model, both actors hold contrasting status with regard to political hierarchy and spatial distribution: high versus low; core versus periphery. Acquisition dynamics between core and periphery involve the appropriation of status objects and wak'as by the dominating party and are usually discontinuous. I concur with Staller (personal communication 2005) that the relationship Cusco-Pacariqtambo is a precise example of this type of acquisition model. According to Sarmiento (1942:107 [1572:Chapter 30] see above), Pachakuti himself went to Tampu T'oqo, declared it a major state wak'a and integrated it into the sacred landscape he was constructing in the environs of Cusco. Pachakuti's vision of his sacred geography was ideologically motivated and signaled Inka-ness as well as Inka con-

trol over natural elements and cultural outsiders (see also Niles 1992). His ideology materialized in architectural construction projects, carved rocks, stone wak'as on zeq'e lines, and most importantly in extended zeq'e and road systems taking their origin in the center of Cusco (Christie n.d., in press). Thus the integration of Maukallaqta/Pumaurqu grounded his views and their material expressions and in particular rock art to the origin site of the Inka state and the Inka people, appropriated status related "wealth" for Cusco and transferred part of it to those ayllus mentioned in the origin story. It is perhaps indicative of the high status of these ayllus that members of two of them, the Mascas and Tampus, appear to have lived near Ollantaytambo, one of Pachakuti's major private estates (see Bengtsson 1998: 120–121).

On a more subtle level, various aspects of state ideology and ruler legitimization may have been copied by Inka officials from the origin story or were reported as lived experiences by informants of the chroniclers. In Juan de Betanzos's (1996:12–16 [1557:Part I:Chapters III, IV]) version of the origin myth, Ayar Kachi plays a special role. Betanzos informs us that Ayar Kachi was the first to emerge together with his wife Mama Waqo. After the four men and their wives had climbed out of the cave, all dressed in fine garments of wool woven with gold, they immediately went to the mountain Guanacaure (Wanakauri) overlooking the Cusco Valley. Here Betanzos adds an interesting feat performed by Ayar Kachi: as he reached the top of the hill, he took out his sling, placed a stone in it, and hurled it hard and far to a high hill where it struck with such force that it knocked down the hill and made a ravine in it. Then he shot three more stones and with each one he created a ravine in the high hills. Watching Ayar Kachi's great strength, his three brothers became fearful that he would quickly overpower them, and they decided to get rid of him in the way paraphrased above: they claimed they had forgotten precious golden objects and fine garments inside the cave at Pacariqtambo and talked Ayar Kachi into entering the cave to retrieve these things, to which he agreed. As soon as his three brothers saw him disappear inside the cave, they sealed the entrance, leaving Ayar Kachi permanently trapped inside.

Pedro de Cieza de Leon (1959:32–37 [1553:ii:VI, ii:VII]) also describes the great strength of Ayar Kachi; for example, after he was locked inside the cave, the earth shook so forcefully that many mountains collapsed (1959:32 [1553:ii:VI]). Further, Cieza de Leon's version of the origin story adds two other episodes supporting the line of reasoning that later rituals organized by the Inka state emulated acts first laid down in the creation stories: episode one is that Ayar Kachi came back to his stunned brothers as a great bird with wings of colored feathers to give them instructions as to where and how they should found the capital Cusco; how Inka rulers should assume the fringe or crown of the empire, be dressed and attired and perform accession ceremonies; and how Inka youths should be initiated into the elite class (1959:33–37 [1553:ii:VII]). The second issue is that Ayar Kachi used

Huana-cauri as a second name, and he and one of his brothers turned into figures of stone in human likeness on top of Huana-cauri (Wanakauri) hill.

Garcilaso de la Vega (1963:27–28 [1609:Book I:Chapter XVI]) relates multiple versions of the origin story including one particularly interesting incident on the mountain Wanakauri. The four ancestral brothers and sisters rested on the summit of Wanakauri and the golden staff sank easily into the ground. Thus Manqo Qhapaq told Mama Oqllu that the valley in sight was the place where their father, the Sun, wanted them to settle and that they should call all the people in the region, living a humble life—*como bestias!*—and teach and civilize them. Manqo Qhapaq went to the north and Mama Oqllu to the south and all the people they met followed them to the site where they began to construct the new capital Cusco with communal labor. The people who had arrived with Manqo Qhapaq settled in Hanan (higher) Cusco and the people who had come with Mama Oqllu settled in Hurin (lower) Cusco, establishing the moiety division that exists in traditional Andean towns to this day. This part of Garcilaso's account partly confirms Sarmiento de Gamboa (cited above), who names the ten ayllus grouped in Hanan-Hurin and the implied ranking system, one category of which is male-female. Garcilaso (1963:27 [1609:Book I:Chapter XVI]) mentions a sun temple on Wanakauri mountain that may correspond to an architectural complex that was recently restored by the Instituto Nacional de Cultura.

The selected episodes from Inka origin mythohistory formulate three concepts that were acted out in Inka state ideology and ritual. First is the great importance of Ayar Kachi. Whereas, in most interpretations, Manqo Qhapaq is foregrounded as the leader of the Inka ancestors and as the founder of Cusco, Ayar Kachi and his sister emerged first from Tampu T'oqo, and Ayar Kachi was physically stronger than his brother. In the episode on the mountaintop of Wanakauri, Ayar Kachi defined the four quadrants of the world and the four-partite division (*suyus*) of the Inka empire by shooting four rocks with his sling. One might consider reading Ayar Kachi's acts as evidence that from the beginning the Inka state was not based upon absolute one-man rulership (here Manqo Qhapaq) and that important responsibilities were shared by high officials (in this case Ayar Kachi). Second, the fundamental geographical and political divisions of the Inka empire were laid down in the origin narratives; that is, the four-partite division into suyus, or quarters, by Ayar Kachi and the dual division into the Hanan and Hurin moieties by Manqo Qhapaq. The suyu division defined the identity of Tawantinsuyu, the Inka empire that claimed to be the land that incorporated the four quarters of the world. The moiety division into Hanan and Hurin was social and determined by groupings of ayllus. Many traditional communities today adhere to Hanan and Hurin moieties.

Third, one may look at the origin mythohistory as a long narrative explaining the relationships among caves, mountains, and stone in the Inka construction of

their sacred geography and stone ideology (Christie n.d., in press). The four brothers and sisters migrated underground through the underworld waters to emerge into the world of man through the cave of Tampu T'oqo. Therefore caves become the vital portals between the two lower levels of the cosmos. From Tampu T'oqo, the ancestors climbed Wanakauri mountain, which functioned as the metaphorical access point to the world above. Here Ayar Kachi defined the four quadrants of the world, turning the summit of Wanakauri into a sacred center. Placing himself at this center, Ayar Kachi personified its vertical central axis as well as the living essence, or *apu* (mountain deity), of Wanakauri. Later he and one of his brothers turned to stone on top of Wanakauri, demonstrating the transformational qualities of stone as the material essence of mountains and the relationship of stone to human life. According to Maria Rostworowski (1999:14), transformed stones functioned as metaphorical landmarks for "the taking possession of a space." In a similar context, the Pumaurqu outcrop was carved.

I argue that these concepts were transferred to Cusco and built into the layout and design of the capital (Christie 2007). The main plaza, composed of Awkaypata and Kusipata, took over the role of the sacred center from which the four roads to the suyus departed. The *usnu* signaled the presence of stone and mountain and may even have been understood as a "miniature Wanakauri" by some Inka. When the ruler assumed his position on the usnu, he, like Ayar Kachi, personified the central axis and acted as the pivot of his empire; he sanctioned and oversaw the four-partite division. At the same time, one has to caution that this four-partite division was not altogether new. Rostworowski (1999:6–7) cites various Spanish writers who inform that the pre-Inka village of Acamama existed on the future site of Cusco. Sarmiento de Gamboa (cited in Rostworowski 1999:7) specifically states that Acamama comprised four local districts: a District of the Humming Bird, another of the Weavers, a third of Tobacco, and a mixed district inhabited by Aymara and Quechua speakers. It appears that the four-partite division was redirected in Inka state ideology to lay claims to the four quarters of the world. The paramount importance of Wanakauri in Inka stone ideology is evident by its copies in various parts of the empire, which are local mountains given the name Wanakauri; one case is situated in the Culluctur Valley near the Inka settlement of Ingapirca in Ecuador (Rojas 2006:36).

In another ritual, the Inka dramatized their ties with the other origin place on the Island of the Sun in Lake Titicaca. Beginning with the accession ceremonies of Inka Roq'a, they brought water from a spring in the bedrock of an island in Lake Titicaca to Cusco. Each new ruler was anointed with the Titicaca water as he took on the highest office (Joan de Santa Cruz Pachacuti Yamqui Salcamayhua cited in Sherbondy 1992:56–57). Such a ritual act implies that origin places could be symbolically displaced by moving water from the original source to a new site just as ayllus were refounded by carrying water from the ayllu's previous water source into

new territory, where it was poured into a spring on the new land. The new water source received the name of the old site of emergence, or *pacarisca* (Albornoz cited in Sherbondy 1992:57). This conceptual moving of origin places was crucial in accounting for the fact that the sacred sites of emergence were not situated in the capital itself; it constituted probably the most significant way of tightening the relations between the center and these so important but geographically peripheral places.

The examples discussed above serve to show that the origin story and its protagonists, the eight ancestors, tied the remote past of Pacariqtambo to the present of Inka Cusco in multiple steps. Our primary sources are the Spanish writers who obtained their information from living Inka descendants, for example, Sarmiento's khipu kamayuqs and Garcilaso's relatives from his mother's side. These descendants retold Inka history as a glorious past and may have witnessed late forms of Inka state ritual as performed by Manqo Inka. Manqo Inka and his predecessors interpreted the origin narratives to best fit their needs of validating and cementing their position of political and religious authority without bothering to verify what precisely and historically had transpired at Pacariqtambo. Of course, this desire to verify is an academic Western concern developed during the Enlightenment and is not shared by most non-Western cultures. It follows that what Pacariqtambo truly is depends upon whose eyes are looking at it.

A complete reversal of directions took place in the sixteenth century when the Callapina family from Pacariqtambo petitioned the Spanish for noble status by claiming descent from Manqo Qhapaq and thus deriving the authority of their request from their ties with Inka Cusco (Urton 1990).

I further argue that one form of marking center—periphery acquisition was the use of rock art. I have presented the case elsewhere that Pachakuti appropriated the characteristic geometric style of Inka rock carving using vertical and horizontal cuts and employed it to transform the natural landscape of his royal estates and of the zeq'e shrines linked to his panaqa into a symbolic language that carries on a dialogue between nature and culture. I think he did the same at Pumaurqu: he likely commissioned the rock carvings (see above) and thus formally and outwardly declared the Inka origin site as a wak'a tied to his reign. While speculative, it is well conceivable that Pachakuti and his successors may have attempted to extend the Cusco zeq'e system to the suyus of the empire and mark the periphery with major sites that possess rock wak'as and/or rock art; for example, in the far north, Chinchaysuyu encompassed Cajamarca, Ingapirca, and Pambamarca (see Van de Guchte 1990:406, Illustration 2), Samaipata with its enormous sculpted outcrop is situated in Antisuyu, and Kollasuyu and Kuntisuyu harbor the powerfully charged Inka origin sites. Interaction between the core and these peripheral sites with rock sculptures would have played out in two directions. Authority and prestige of the Inka state government in the core rose on a vertical scale as individual rulers es-

tablished peripheral centers on a geographic horizontal level (see Staller n.d.). Distance of the peripheral site may have affected the rise of authority in the center. Interaction also worked in the opposite direction. Many peripheral centers were founded by Inka rulers and the state government behind them and thus owed their existence to the core and depended on continuous exchange. The origin site on the Island of the Sun is an excellent example. While the actual sanctuary on the Island of the Sun is a rock wak'a that had functioned as a pre-Inka and pan-Andean pilgrimage site, the Inka rebuilt Copacabana on the nearby shore of Lake Titicaca as their regional center to oversee the pilgrimage system. I have shown elsewhere (Christie 2006) that Copacabana was an important administrative center that derived its high status from its close ties to Cusco. One bond that links these rather heterogeneous sites together and to Cusco as the center seems to be the rock art and the symbolic, political, as well as aesthetic messages the carvings convey.

Conclusions

I have outlined several levels of interaction between Cusco and Pacariqtambo, which can be summarized as follows:

First, there is the mythohistorical emergence event during which the four Ayar brothers and their sisters climbed out of Qhapaq T'oqo and subsequently migrated to the Cusco Valley to found the capital. Garcilaso and other chronicle writers connect Qhapaq T'oqo and Tampu T'oqo to the other origin places at Lake Titicaca. In those versions, Wiraqocha created human beings, animals, and plants at the site of Tiwanaku. At his wish, the Sun and the Moon first rose from openings in a sacred rock outcrop on the Island of the Sun. The Sun—appearing as a resplendent personage with a human body—called forth Manqo Qhapaq and Mama Oqllu and sent them on a civilizing mission: they were ordered to travel to the northwest underground and reemerge at the cave of Pacariqtambo and to educate and elevate the standard of living of the people they encountered (Salles-Reese 1997:53–88, 93–108; Urton 1999). In this manner, origin narratives linked Inka Cusco not only with the emergence of the Inka dynasty but also with the creation of the world. The Inka explained themselves as special beings singled out and chosen by Wiraqocha and the Sun to populate the earth with humans—defined as the Inka—who would live more wisely and would have greater knowledge than their predecessors. I argue that this ingeniously constructed identity had its material reflections in the rock art (Pumaurqu!) and in Inka architectural stonework, both of which show visual parallels with Tiwanaku. These connections validated the Inka ruler and legitimized his campaigns to conquer the four quarters of the world, Tawantinsuyu. I argue that during the process of state formation, the oral traditions of origins were strategically spread among the local populations and among non-Inka societies to provide an ideological basis for the Inka right to rule. Perhaps

the most ingenious aspect of this strategy was that Inka origin narratives were internally consistent with pan-Andean explanations of creation; while boldly weaving in their own paqarina, the stories would have been understood by all Andean peoples.

It has to be stated very clearly, though, that the ethnohistoric and ethnographic sources outlining the creation narratives find themselves at odds with recent archaeological evidence compiled in mosaic fashion by means of the painstaking surveys conducted by Bauer and colleagues (Bauer 1992, 2004; Bauer and Covey 2002). These archaeological data reconstruct a scenario in which the Cusco Basin was much more densely populated during the late intermediate period (which precedes the late horizon of the Inka) than had previously been thought; for example, on the north side of the basin, an extensive terrace system was constructed, large villages existed, and the Killke period occupation of the site of Cusco came close to the extent of the later capital (Bauer 2004:76–78). Therefore the archaeological picture is very different from that of the simple and uncivilized savages populating the Cusco Valley as described by Garcilaso. It would seem that the origin stories do not relate history in a Western historical sense, that is, as progressing in a straight line from the past to the present; instead, the chronicles offer us protagonists and events that happened sometime in the past. Again, it is a matter of "which eyes" are looking at history: archaeologists who reconstruct history applying Western empirical methodologies or indigenous consultants—filtered through the colonial interests of Spanish writers—who remember things from the past that were important to them.

On the second level, once the Inka dynasty had solidified their position in the Valley of Cusco, Inka rulers apparently felt the necessity to reestablish and formalize ties with their origin site. They built Pacariqtambo/Maukallaqta on top of an earlier settlement as a ceremonial center serving the actual place of emergence, or Tampu T'oqo, identified with Pumaurqu. The central court of the northern sector of Maukallaqta may have functioned as a temple complex associated with Manko Qhapaq, and Pachakuti was possibly the ruler who had Pumaurqu remodeled into a state wak'a. One might say in return for bestowing ideological legitimacy on the Inka dynasty ruling in Cusco, Pacariqtambo/Maukallaqta/Pumaurqu received material elaboration. So, clearly, Inka rulers gave form to their place of origin at Pacariqtambo/Maukallaqta and Tampu T'oqo/Pumaurqu and assigned to these sites crucial roles in the cosmological justification of state government. Richard Stoffle and colleagues (Chapter 3) talk about a "birthright connection" between Native North American people and their origin places. A birthright connection establishes a bond between a people and a place that can never be taken away and is and always will be theirs. Apparently the Inka cultivated such a tie with Pacariqtambo/Maukallaqta/Pumaurqu; while the region was militarily and eco-

nomically unimportant, the cosmological identity it transferred to Cusco was what mattered.

The third level of interaction leads into the colonial period. The Spanish established the new town of Pacariqtambo in 1571 as a *reducción* of isolated ayllus, and Urton (1990) has documented diligently how members of the Callapina family from this community petitioned the Spanish authorities in Cusco for noble status by tracing their descent line to Manqo Qhapaq. This represents a case in which individuals from what in the colonial period certainly was a peripheral center claimed high status and the privileges associated with it by citing their close ties with the Inka core during precontact times.

The fourth level is the willful move of the place of emergence from Pumaurqu to a small cave located to the northeast of the new town of Pacariqtambo. Obviously, this translocation had nothing to do with any central authority in Cusco and must have been a decision by the people of Pacariqtambo. I would interpret this fourth level not as another interaction but as an act of independence undertaken by the local residents. It also constitutes an example of how origin places can be recreated and redefined by local people in more recent history. Again, what the origin place is depends "which eyes are looking at it."

Notes

1. According to Sarmiento (1942:67 [1572:Chapter 12]), the Quechua word for rainbow is *guanacauri,* which suggests that the mountain received its name later as a reference point in the origin story.

2. Sarmiento (1942:69–70 [1572:Chapter 13]) says that this stone pillar stood near the Monastery of Santo Domingo, the Qorikancha of Cusco, while Urton (1990: 38–39) locates the same pillar in the central plaza, Wanaypata. He is referring to what is today the Plaza de Armas. It would be interesting to test whether Ayar Awka turned stone pillar has any connection with the Cusco usnu.

3. The Inka empire Tawantinsuyu, or Land of the Four Quarters, was divided into four quarters/suyus: Chinchaysuyu in the northwest, Antisuyu in the northeast, Kollasuyu in the southeast, and Kuntisuyu in the southwest. Chinchaysuyu and Antisuyu were grouped into the upper, or Hanan, half, Kollasuyu and Kuntisuyu into the lower, or Hurin, half.

References Cited

Aguilar-Moreno, Manuel

1999 *The Tequitqui Art of Sixteenth-Century Mexico: An Expression of Transculturation.* Unpublished Ph.D. dissertation, University of Texas at Austin.

2005 *Utopía de piedra: El arte Tequitqui de México.* Conexión Gráfica, Guadalajara.

2006 *Handbook to Life in the Aztec World.* Facts on File, New York.

Aguilar, Manuel, Miguel Medina Jaen, Tim Tucker, and James Brady

2005 Origin Caves and Cosmology: A Man-Made Chicomoztoc Complex at Acatzingo Viejo. In *In the Maw of the Earth Monster: Studies in MesoAmerican Ritual Cave Use,* edited by James Brady and Keith Prufer, pp. 69–88. University of Texas Press, Austin.

Alcina Franch, José, et al.

1992 *Azteca-Mexica.* Lunwerg Editores, Madrid.

Altman, Heidi M.

2006 *Eastern Cherokee Fishing.* University of Alabama Press, Tuscaloosa.

Alvarado Tezozómoc, Fernando

1944 *Crónica mexicana* (1598). Annotated by Manuel Orozco y Berra. Editorial Leyenda, México D.F.

Álvarez Lomelí, María Cristina

1980 *Diccionario etnolingüístico del idioma Maya yucateco colonial: Volumen I, Mundo físico.* Universidad Nacional Autónoma de México (Instituto de Investigaciones Filológicas, Centro de Estudios Mayas), México D.F.

Amsden, Charles Avery

1990 *Navajo Weaving: Its Technic and Its History.* Rio Grande Press, Glorieta, New Mexico. Originally published by the Fine Arts Press, Santa Ana, California in cooperation with The Southwest Museum, Los Angeles.

Anales de Cuauhtitlan

1975 Anales de Cuauhtitlan. In *Códice Chimalpopoca.* IIH-UNAM, México D.F.

Anders, Ferdinand (editor)

1967 *Codex Tro-Cortesianus (Codex Madrid).* Akademische Druck- u. Verlagsanstalt, Graz.

Ashmore, Wendy, and A. Bernhard Knapp (editors)

1999 *Archaeologies of Landscape: Contemporary Perspectives.* Blackwell Publishers, Malden, Massachusetts.

Baquedano, Elizabeth

1984 *Aztec Sculpture.* British Museum Publications, London.

Barrera Vásquez, Alfredo, Juan Ramón Bastarrachea Manzano, and William Brito Sansores
 1980 *Diccionario maya Cordemex: Maya-español, español-maya.* Ediciones Cordemex,
 Mérida, Yucatán.
Barrera Vásquez, Alfredo, and Sylvanus G. Morley
 1949 The Maya Chronicles. In *Carnegie Institution of Washington, D.C.,* Pub. 585, Con-
 tributions to American Anthropology and History, Vol. 10, No. 48, pp. 1–85,
 Washington, D.C. Reprinted 1970, Johnson Reprint Corp., New York.
Barrera Vásquez, Alfredo, and Silvia Rendón
 1963 *El libro de los libros de Chilam Balam.* Fondo de Cultura Económica, México
 [1948] D.F. First Colección Popular edition published from 1948 Biblioteca Americana
 publication; reprinted numerous times.
Bauer, Brian S.
 1991 Pacariqtambo and the mythical origins of the Inca. *Latin American Antiquity*
 2:7–26.
 1992 *The Development of the Inca State.* University of Texas Press, Austin.
 1998 *The Sacred Landscape of the Inca: The Cusco Ceque System.* University of Texas
 Press, Austin.
 2004 *Ancient Cuzco.* University of Texas Press, Austin.
Bauer, Brian, and Alan Covey
 2002 Processes of State Formation in the Inca Heartland (Cuzco, Peru). *American An-
 thropologist* 104(3):846–864.
Bawden, Garth
 1996 *The Moche.* Oxford University Press, Oxford and Cambridge, Massachusetts.
Bean, Lowell, and Sylvia Vane (editors)
 1982 *Intermountain Power Project Intermountain—Adelanto Bipole 1 Transmission Line
 California: Ethnographic (Native American) Resources.* Cultural Systems Research,
 Menlo Park, California.
Bengtsson, Lisbet
 1998 *Prehistoric Stone Work in the Peruvian Andes: A Case Study at Ollantaytambo.* Et-
 nologiska studiar 44, GOTARC Series B, No. 10. Göteborg University, Depart-
 ment of Archaeology, Göteborg, Sweden.
Bernal, Ignacio
 1980 *Tenochtitlan en una isla.* Instituto Nacional de Antropología e Historia, México D.F.
Betanzos, J. de
 1996 *Narrative of the Incas.* Translated and edited by R. Hamilton and D. Buchanan
 [1551] from the Palma de Mallorca Manuscript. University of Texas Press, Austin.
Blackhorse, Taft
 2001 Navajo Rock Art Discussion. In *American Indian Rock Art,* Vol. 27, edited by
 Steven M. Freers and Alanah Woody, pp. 73–76. American Rock Art Research
 Association, Tucson.
Bricker, Harvey M.
 2004 The Paper Patch on Page 56 of the *Madrid Codex.* In *The Madrid Codex: New
 Approaches to Understanding an Ancient Maya Manuscript,* edited by G. Vail and
 A. F. Aveni, pp. 33–56. University Press of Colorado, Boulder.

Bricker, Victoria Reifler
1981 *The Indian Christ, the Indian King: The Historical Substrate of Maya Myth and Ritual.* University of Texas Press, Austin.

Brown, Lloyd A.
1949 *The Story of Maps.* Little, Brown, New York. Reprinted 1979, Dover, New York.

Brugge, David M.
1994 The Palluche Canyon Cache. MS. Copy at the Museum of Indian Arts and Culture\Laboratory of Anthropology, Santa Fe.

1996 Navajo Caches of the Dinétah. In *La Jornada: Papers in Honor of William F. Turney,* edited by Meliha S. Duran and David T. Kirkpatrick, pp. 33–45. Archaeological Society of New Mexico 22, Albuquerque.

2001 A History of Navajo Rock Art Research. In *American Indian Rock Art,* Vol. 27, edited by Steven M. Freers and Alanah Woody, pp. 5–16. American Rock Art Research Association, Tucson.

Bruhns, Karen Olsen
2003 Social and Cultural Development in the Ecuadorian Highlands and Eastern Lowlands during the Formative. In *Archaeology of Formative Ecuador,* edited by J. Scott Raymond and Richard Burger. Dumbarton Oaks, Washington, D.C.

Brüning, Heinrich
1922 *Jayanca.* Editorial D. Mendoza, Chiclayo, Peru.

Cabello Valboa, Miguel
[1586] *Miscelánea Antártica.* Universidad Nacional Mayor de San Marcos, Lima.
1951

Calancha, Antonio de la
1638 *Crónica moralizada del orden de San Agustín en el Perú.* Pedro Lacavalleria, Barcelona.

Camp, Cordelia
1963 *The Influence of Geography upon Early North Carolina.* Carolina Tercentenary Commission, Raleigh.

Carlsen, Robert S.
1996 Social Organization and Disorganization in Santiago Atitlán, Guatemala. *Ethnology* 2(1):141–160.

1997 *The War for the Heart and Soul of a Highland Maya Town.* University of Texas Press, Austin.

Carlsen, Robert S., and Martín Prechtel
1991 The Flowering of the Dead: An Interpretation of Highland Maya Culture. *Man* 26:23–42.

1994 Walking on Two Legs: Shamanism in Santiago Atitlán, Guatemala. In *Ancient Traditions: Culture and Shamanism in Central Asia and the Americas,* edited by Gary Seaman and Jane Day. University Press of Colorado, Niwot.

Carlson, John B.
1981 A Geomantic Model for the Interpretation of MesoAmerican Sites: An Essay in Cross-Cultural Comparison. In *MesoAmerican Sites and World-Views,* edited by Elizabeth P. Benson, pp. 143–215. Dumbarton Oaks Research Library and Collections, Washington, D.C.

Carlson, Roy L.

1965 *Eighteenth-Century Navajo Fortresses of the Gobernador District: The Earl Morris Papers No. 2.* University of Colorado Studies, Series in Anthropology No. 10, Boulder.

Carrasco, Davíd

1993 *Religions of Mesoamerica.* Harper and Row, New York.

Carrasco, Pedro

1967 Don Juan Cortés, Cacique de Santa Cruz Quiché. *Estudios de Cultura Maya* VI. Universidad Nacional Autónoma de México, México, D.F.

Carrera, Fernando de la

[1644] *Arte de la lengua yunga,* edited by Radames A. Altieri. Publicaciones especiales del
1939 Instituto de Antropología, No. 3. Universidad Nacional de Tucumán, Tucumán, Argentina.

Caso, Alfonso

1974 *El Pueblo del Sol.* Fondo de Cultura Económica, Colección Popular 104, México D.F.

Cervantes, Fernando

1994 *The Devil in the New World: The Impact of Diabolism in New Spain.* Yale University Press, New Haven.

Chamberlain, Robert S.

1948 *The Conquest and Colonization of Yucatan, 1517–1550.* Carnegie Institution of Washington, D.C., Publication 582. Washington, D.C.

Chamberlain, Von Del, and Hugh Rogers

2001 On the Trail of Dinétah Skywatchers: Patterned Dots and Scattered Pluses. In *American Indian Rock Art,* Vol. 27, edited by Steven M. Freers and Alanah Woody, pp. 49–58. American Rock Art Research Association, Tucson.

Chamberlain, Von Del, and Polly Schaafsma

2005 Origin and Meaning of Navajo Star Ceilings. In *Songs from the Sky,* edited by Von Del Chamberlain, John B. Carlson, and M. Jane Young, pp. 80–98. Ocarina Books in cooperation with the Center for Archaeoastronomy, West Sussex, United Kingdom, and College Park, Maryland.

Christenson, Allen J.

2001 *Art and Society in a Highland Maya Community.* University of Texas Press, Austin.

2007 *Popol Vuh: Sacred Book of the Maya.* 2nd rev. ed. University of Oklahoma Press, Norman.

2008 Places of Emergence: Sacred Mountains and Cofradía Ceremonies. In *Pre-Columbian Landscapes of Creation and Origin,* edited by John Staller, pp. 95–121. Springer, New York.

Christie, Jessica Joyce

2006 Inca Copacabana: A Reconstruction from the Perspective of the Carved Rocks. *Anthropos* 101:179–201.

2007 Did the Inka Copy Cusco? An Answer Derived from an Architectural-Sculptural Model. *Journal of Latin American and Caribbean Anthropology* 12(1):164–199.

2008 Inka Roads, Lines, and Rock Shrines: A Discussion of the Contexts of Trail Markers. *Journal of Anthropological Research* 64(1):41–66.

n.d. *The Sculpted Outcrops of the Inka.* Book manuscript in preparation.

Chuchiak, John F.
 2004 Papal Bulls, Extirpators, and the *Madrid Codex:* The Content and Probable Provenience of the M. 56 Patch. In *The Madrid Codex: New Approaches to Understanding an Ancient Maya Manuscript,* edited by G. Vail and A. F. Aveni, pp. 57–
 88. University Press of Colorado, Boulder.
Ciaramella, Mary A.
 1994 The Lady with the Snake Headdress. In *Seventh Palenque Round Table, 1989,* edited by M. G. Robertson and V. M. Fields, pp. 201–209. Pre-Columbian Art Research Institute, San Francisco.
Cieza de Leon, Pedro de
 1959 *The Incas.* Translated by Harriet de Onis and edited by Victor Wolfgang von
 [1553] Hagen. University of Oklahoma Press, Norman.
Classen, Constance
 1993 *Inca Cosmology and the Human Body.* University of Utah Press, Salt Lake
 City.
Clunas, Craig
 1997 *Art in China.* Thames and Hudson, New York.
Cobo, Bernabe
 1979 *History of the Inca Empire: An Account of the Indian's Customs and Their Origin*
 [1653] *Together with a Treatise of Inca Legends, History, and Social Institutions.* Translated
 and edited by R. Hamilton. Forward by J. H. Rowe. University of Texas Press,
 Austin.
Codex Aubin
 1893 Edition of J. M. A. Aubin, Paris.
Codex Azcatitlan
 1949 Edition by the Societé des Americanistes, Paris.
Codex Borgia
 1993 Estudio y Notas de Ferdinand Anders, Maarten Jansen y Luis Reyes García.
 Fondo de Cultura Económica, México, D.F.
Codex Boturini: Tira de la peregrinacion mexica
 1944 Librería Anticuaria, México, D.F.
Codex Chimalpopoca: Anales de Cuauhtitlan y Leyenda de los Soles
 1945 Traducción de Primo Feliciano Velázquez. Universidad Nacional Autónoma de
 México, México, D.F.
Codex Fejervary-Mayer
 1071 Edition of the Akademische Druck, Graz.
Codex Magliabecchi
 1970 Edition by Akademische Druck, Graz.
Codex Mendoza
 1979 Edición de Francisco del Paso y Troncoso. Editorial Cosmos, México D.F.
Codex Nuttall
 1974 Reprint of the facsimile edition with study of Zelia Nuttall. Peabody Museum of
 Harvard University, Cambridge, Massachusetts.
Codex Telleriano-Remensis
 1995 Edited by Eloise Quiñones Keber. University of Texas Press, Austin.

Codex Vindobonensis

1963 Edition by Akademische Druck, Graz.

Codex Xolotl

1980 Estudio y Notas de Charles Dibble. Universidad Nacional Autónoma de México, México D.F.

Códice de Calkiní

1957 *Códice de Calkiní.* Gobierno del Estado, Campeche.

Coe, Michael

1965 A Model of Ancient Community Structure in the Maya Lowlands. *Southwestern Journal of Anthropology* 21(2):97–114.

1994 *Mexico: From the Olmecs to the Aztecs.* Thames and Hudson, New York.

Coe, Michael D., and Justin Kerr

1998 *The Art of the Maya Scribe.* Harry N. Abrams, New York. First published 1997, Thames and Hudson, London.

Connerton, Paul

1989 *How Societies Remember.* Cambridge University Press, Cambridge.

Cook, Garrett

1986 Quichean Folk Theology and Southern Maya Supernaturalism. In *Symbol and Meaning beyond the Closed Community: Essays in MesoAmerican Ideas,* edited by Gary H. Gossen, pp. 139–153. Institute for MesoAmerican Studies, University of Albany, Albany.

2000 *Renewing the Maya World: Expressive Culture in a Highland Town.* University of Texas Press, Austin.

Copeland, James Matthew

2001 Dinétah Ceremonial Rock Art and Cultural Affiliation in Northwest New Mexico. In *American Indian Rock Art,* Vol. 27, edited by Steven M. Freers and Alanah Woody, pp. 35–42. American Rock Art Research Association, Tucson.

Copeland, James Matthew, and Hugh C. Rogers

1996 In the Shadow of the Holy People: Ceremonial Imagery in the Dinétah. In *The Archaeology of Navajo Origins,* edited by Ronald H. Towner, pp. 213–229. University of Utah Press, Salt Lake City.

Cordy-Collins, Alana

1990 Fonga Sigde, Shell Purveyor to the Chimú Kings. In *The Northern Dynasties: Kingship and Statecraft in Chimor,* edited by Michael E. Moseley and Alana Cordy-Collins, pp. 393–417. Dumbarton Oaks, Washington, D.C.

Craine, Eugene R., and Reginald Carl Reindorp (translators and editors)

1979 *The Codex Pérez and the Book of Chilam Balam of Maní.* University of Oklahoma Press, Norman.

Craven, Roy

1985 *Indian Art.* Thames and Hudson, New York.

D'Altroy, Terence

2002 *The Incas.* Blackwell Publishers, Malden, Massachusetts and Oxford.

David, Bruno, and Meredith Wilson (editors)

2002 *Inscribed Landscapes. Marking and Making Place.* University of Hawai'i Press, Honolulu.

Deloria, Vine, Jr.
 1995 *Red Earth, White Lies: Native Americans and the Myth of Scientific Fact.* Scribner,
 New York.
Deloria, Vine, Jr., and Richard Stoffle
 1998 *Native American Sacred Sites and the Department of Defense.* United States De-
 partment of Defense, Washington, D.C., https://www.denix.osd.mil.
Dewey-Hefley, Genevieve, Nieves Zedeño, Richard Stoffle, and Fabio Pittaluga
 1998/ Piecing the Puzzle: Perfecting a Method for Profiling Cultural Places. *Common* ✓
 1999 *Ground* (Winter/Spring):15.
Díaz del Castillo, Bernal
 1975 *Historia verdadera de la conquista de Nueva España (1580).* Editorial Porrúa,
 México D.F.
Dickens, Roy S.
 1979 The Origins and Development of Cherokee Culture. In *The Cherokee Nation: A
 Troubled History,* edited by Duane King. University of Tennessee Press, Knoxville.
Dillehay, Tom D.
 2001 Town and Country in Late Moche Times: A View from Two Northern Valleys. In
 Moche Art and Archaeology in Ancient Peru, edited by Joanne Pillsbury, pp. 259–
 283. National Gallery of Art, Washington, D.C.
Dittert, Alfred E., James J. Hester, and Frank W. Eddy
 1961 *An Archaeological Survey of the Navajo Reservoir District, Northwestern New
 Mexico.* Monographs of the School of American Research and the Museum of
 New Mexico No. 23, Santa Fe.
Donnan, Christopher B.
 1990a An Assessment of the Naymlap Dynasty. In *The Northern Dynasties: Kingship
 and Statecraft in Chimor,* edited by Michael E. Moseley and Alana Cordy-Collins,
 pp. 243–274. Dumbarton Oaks, Washington, D.C.
 1990b The Chotuna Friezes and the Chotuna-Dragon Connection. In *The Northern
 Dynasties: Kingship and Statecraft in Chimor,* edited by Michael E. Moseley and
 Alana Cordy-Collins, pp. 275–296. Dumbarton Oaks, Washington, D.C.
Duncan, Barbara R. (editor)
 1998 *Living Stories of the Cherokee.* Chapel Hill: University of North Carolina Press.
Durán, Fray Diego
 1967 *Historia de las Indias de Nueva España y islas de tierra firme* (1579–1581) (Atlas of
 Durán). Editorial Porrúa, México D.F.
 1971 *Book of the Gods and Rites and the Ancient Calendar.* Translated by D. Heyden and
 F. Horcasitas. University of Oklahoma Press, Norman.
Duverger, Christian
 1983 *La Flor Letal. Economía del Sacrificio Azteca.* Fondo de Cultura Económica,
 México D.F.
Edmonson, Munro S. (translation and annotation)
 1986 *Heaven Born Mérida and Its Destiny: The Book of Chilam Balam of Chumayel.*
 University of Texas Press, Austin.
Eliade, Mircea
 1969 *The Quest: History and Meaning in Religion.* University of Chicago Press, Chicago.

1974 *Man and the Sacred: A Thematic Source Book of the History of Religions.* Harper and Row, New York.

Faris, James C.

1990 *The Nightway: A History and a History of Documentation of a Navajo Ceremonial.* University of New Mexico Press, Albuquerque.

Farriss, Nancy M.

1984 *Maya Society under Colonial Rule: The Collective Enterprise of Survival.* Princeton University Press, Princeton.

Finger, John R.

1984 *The Eastern Band of Cherokee Indians, 1819–1900.* University of Tennessee Press, Knoxville.

Foster, Kenneth E.

1964 The Art of Sand Painting Practised by American Navajo Indians. Supplement to the *Illustrated London News,* 244:608–611. London.

Fowler, Catherine

1992 *In the Shadow of Fox Peak: An Ethnography of the Cattail-Eater Northern Paiute People of Stillwater Marsh.* Cultural Resource Series, Number 5. U.S. Department of the Interior, Fish and Wildlife Service, Fallon, Nevada.

Fowler, Don, and Catherine Fowler (editors)

1971 *Anthropology of the Numa: John Wesley Powell's Manuscripts on the Numic Peoples of Western North America, 1868–1880.* Smithsonian Institution Press, Washington, D.C.

Freidel, David, Linda Schele, and Joy Parker

1993 *Maya Cosmos: Three Thousand Years on the Shaman's Path.* William Morrow, New York.

Frisbie, Charlotte J.

1987 *Navajo Medicine Bundles or Jish: Acquisition, Transmission, and Disposition in the Past and Present.* University of New Mexico Press, Albuquerque.

Galindo Trejo, Jesús

1989 Cuando Huitzilopochtli descendió en Malinalco. In *México Desconocido,* October 1989, Nr. 152, pp. 17–22. México D.F.

García Payón, José

1958 Guía oficial de la zona arqueológica de Malinalco, Estado de México. Instituto Nacional de Antropología e Historia, México D.F.

1974 *Los monumentos arqueológicos de Malinalco.* Reimpresión de la edición de 1947. Biblioteca Enciclopédica del Estado de México, México D.F.

Garza, Mercedes de la (editor)

1983 *Relaciones histórico-geográficas de la gobernación de Yucatán.* 2 Vols. Universidad Nacional Autónoma de México, México D.F.

Gendrop, Paul

1985 *Arquitectura Prehispánica en Mesoamérica.* Trillas, Mexico.

Gibson, Charles, and John B. Glass

1975 Prose Sources in the Native Historical Tradition; B: A Census of Middle American Prose Manuscripts in the Native Historical Tradition. In *Guide to Ethnohis-*

torical Sources, Part Four, H. F. Cline, vol. ed., C. Gibson and H. B. Nicholson, assoc. vol. eds., pp. 322–400. *Handbook of Middle American Indians,* Vol. 15, R. Wauchope, general editor, University of Texas Press, Austin.

Gill, Sam D.
1983 Navajo Views of Their Origin. In *Southwest,* edited by Alfonso Ortiz, pp. 502–505. *Handbook of North American Indians,* Vol. 10, William C. Sturtevant, general editor, Smithsonian Institution, Washington, D.C.

Gilpin, Dennis
1996 Early Navajo Occupation West of the Chuska Mountains. In *The Archaeology of Navajo Origins,* edited by Ronald H. Towner, pp. 171–196. University of Utah Press, Salt Lake City.

Golden, Charles
2005 Where Does Memory Reside, and Why Isn't It History? *American Anthropologist* 107(2):270–274.

González Torres, Yólotl
1985 *El Sacrificio humano entre los Aztecas.* Instituto Nacional de Antropología e Historia–Fondo de Cultura Económica, México D.F.
1991 *Diccionario de mitología y religión de Mesoamérica.* Larousse, México D.F.

Goss, James
1972 A Basin-Plateau Shoshonean Ecological Model. In *Great Basin Cultural Ecology: A Symposium,* edited by D. Fowler, pp. 123–128. Publications in the Social Sciences, No. 8. University of Nevada, Desert Research Institute, Reno.

Graff, Donald H., and Gabrielle Vail
2001 Censers and Stars: Issues in the Dating of the *Madrid Codex. Latin American Indian Literatures Journal* 17(1):58–95.

Greider, Thomas, and Lorraine Garkovich
1994 Landscapes: The Social Construction of Nature and the Environment. *Rural Sociology* 59(1):1–24.

Gruzinski, Serge
1992 *The Aztecs.* Abrams, New York.

Haile, Father Berard
1938 *Origin Legend of the Navaho Enemy Way.* Yale University Press; Yale University Publications in Anthropology No. 17. New Haven.

Hanks, William F.
1988 Grammar, Style, and Meaning in a Maya Manuscript. Review of *Heaven Born Mérida and Its Destiny: The Book of Chilam Balam of Chumayel,* translated and annotated by Munro S. Edmonson. *International Journal of American Linguistics* 54(3):331–365.
1989 Elements of Maya Style. In *Word and Image in Maya Culture: Explorations in Language, Writing, and Representation,* edited by W. F. Hanks and D. S. Rice. University of Utah Press, Salt Lake City.

Helms, Mary W.
1993 *Craft and the Kingly Ideal: Art, Trade, and Power.* University of Texas Press, Austin.

Hernández Rivero, José
 1993 *Ideología y práctica militar mexica: El Cuauhcalli de Malinalco.* Ayuntamiento
 Constitucional, Malinalco.

Hester, James J.
 1962 *Early Navajo Migrations and Acculturation in the Southwest.* Museum of New
 Mexico Papers in Anthropology No. 6, Santa Fe.

Hinton, Leanna, and Lucille J. Watomigie
 1984 *Spirit Mountain: An Anthology of Yuman Story and Song.* University of Arizona
 Press, Tucson.

Hirsch, Eric
 1995 Introduction Landscape: Between Place and Space. In *The Anthropology of Land-
 scape. Perspectives on Place and Space,* edited by Eric Hirsch and Michael O'Han-
 lon, pp. 1–29. Clarendon Press, Oxford.

Histoire du Mechique
 1965 In *Teogonía e historia de los mexicanos: Tres opúsculos del siglo XVI,* edited by Angel
 María Garibay. Editorial Porrúa, México D.F.

Historia Tolteca-Chichimeca
 1989 *Traducción, análisis y comentarios de Paul Kirchhoff, Lina Odena Güemes y Luis
 Reyes García.* Fondo de Cultura Económica, México D.F.

Holm, Bill, and Bill Reid
 1976 *Indian Art of the Northwest Coast.* Institute of Arts, Rice University, Houston;
 University of Washington Press, Seattle.

Hudson, Charles
 1976 *The Southeastern Indians.* University of Tennessee Press, Knoxville.

Hudson, Charles, and Robbie Ethridge (editors)
 2002 *The Transformation of the Southeastern Indians, 1540–1760.* University Press of
 Mississippi, Jackson.

Huertas, Lorenzo
 1991 Perturbaciones étnicas en Piura. *Bulletin de l'Institut Français d'Études Andines*
 20(2):489–500.

Jackson, Margaret A.
 2004 The Chimú Sculptures of Huacas Tacaynamo and El Dragón, Moche Valley,
 Peru. *Latin American Antiquity* 15:298–322.

Jeancon, J. A., and Frank H. H. Roberts
 1923 Further Archaeological Research in the Northeastern San Juan Basin of Colo-
 rado during the Summer of 1922: The Pagosa-Piedra Region. *Colorado Maga-
 zine* 1(1):1–26.

Jensen, Andrew
 1926 *History of the Las Vegas Mission,* Vol. 5. Nevada State Historical Society Papers,
 Reno.

Jett, Stephen C.
 1982 "Ye'iis Lying Down," a Unique Navajo Sacred Place. In *Navajo Religion and Cul-
 ture: Selected Views,* edited by David Brugge and Charlotte Frisbie, pp. 138–149.
 Museum of New Mexico Press, Santa Fe.

Karttunen, Francis

1992 *An Analytical Dictionary of Nahuatl.* University of Oklahoma Press, Norman.

Kato, Yasutaki

1993 Resultados de las excavaciones en Kuntur Wasi. In *El mundo ceremonial andino,* edited by Luis Millones and Yoshio Onuki. *Senri Ethnological Studies* 37:203–228. Osaka.

Keen, A. Myra

1971 *Sea Shells of Tropical West America.* 2nd ed. Stanford University Press, Stanford, California.

King, Duane H. (editor)

1979 *The Cherokee Nation: A Troubled History.* University of Tennessee Press, Knoxville.

Kluckhohn, Clyde

1944 *Navaho Witchcraft.* Beacon Press, Boston.

Knauth, Lothar

1994 Reseña bibliográfica de los Monumentos Arqueológicos de Malinalco. In *Historia Mexicana.* México: Centro de estudios históricos de El Colegio de México. Vol. 25(99):490–494.

Kolber, Jane

2001 Recording, Protecting, and Studying Navajo Rock Art: A Project in Chaco Canyon. In *American Indian Rock Art,* Vol. 27, edited by Steven M. Freers and Alanah Woody, pp. 17–24. American Rock Art Research Association, Tucson.

Kosok, Paul

1965 *Life, Land, and Water in Ancient Peru.* Long Island University Press, New York.

Kostof, Spiro

1972 *Caves of God: The Monastic Environment of Byzantine Cappadocia.* MIT Press, Cambridge.

Kowalski, Jeff Karl

1999 The Puuc as Seen from Uxmal. In *Hidden among the Hills: Maya Archaeology of the Northwest Yucatan Peninsula.* First Maler Symposium, Bonn, 1990. Acta Mesoamericana, Vol. 7, edited by Hanns J. Prem, pp. 93–120.

Kroeber, A. L.

1935 Walapai Ethnography. Memoirs of the American Anthropological Association No. 42. American Anthropological Association, Menasha, Wisconsin.

Landa, Diego de

1937 *Yucatán before and after the Conquest.* Translated with notes by William Gates. The Maya Society, Baltimore. Unabridged republication 1978, Dover, New York. Also reprinted 1987, Editorial San Fernando, Mérida, Yucatán, and 1990, Editorial Dante, Mérida, Yucatán.

Lathrap, Donald W.

1973 Gifts of the Cayman: Some Thoughts on the Subsistence Base of Chavin. In *Variations in Anthropology: Essays in Honor of John C. McGregor,* edited by Donald W. Lathrap and Jody Douglas, pp. 91–106. Illinois Archaeological Survey, Urbana.

Leeming, David, and Jake Page
 1998 *The Mythology of Native North America.* University of Oklahoma Press, Norman.

León-Portilla, Miguel
 1971 *De Teotihuacan a los Aztecas.* Universidad Nacional Autónoma de México, México D.F.
 1993 *Los antiguos mexicanos.* Fondo de Cultura Económica, México D.F.

Lévi-Strauss, Claude
 1982 *The Way of the Masks.* University of Washington Press, Seattle.

Liza, Jacinto
 1967 *Historia de la aparición del divino Niño Jesús en el antigüo pueblo mochica de Eten en 1649,* edited by Jacinto A. Liza Q. Chiclayo and Ciudad Eten, Peru.

Lizárraga, Fray Reginaldo de
 [1603– *Descripción breve de toda la tierra del Perú.* Biblioteca de Autores Españoles, Vol.
 1608] 216. Editorial Atlas, Madrid.
 1968

López Austin, Alfredo
 1980 *Cuerpo humano e ideología.* Conceptos de los Antiguos Nahuas. 2 Vols. Universidad Nacional Autónoma de México, México D.F.
 1988 *The Human Body and Ideology.* Concepts of the Ancient Nahuas. 2 Vols. University of Utah Press, Salt Lake City.

Lothrop, Samuel K.
 1928 Santiago Atitlán, Guatemala. *Indian Notes* 5:370–395.
 1929 Further Notes on Indian Ceremonies in Guatemala. *Indian Notes* 6:1–25.

Lowie, Robert
 1924 *Notes on Shoshone Ethnography.* American Museum Press, New York.

Luckert, Karl W.
 1977 *Navajo Mountain and Rainbow Bridge Religion.* American Tribal Religions, Vol. 1. Museum of Northern Arizona, Flagstaff.

Marquina, Ignacio
 1964 *Arquitectura prehispánica.* Instituto Nacional de Antropología e Historia, México D.F.

Martínez de Compañón, Baltasar Jaime
 [1782– *Trujillo del Perú a fines del siglo XVIII,* Vol. II. Editorial Cultura Hispánica,
 1788] Madrid.
 1982

Matos Moctezuma, Eduardo
 1988 *The Great Temple of the Aztecs: Treasures of Tenochtitlan.* Thames and Hudson, London.

Matthews, Washington
 1883 A Part of Navajo's Mythology. *American Antiquarian.* April.
 1887 The Mountain Chant. *Annual Report of the Bureau of American Ethnology* 5:385–467, Smithsonian Institution, Washington, D.C.
 1897 *Navaho Legends.* American Folklore Society Memoirs 5.

1902 *The Night Chant.* Memoirs of the American Museum of Natural History 6. New York.

McClelland, Donna

1990 A Maritime Passage from Moche to Chimú. In *The Northern Dynasties: Kingship and Statecraft in Chimor,* edited by Michael E. Moseley and Alana Cordy-Collins, pp. 75–106. Dumbarton Oaks, Washington, D.C.

McQuitty, William

1965 *Abu Simbel.* Putnam, New York.

Mendelson, E. Michael

1956 *Religion and World-View in Santiago Atitlán.* Ph.D. dissertation, University of Chicago.

1957 *Religion and World-View in a Guatemalan Village.* Microfilm Collection of Manuscripts on Middle American Cultural Anthropology No. 52. University of Chicago Library, Chicago.

1958a A Guatemalan Sacred Bundle. *Man* 58(August):121–126.

1958b The King, the Traitor, and the Cross: An Interpretation of a Highland Maya Religious Conflict. *Diogenes* 21:1–10.

1959 Maximon: An Iconographical Introduction. *Man* 59:57–60.

1965 *Las escándolas de Maximon,* Publication 19. Seminario de Integración Social Guatemalteca, Guatemala City.

1967 Ritual and Mythology, pp. 392–415. *Handbook of Middle American Indians,* Vol. 7. University of Texas Press, Austin.

Mendieta, Fray Gerónimo de

1993 *Historia eclesiástica indiana.* Editorial Porrúa, México D.F.

Mendoza, Rubén

1977 Worldview and the Monolithic Temples of Malinalco, México: Iconography and Analogy in Pre-Columbian Architecture. *Journal de la Societé des Americanistes* LXIV:63–80. Paris.

Milbrath, Susan

1999 *Star Gods of the Maya: Astronomy in Art, Folklore, and Calendars.* University of Texas Press, Austin.

Miller, Jay

1983 Basin Religion and Theology: A Comparative Study of Power (Puha). *Journal of California and Great Basin Anthropology* 5(1, 2):66–86.

Mogrovejo, Toribio de

[1593– Libro de visita. *Revista del Archivo Nacional* (Lima)1:49–81, 227–279, 401–
1598] 419.
1920

[1593– Libro de visita. *Revista del Archivo Nacional* (Lima) 2:37–78.
1598]
1921

Molina, Alonso de

1970 *Vocabulario en lengua castellana y mexicana y mexicana y castellana.* Preliminary Study by Miguel León-Portilla. Editorial Porrúa, México D.F.

Mooney, James
 1992 *James Mooney's History, Myths, and Sacred Formulas of the Cherokees.* Historical
 Images, Asheville, North Carolina.
 1995 *Myths of the Cherokee.* Dover Publications, New York.
Moore, Jerry
 1996 *Architecture and Power in the Ancient Andes: The Archaeology of Public Buildings.*
 Cambridge University Press, New York.
Morphy, Howard
 1995 Landscape and the Reproduction of the Ancestral Past. In *The Anthropology of
 Landscape: Perspectives on Place and Space,* edited by Eric Hirsch and Michael
 O'Hanlon, pp.184–209. Clarendon Press, Oxford.
Mundy, Barbara
 1998 MesoAmerican Cartography. In *The History of Cartography,* Vol. 2, Book 3. In
 *Cartography in the Traditional African, American, Arctic, Australian, and Pacific So-
 cieties,* edited by David Woodward and G. Malcolm Lewis, pp. 183–256. Univer-
 sity of Chicago Press, Chicago.
Muñoz Camargo, Diego
 1978 *Historia de Tlaxcala (Siglo XVI).* Annotated by Alfredo Chavero. Editorial Ino-
 vación, México D.F.
Murra, John V.
 1975 El tráfico de *mullu* en la costa del Pacífico. In *Formaciones económicos y políticos
 del mundo andino,* pp. 255–267. Instituto de Estudios Peruanos, Lima.
Netherly, Patricia J.
 1977 *Local Level Lords on the North Coast of Peru.* Ph.D. dissertation, Department of
 Anthropology, Cornell University, Ithaca.
 1984 The Management of Late Andean Irrigation Systems on the North Coast of
 Peru. *American Antiquity* 49:227–254.
 1990 Out of Many, One: The Organization of Rule in the North Coast Polities. In
 The Northern Dynasties: Kingship and Statecraft in Chimor, edited by Michael E.
 Moseley and Alana Cordy-Collins, pp. 353–377. Dumbarton Oaks, Washing-
 ton, D.C.
 2005 Pathways to Complexity: A Comparison of the North Coast of Peru and the Cir-
 cum Gulf of Guayaquil Region. Paper read at the 70th Annual Meeting of the
 Society for American Archaeology, Salt Lake City.
Newcomb, Franc Johnson
 1964 *Hosteen Klah: Navaho Medicine Man and Sand Painter.* University of Oklahoma
 Press, Norman.
Niles, Susan
 1992 Inca Architecture and Sacred Landscape. In *The Ancient Americas: Art from Sa-
 cred Landscapes,* edited by Richard Townsend, pp. 347–357. The Art Institute of
 Chicago, Chicago.
Olin, Caroline, and Sally Hadlock
 1980 Recording the Roots of Navajo Culture. *Exxon, USA,* pp. 26–31. Houston.

Orellana, Sandra L.

1975a La introducción del sistema de cofradía en la región del lago de Atitlán en los al-
tos de Guatemala. *América Indígena* 35:845–856.

1975b Folk Literature of the Tzutujil Maya. *Anthropos* 70:839–876.

1984 *The Tzutujil Mayas: Continuity and Change, 1250–1630.* University of Okla-
homa Press, Norman.

Ortiz, Alfonso

1969 *The Tewa World: Space, Time, Being, and Becoming in a Pueblo Society.* University
of Chicago Press, Chicago.

Palacios, Enrique Juan

1935 *La cintura de serpientes de la Pirámide de Tenayuca.* Publicaciones de la Secretaría
de Educación Pública, México D.F.

Pardo, Luis A.

1946 La metropoli de Paccarictampu. *Revista de la Seccion Arqueologica de la Universi-
dad Nacional del Cuzco* 2:3–46.

Parker, G. Keith

2006 *Seven Cherokee Myths: Creation, Fire, the Primordial Parents, the Nature of Evil,
the Family, Universal Suffering, and Communal Obligation.* McFarland, Jefferson,
North Carolina.

Parsons, Elsie Clews

1939 *Pueblo Indian Religion.* 2 Vols. University of Chicago Press, Chicago.

Pasztory, Esther

1983 *Aztec Art.* Abrams, New York.

Paternosto, C.

1989 *The Stone and the Thread: Andean Roots of Abstract Art.* Translated by Esther Allen.
University of Texas Press, Austin.

Paulsen, Allison

1974 The Thorny Oyster and the Voice of God: *Spondylus* and *Strombus* in Andean
Prehistory. *American Antiquity* 39:597–607.

Paxton, Merideth

1986 *Codex Dresden: Stylistic and Iconographic Analysis of a Maya Manuscript.* Ph.D.
dissertation, University of New Mexico. University Microfilms, Ann Arbor.

1997 Códice Madrid: Análisis de las páginas 75–76. In *Códices y documentos sobre
México, segundo simposio.* 2 Vols., edited by S. Rueda Smithers, C. Vega Sosa, and
R. Martínez Baracs, pp. 1:63–80. Instituto Nacional de Antropología e Historia
(Dirección de Estudios Históricos) and Consejo Nacional para la Cultura y las
Artes (Dirección General de Publicaciones), México D.F.

2000 Páginas 75–76 de Códice Madrid y el simbolismo del tzolkín y del haab. In
Códices y documentos sobre México, tercer simposio internacional, edited by C. Vega
Sosa, pp. 257–269. Instituto Nacional de Antroplolgía e Historia, México D.F.

2001a Chilam Balam, Books of. In *The Oxford Encyclopedia of MesoAmerican Cultures:
The Civilizations of Mexico and Central America.* 3 Vols, edited by D. Carrasco,
pp. 1:190–195. Oxford University Press, New York.

2001b *The Cosmos of the Yucatec Maya: Cycles and Steps from the Madrid Codex.* University of New Mexico Press, Albuquerque.

2004a Tayasal Origin of the *Madrid Codex:* Further Consideration of the Theory. In *The Madrid Codex: New Approaches to Understanding an Ancient Maya Manuscript,* edited by G. Vail and A. F. Aveni, pp. 89–127. University Press of Colorado, Boulder.

2004b The *Uinal* in the Books of Chilam Balam and Interpretation of Pages 76–75 of the *Madrid Codex. Latin American Indian Literatures Journal* 20(2):113–139.

Peñafiel, Antonio

1885 *Nombres geográficos de México en Nahuatl.* Secretaría de Fomento, México D.F.

1897 *Nomenclatura geográfica de México.* Secretaría de Fomento, México D.F.

Perdue, Theda

1985 *Native Carolinians: The Indians of North Carolina.* Division of Archives and History, North Carolina Department of Cultural Resources, Raleigh.

1989 *The Cherokee.* Chelsea House Publishers, New York.

1998 *Cherokee Women: Gender and Culture Change, 1700–1835.* University of Nebraska Press, Lincoln.

Peterson, Jeanette F.

1993 *The Paradise Garden Murals of Malinalco.* University of Texas Press, Austin.

PHYSORG.com

2005 Antifreeze Protein Found in Snow Fleas May Allow Longer Storage of Transplant Organs. At http://www.physorg.com/news7456.html.

Pillsbury, Joanne

1996 The Thorny Oyster and the Origins of Empire: Implications of Recently Uncovered *Spondylus* Imagery from Chan Chan, Peru. *Latin American Antiquity* 7:313–340.

Plancarte y Navarrete, Francisco

1911 *Tamoanchan: El estado de Morelos y el principio de la civilización en México.* Editorial el Mensajero, México D.F.

Porras Barrenechea, Raúl

1986 *Los cronistas del Perú (1528–1650) y otros ensayos.* Banco de Crédito del Perú, Lima.

Porter, James B.

1997 Drawing the Maya Screenfold Books: Preliminary Observations. In *Latin American Indian Literatures: Messages and Meanings,* edited by M. H. Preuss, pp. 33–46. Labyrinthos, Lancaster, California.

Prechtel, Martín, and Robert S. Carlsen

1988 Weaving and Cosmos amongst the Tzutujil Maya. *Res* 15:122–132.

Ramos de Cox, Josefina

1950 Ensayo de un vocabulario de la lengua tallan o tallanca. *Cuadernos de Estudio* 2(8). Instituto Riva-Agüero, Pontificia Universidad Católica del Perú, Lima.

Raymond, J. Scott, and Richard L. Burger (editors)

2003 *Archaeology of Formative Ecuador.* Dumbarton Oaks, Washington, D.C.

Reichard, Gladys A.

1963 *Navaho Religion: A Study in Symbolism.* 2nd ed. Bollingen Foundation, Pantheon Books, New York.

1977 *Navajo Medicine Man Sandpaintings.* Originally published by J. J. Augustin, New York 1939. Dover Publications, New York.

Restall, Matthew

1997 *The Maya World: Yucatec Culture and Society, 1550–1580.* Stanford University Press, Stanford, California.

Riese, Frauke Johanna

1981 *Indianische Landrechte in Yukatan um de Mitte des 16. Jahrhunderts.* Hamburgisches Museum für Völkerkunde, Hamburg.

Rivet, Paul

1949 Les langues de l'ancien diocese de Trujillo. *Journal de la Société des Américanistes* N.S. 38.

Robelo, Cecilio

1951 *Diccionario de mitología Nahuatl.* Editorial Fuente Cultural, México D.F.

1974 *Nombres geográficos indígenas del Estado de México.* Gobierno del Estado de México, Toluca.

Rodning, Christopher B.

2002 Reconstructing the Coalescence of Cherokee Communities in Southern Appalachia. In *The Transformation of the Southeastern Indians, 1540–1760,* edited by Charles Hudson and Robbie Ethridge. University Press of Mississippi, Jackson.

Roessel, Robert A., Jr.

1983 Navajo History, 1850–1923. In *Southwest,* edited by Alfonso Ortiz, pp. 506–523. *Handbook of North American Indians,* Vol. 10, William C, Sturtevant, general editor, Smithsonian Institution, Washington, D.C.

Rojas C., J. Heriberto

2006 *El complejo arqueológico de Ingapirca,* Vol. 3. Offset Color Cuenca, Azogues, Ecuador.

Romero-Quiroz, Javier

1958 *El Huéhuetl de Malinalco.* Universidad Autónoma del Estado de México, Toluca.

1964 *El Teponaztli de Malinalco.* Universidad Autónoma del Estado de México, Toluca.

1980 *Historia de Malinalco.* Gobierno del Estado de México, Toluca.

1987 *Solsticio de invierno en Malinalco.* Universidad Autónoma del Estado de México, Toluca.

Ross, Thomas E.

1999 *American Indians in North Carolina: Geographic Interpretations.* Karo Hollow Press, Southern Pines.

Rostworowski de Diez Canseco, Maria

1961 *Curacas y sucesiones: Costa Norte.* Imprenta Minerva, Lima.

1970 Mercaderes del valle de Chincha en la época prehispánica: Un documento y unos comentarios. *Revista Española de Antropología Americana* 5. Madrid.

1975a *History of the Inca Realm.* Cambridge University Press, Cambridge.

1975b Pescadores, artesanos y mercaderes costeños en el Perú prehispánico. *Revista del Museo Nacional* XLI:311–349. Lima.

1977 *Etnía y sociedad: Ensayos sobre la costa central prehispánica.* Instituto de Estudios Peruanos, Lima.

Rowe, Anne P.

1984 *Costume and Featherwork of the Lords of Chimor: Textiles of Peru's North Coast.* The Textile Museum, Washington, D.C.

Roys, Ralph L.

1943 *The Indian Background of Colonial Yucatán.* Carnegie Institution of Washington, D.C., Publication 548. Washington, D.C. Reprinted 1972, University of Oklahoma Press, Norman.

Roys, Ralph L. (translator and editor)

1967 *The Book of Chilam Balam of Chumayel.* University of Oklahoma Press, Norman.

[1933] Reproduced from first edition, published by Carnegie Institution of Washington, D.C, 1933, Washington, D.C.

Rozema, Vicki

1995 *Footsteps of the Cherokees: A Guide to the Eastern Homeland of the Cherokee Nation.* John F. Blair, Winston-Salem.

Sáenz, César

1963 Exploraciones en Malinalco. *Boletín del INAH* 14:4–9. México, D.F.

Sahagún, Fray Bernardino

1951– *Florentine Codex: General History of the Things of New Spain.* 12 Vols. Trans-
1969 lated from Nahuatl into English by Arthur J. O. Anderson and Charles E. Dibble. School of American Research, Santa Fe; University of Utah, Salt Lake City.

1975 *Historia general de las cosas de la Nueva España (1540–1577)* (Florentine Codex). Editorial Porrúa, México D.F.

Salazar, Lucy

2004 Machu Picchu: Mysterious Royal Estate in the Cloud Forest. In *Machu Picchu: Unveiling the Mysteries of the Incas,* edited by Richard Burger and Lucy Salazar, pp. 21–47. Yale University Press, New Haven.

Salles-Reese, Veronica

1997 *From Viracocha to the Virgin of Copacabana.* University of Texas Press, Austin.

Salomon, F. L., and Urioste, G. L. (translators)

1991 *The Huarochirí Manuscript: A Testament of Ancient and Colonial Andean Religion.*
[ca. Translated from Quechua by F. L. Salomon and G. L. Urioste. University of
1598– Texas Press, Austin.
1608]

Sarmiento de Gamboa, Pedro

1942 *Historia de los Incas.* Emece Editores, Buenos Aires.
[1572]

Satz, Ronald

1979 *Tennessee's Indian Peoples: From White Contact to Removal, 1540–1840.* University of Tennessee Press, Knoxville.

Schaafsma, Curtis Forrest

2002 *Apaches de Navajo.* University of Utah Press, Salt Lake City.

2004 Truth Dwells in the Deeps: Southwestern Oral Traditions and Archaeological Interpretations. In *New World Edens,* edited by D. Bahr and P. Zolbrod. *Journal of the Southwest* 46(4):621–662. The Southwest Center, University of Arizona, Tucson.

Schaafsma, Curtis F., and Polly Schaafsma

1996 Traditional Narratives and Archaeology. In *La Jornada: Papers in Honor of William F. Turney,* edited by Meliha S. Duran and David T. Kirkpatrick, pp. 171–178. The Archaeological Society of New Mexico No. 22, Albuquerque.

Schaafsma, Polly

1963 *Rock Art in the Navajo Reservoir District.* Laboratory of Anthropology, Santa Fe.

1965 *Early Navajo Rock Carvings and Paintings.* Museum of Navajo Ceremonial Art, Santa Fe.

1980 *Indian Rock Art of the Southwest.* School of American Research, Santa Fe; University of New Mexico Press, Albuquerque.

1992 *Rock Art in New Mexico.* Museum of New Mexico Press, Santa Fe.

Schroeder Cordero, Francisco

1985 La arquitectura monolítica en Tezcotzinco y Malinalco, Edo. de México. In *Cuadernos de arquitectura mesoamericana* Nr. 4, pp. 65–90. Universidad Nacional Autónoma de México, México D.F.

Seler, Eduard

1960 Die holgeschnitzte Pauke von Malinalco und das Zeichen Atl-Tlachinolli (Timbal de madera de Malinalco y el signo Atl-Tlachinolli), Versión en Español en *Colección de Disertaciones* de Eduard Seler, tomo 3. Museo Nacional de Antropología e Historia, México D.F.

Sharpe, Bill

1958 *A New Geography of North Carolina,* Vol. 2. Sharpe Publishing, Raleigh.

1965 *A New Geography of North Carolina,* Vol. 4. Sharpe Publishing, Raleigh.

Sherbondy, Jeanette

1992 Water Ideology in Inca Ethnogenesis. In *Andean Cosmologies through Time,* edited by Robert Dover, Katharine Seibold, and John McDowell, pp.46–66. Indiana University Press, Indianapolis.

Shimada, Izumi

1990 Cultural Continuities and Discontinuities on the Northern North Coast of Peru, Middle-Late Horizons. In *The Northern Dynasties: Kingship and Statecraft in Chimor,* edited by Michael E. Moseley and Alana Cordy-Collins, pp. 297–392. Dumbarton Oaks, Washington, D.C.

1994 *Pampa Grande and the Mochica Culture.* University of Texas Press, Austin.

Smith, Adam T.

2003 *The Political Landscape: Constellations of Authority in Early Complex Polities.* University of California Press, Berkeley.

Smith, Michael

2003 *The Aztecs.* Blackwell Publishers, Malden, Massachusetts.

Sosa, John

 1985 *The Maya Sky, the Maya World: A Symbolic Analysis of Yucatec Maya Cosmology.*
 Ph.D. dissertation, State University of New York at Albany. University Micro-
 films, Ann Arbor.

 1989 Cosmological, Symbolic, and Cultural Complexity among the Contemporary
 Maya of Yucatan. In *World Archaeoastronomy: Selected Papers from the 2nd Oxford
 International Conference on Archaeoastronomy Held at Mérida, Yucatán, Mexico
 (13–17 January 1986),* edited by A. F. Aveni, pp. 130–142. Cambridge Univer-
 sity Press, Cambridge.

Soustelle, Jacques

 1979 *The Daily Life of the Aztecs on the Eve of the Spanish Conquest.* Macmillan, New York.

 1982 *El universo de los Aztecas.* Fondo de Cultura Económica, México D.F.

 1992 *La vida cotidiana de los Aztecas en vísperas de la conquista.* Fondo de Cultura Eco-
 nómica, México D.F.

Spicer, Edward

 1957 Worlds Apart: Cultural Differences in the Modern Southwest. *Arizona Quarterly*
 13(3):197–203.

Staller, John E.

 n.d. Forms of Interaction and Their Significance to Archaeological Patterning in a
 Sacred Landscape. *Journal of World Prehistory.*

Starr, Frederick

 1920 *Aztec Place-Names: Their Meaning and Mode of Composition.* Private edition,
 Chicago.

Stephens, John L.

 1963 *Incidents of Travel in Yucatan.* 2 Vols. Dover, New York. Originally published
 [1843] 1843, Harper and Brothers, New York.

Stevenson, James A.

 1886 Ceremonial of Hasjelti Dailjis. *Annual Report of the Bureau of American Eth-
 nology* 8:229–85, Smithsonian Institution, Washington, D.C.

Stierlin, Henri

 1967 *Ancient Mexico.* Taschen, Cologne.

Stoffle, Richard, Fletcher P. Chmara-Huff, Kathleen A. Van Vlack, Rebecca S. Toupal

 2004 Puha Flows from It: Spring Mountains Cultural Landscape Study. Prepared for
 the United States Forest Service. Bureau of Applied Research in Anthropology,
 University of Arizona, Tucson.

Stoffle, Richard, and Henry Dobyns

 1983 Nuvagantu: *Nevada Indians Comment on the Intermountain Power Project.* Nevada
 State Office of the Bureau of Land Management, Reno.

√ Stoffle, Richard, David Halmo, and Diane Austin

 1997 Cultural Landscapes and Traditional Cultural Properties: A Southern Paiute View
 of the Grand Canyon and Colorado River. *American Indian Quarterly* 21(2):229–
 250.

Stoffle, Richard, Fabio Pittaluga, Tray Earnest, Amy Eisenberg, John Amato, and Genevieve
Dewey-Hefley

 1998 *Pah hu wichi (From Big Spring Running Down): Big Spring Ethnographic Assess-*

ment, US 95 Corridor Study. Bureau of Applied Research in Anthropology, University of Arizona, Tucson.

Stoffle, Richard, Rebecca Toupal, and Nieves Zedeño

2002 *East of Nellis: Cultural Landscapes of the Sheep and Pahranagat Mountain Ranges.* Bureau of Applied Research in Anthropology, University of Arizona, Tucson.

Stoffle, Richard, Nieves Zedeño, Amy Eisenberg, Rebecca Toupal, Alex Carroll, Fabio Pittaluga, John Amato, Tray Earnest, and Genevieve Dewey-Hefley

2000a *Ha'tata (The Backbone of the River): American Indian Ethnographic Studies Regarding the Hoover Dam Bypass Project.* Report Prepared for CH2M Hill Inc. and the Federal Highway Administration, Central Lands Highway Division. Bureau of Applied Research in Anthropology, University of Arizona, Tucson.

Stoffle, Richard, Nieves Zedeño, Jaime Eyrich, and Patrick Barabe

2000b The Wellington Canyon Ethnographic Study at Pintwater Range, Nevada. Bureau of Applied Research in Anthropology, University of Arizona, Tucson.

Tarn, Nathaniel, and Martín Prechtel

1986 Constant Inconstancy: The Feminine Principle in Atiteco Mythology. In *Symbol and Meaning beyond the Closed Community: Essays in MesoAmerican Ideas,* edited by Gary Gossen, pp. 173–184. Studies on Culture and Society, Vol. 1. Institute for MesoAmerican Studies, Albany.

1990 Comiéndose la fruta: Metáforos sexuales e iniciaciones en Santiago Atitlán. *Mesoamérica* 19:73–82.

1998 *Scandals in the House of Birds: Shamans and Priests on Lake Atitlán.* Marsilio Publishers, New York.

Taylor, Jane

2001 *Petra and the Lost Kingdom of the Nabateans.* I. B. Tauris Publisher, London.

Tedlock, Barbara

1982 *Time and the Highland Maya.* University of New Mexico Press, Albuquerque.

1986 On a Mountain Road in the Dark: Encounters with the Quiche Maya Culture Hero. In *Symbol and Meaning beyond the Closed Community: Essays in MesoAmerican Ideas,* edited by Gary H. Gossen, pp. 125–138. Institute for MesoAmerican Studies, University of Albany, Albany.

Thompson, G.

1879 Notes on the Pueblos and Their Inhabitants. *Report upon United States Geographical Surveys West of the One Hundredth Meridian: Archaeology,* 7:319–324. Engineer Department, United States Army, Washington, D.C.

Thompson, John Eric Sidney

1950 *Maya Hieroglyphic Writing: Introduction.* Carnegie Institution of Washington,
[1960] D.C., Publication 589, Washington, D.C. Reprinted 1960 as *Maya Hieroglyphic Writing, an Introduction.* University of Oklahoma Press, Norman; numerous subsequent printings.

1960 *Maya Hieroglyphic Writing.* University of Oklahoma Press, Norman.

1970 *Maya History and Religion.* University of Oklahoma Press, Norman.

1972 *A Commentary on the Dresden Codex: A Maya Hieroglyphic Book.* American Philosophical Society, Philadelphia.

Tilley, Christopher
1994 *A Phenomenology of Landscapes: Places, Paths and Monuments.* Berg Publishers, Oxford.
Tokovinine, Alexandre
2008a *The Power of Place: Political Landscape and Identity in Classic Maya Inscriptions, Imagery, and Architecture.* Ph.D. dissertation, Department of Anthropology, Harvard University, Cambridge, Massachusetts.
2008b Of Mountains, Caves, and People: Landscape and Identity in Classic Maya Texts and Images. Lecture presented to the Pre-Columbian Society of Washington, D.C.
Torero, Alfredo
1986 Deslindes lingüísticos en la costa norte peruana. *Revista Andina* 4:523–548.
1989 Áreas toponímicas e idiomas en la sierra norte peruana: Un trabajo de recuperación lingüística. *Revista Andina* 7:217–257.
2005 *Idiomas de los Andes: Lingüística e historia.* 2nd ed. Editorial Horizonte, Lima.
Torquemada, Fray Juan de
1986 *Monarquía Indiana,* Vol. 1. Editorial Porrúa, México D.F.
Toupal, Rebecca S.
2003 Cultural Landscapes as a Methodology for Understanding Natural Resource Management Impacts in the Western United States. *Conservation Ecology* 7(1):12–53.
Towner, Ronald H. (editor)
1996 *The Archaeology of Navajo Origins.* University of Utah Press, Salt Lake City.
2003 *Defending the Dinétah: Pueblitos in the Ancestral Navajo Heartland.* University of Utah Press, Salt Lake City.
Townsend, Richard
1979 State and Cosmos in the Art of Tenochtitlan. Studies in Pre-Columbian Art and Archaeology No. 20. Dumbarton Oaks, Washington, D.C.
1982 Malinalco and the Lords of Tenochtitlan. In *The Art and Iconography of Late Post-Classic Mexico,* edited by Elizabeth H. Boone, pp. 111–140. Dumbarton Oaks, Washington, D.C.
1992 *The Ancient Americas: Art from Sacred Landscapes.* Art Institute of Chicago, Chicago.
2000 *The Aztecs.* Thames and Hudson, New York.
Tozzer, Alfred M. (editor)
1941 *Landa's relación de las cosas de Yucatán.* Peabody Museum of American Archaeology and Ethnology, Harvard University, Papers Vol. 18, Cambridge, Massachusetts.
U'mista Cultural Society
2007 Electronic document, http://www.umista.ca /kwakwakawakw/index.php, accessed on May 27, 2007.
Urton, Gary
1981 *At the Crossroads of the Earth and the Sky: An Andean Cosmology.* University of Texas Press, Austin.
1990 *The History of a Myth: Pacariqtambo and the Origin of the Inkas.* University of Texas Press, Austin.
1999 *Inca Myths.* British Museum Press, London; University of Texas Press, Austin.
Vail, Gabrielle
1996 *The Gods in the Madrid Codex: An Iconographic and Glyphic Analysis.* Ph.D. dissertation, Tulane University, New Orleans.

2000 Issues of Language and Ethnicity in the Postclassic Maya Codices. *Written Language and Literacy* 3(1):37–75.

Vail, Gabrielle, and Anthony Aveni
2004 Research Methodologies and New Approaches to Interpreting the *Madrid Codex*. In *The Madrid Codex: New Approaches to Understanding and Ancient Maya Manuscript,* edited by Gabrielle Vail and Anthony Aveni, pp. 1–30. University Press of Colorado, Boulder.

Valcarcel, Luis
1951 Vida de Miguel Cabello Valboa. In *Miscelánea Antártica,* by Miguel Cabello Valboa, pp. xvii–xl. Universidad Nacional Mayor de San Marcos, Lima.

Valette, Jean-Paul, and Rebecca M. Valette
1997 In Search of Yah-na-pah. *American Indian Art* (Winter):56–69.

Valette, Rebecca M., and Jean-Paul Valette
2000 The Life and Work of Clitso Dedman, Navajo Woodcarver (1879?–1953). *American Indian Art* (Spring):54–56.

Van de Guchte, Maarten
1990 *"Carving the World": Inca Monumental Sculpture and Landscape.* Ph.D. dissertation, Department of Anthropology, University of Illinois at Urbana-Champaign. University Microfilms, Ann Arbor.

Van Valkenburgh, Richard F.
1941 Diné Bikéyah. Unpublished manuscript. United States Department of the Interior, Navajo Service. Window Rock, Arizona.

Van Valkenburgh, Richard F., and Clyde Kluckhohn
1974 Navajo Sacred Places. Unpublished manuscript left by Van Valkenburgh and edited posthumously by Kluckhohn. On file in Research Section, Navajo Tribe, Window Rock, Arizona.

Vargas Ugarte, Rubén, S.J.
1936 La fecha de la fundación de Trujillo. *Revista Historica* 10. Lima.

De la Vega, Garcilaso
1963 *Obras completas del Inca Garcilaso de la Vega II,* edited by P. Carmelo Saenz de
[1609] Santa Maria. Biblioteca de Autores Espanoles, Madrid.

Villa Rojas, Alfonso
1988 The Concepts of Space and Time among the Contemporary Maya. In *Time and Reality in the Thought of the Maya,* by Miguel León-Portilla, pp. 113–159. University of Oklahoma Press, Norman. 2nd ed., translated from *Tiempo y realidad en el pensamiento Maya: Ensayo de acercamiento.* Universidad Nacional Autónoma de México, 1968, México D.F.

Villacorta C., J. Antonio, and Carlos A. Villacorta
1976 *Códices mayas reproducidos y desarrollados.* Tipografía Nacional, reprinted from Villacorta and Villacorta 1930. Guatemala.

Ward, H. Trawick, and R. P. Stephen Davis, Jr.
1991 *Time before History: The Archaeology of North Carolina.* University of North Carolina Press, Chapel Hill.

Wood, Denis
1992 *The Power of Maps.* Guilford Press, New York.

Wyman, Leland C.

1983a *Southwest Indian Drypainting.* A School of American Research Book. School of American Research, Santa Fe; University of New Mexico Press, Albuquerque.

1983b Navajo Ceremonial System. In *Southwest,* edited by Alfonso Ortiz, pp. 536–557. *Handbook of North American Indians,* Vol. 10, William C. Sturtevant, general editor, Smithsonian Institution, Washington, D.C.

Yoder, Donna

2001 Livestock in Navajo Rock Art: A Reflection of Life. In *American Indian Rock Art,* Vol. 27, edited by Steven M. Freers and Alanah Woody, pp. 67–72. American Rock Art Research Association, Tucson.

Zárate, Agustín de

[1555] *Historia del descubrimiento y conquista del Perú.* Imprenta Miranda, Lima.
1944

✓ Zedeño, María Nieves

1997 Landscapes, Land Use, and the History of Territory Formation: An Example from the Puebloan Southwest. *Journal of Archaeological Method and Theory* 4(1): 67–103.

Zevallos Quiñones, Jorge

1948 Primitivas lenguas de la costa. *Revista del Museo Nacional* XVII:114–119. Lima.

Zolbrod, Paul

1984 *Diné bahané: Navajo Creation Story.* University of New Mexico Press, Albuquerque.

List of Contributors

Manuel Aguilar-Moreno is Associate Professor of Art History at California State University in Los Angeles.

Richard Arnold is Chairman of the Pahrump Paiute Tribe, Pahrump, Nevada.

Allen J. Christenson is Associate Professor, Department of Humanities, Classics, and Comparative Literature, at Brigham Young University.

Jessica Joyce Christie is Associate Professor in the School of Art and Design, East Carolina University.

Betty Cornelius is a tribal member of the Colorado River Indian Tribes, Parker, Arizona.

Larry Eddy is a tribal member of the Colorado River Indian Tribes, Parker, Arizona.

Patricia J. Netherly is research associate with the Anthropology Department at Vanderbilt University.

Christopher Arris Oakley is Assistant Professor in the History Department of East Carolina University.

Merideth Paxton is research affiliate with the Latin American Studies Department at the University of New Mexico in Albuquerque.

Polly Schaafsma is a research associate of the Museum of Indian Arts and Culture/Laboratory of Anthropology of the Museum of New Mexico, Santa Fe.

Richard Stoffle is a Full Research Anthropologist with the Bureau of Applied Research in Anthropology at the University of Arizona, Tucson.

Will Tsosie is a Navajo tribal member living in Shiprock, N.M. He works as an archaeologist/ethnographer of the Navajo world for the firm Woods Canyon Archaeological Consultants in Cortez, Colorado.

Kathleen Van Vlack is a Ph.D. student in American Indian Studies at the University of Arizona, Tucson.

Index